/375

D0612134

Love, Sal

letters from a boy in The City

by Sal Iacopelli
illustrated by Phil Foglio

grass
stain
press

a division of Greenery Press

© 2000 by Sal Iacopelli

All rights reserved. Except for brief passages quoted in newspaper, magazine, radio or television reviews, no part of this book may be reproduced in any form or by any means, electronic or mechanical, including photocopying or recording or by information storage or retrieval system, without permission in writing from the Publisher.

Published in the United States by Greenery Press, 1447 Park Ave., Emeryville, CA 94608.

Cover design by DesignTribe, www.designtribe.com

All illustrations by Phil Foglio, www.studiofoglio.com

Truman Capote quote from "Other Voices, Other Rooms," Vintage, 1994, used with permission

www.greenerypress.com

ISBN 1-890159-24-7

This is a fictionalized work based on the author's real life experiences. Any resemblance to actual persons, living or dead, or to any actual businesses, places, locales or events, have been changed to disguise any actual such persons, businesses, places, locales and events.

This book would have never come to fruition without the support of many. First... I thank Tim Fiori, Olga Reyes and Ellen Skye who planted the first seeds of the idea to pursue getting this work published and who encouraged, badgered, insisted and cajoled me until it was done. Your love, support, friendship and advice mean the world to me.

Also thanks to Sue Saltmarsh, who is a constant source of loving, wise, spiritual guidance...

... to my mother, Rosalyn Iacopelli, who has been an accepting, supportive model of strength. To my brother Frank Iacopelli... who is the finest brother one could ever ask for.

... also... to my San Francisco friends who made my time in San Francisco so special and memorable and who graciously gave permission to be "exposed" in the book... Blake Arnall, Irl Barefield, Mario Mondelli and Sher and Max Vieira.

... to Patrick Batt, mentor, top and good friend.

...to my publisher, Janet Hardy, who believed in my work, who was constantly and consistently patient and unflaggingly supportive throughout this process... and who is also a kick-ass editor.

...and to the many who have read this book in various unpublished forms... David Reid, Mark Reese, Lotte M. Langer, Ed Spagnola, Daniel P. Delany, Linda Kroning, Gerardo Montemayor, Camille Gielicz-Moline, e. Smith Dudley, Beth and Victor Foster-Peterson, Pamela Blake, Victor Pond, Kelly Harmon and Cathryn Majkowski.

I express my utmost gratitude to you all... thank you for accompanying me on this journey.

Love, Sal

"So few things are fulfilled; what are most lives but a series of uncompleted episodes? Our doubt is our passion and our passion is our task. It is wanting to know the end that makes us believe in God, or witchcraft… to believe, at least, in something." – Truman Capote, "Other Voices, Other Rooms"

for **Max Vieira**

April Fools Day, 1995. San Francisco

Dear Tim:

Nothing shakes up your identity *quite* like moving across the country. In Chicago I knew who I was... a no-nonsense, ball-busting Dago. And I knew what the rules were. This town is pretty damned different... and difficult.

What's more disgusting than a San Francisco sex-club at 5:00am? *Nothing.* Last week, I got a job at San Francisco's most outrageous sex-club. It's called the Suck Hole. *I* call it the "Squat and Gobble." It's located in a renovated warehouse in the South of Market District (known as SoMa)... the hotbed of sleazy, queer, San Francisco nightlife. As guests enter, they're required to go through a "sniff test." After all, the Suck Hole caters (or *strives* to cater) to that masculine, butch subculture of queer men. No cologne or "flowery scent" is tolerated. BO is the order of the day, thank you very much. Masculine attire (and very *little* attire) is strictly enforced. The door monitors are instructed to allow no one entrance wearing sweaters, slacks or gaudy clothing. The club is dimly lit, painted in dark colors with erotic pictures, posters and paraphernalia littering the walls. The best porn flicks of the '70s, '80s and '90s play continuously for our guests' viewing pleasure. Loud, pounding music blares (hell, did you think they'd be spinning show tunes?) The owner (whom I call "Uncle Ed") (who's a *very* sexy enigmatic Dad) refers to the club as "The Leatherman's Disneyland." It's called the Suck Hole because they don't allow fucking, rimming or fisting. If *all* sex acts were allowed it would be too difficult to monitor for unsafe sex. Yes we check... that's part of my job. I wander around checking if our patrons are behaving. Last night I worked the floor. For six hours I walked through the hottest sex-club I've ever been in, peeking into booths looking for unsafe sex acts and drug use. and I got to bust up two couples. The first couple was fucking. My job is to say, as discreetly as possible, "Excuse me, I'm on staff here and it *appears* to me you are fucking. I'm sorry, but that's against club policy. Please

change your position to one less compromising." This guy pulled his hog out of another guy's ass and apologized to me. What *power* I have.

The other instance was in sort of a pile. I had to climb over three suck queens to get to a guy rimming someone. I got on my knees and said in his ear, "Excuse me..." He defensively said, "*I wasn't rimming him!*" To which I replied, "Well, you did a good job fooling me, which means you would do a great job at fooling the health department, who would close us down in a hot second if they saw what you were doing." He stopped. Life is good.

I'm sharing an apartment at the top of Russian Hill with a friend I knew in Chicago who moved here a year ago. It's a rather whimsical place, tucked in the back of the main house. The living room is quite small... yet has a two-story ceiling with a skylight and windows all around... it used to be an artist's workspace. The industrial '50s furniture I dragged with me from Chicago looks *fabulous* on the white tiled floors. We've got no view (damn) because we're jammed in, *surrounded* by buildings. This city is *so* densely packed. But once on the roof, we have an incredible view of downtown (which is minutes away), Chinatown, the sweep of the San Francisco Bay and the Bay Bridge. It's a magnificent sight at night when the fog rolls in and the twinkling city lights reflect on the calm waters of the bay. What a magical fairyland this place is. *So to speak.* I do some of my grocery shopping in Chinatown, being jostled by scores of tiny Chinese women of varying ages, squabbling in their curious tongue over the produce. The rest I take care of in neighboring North Beach (the old Italian neighborhood) feeling quite cosmopolitan and San Franciscoesque. I've found a fantastic deli (Molinari's) where I get the best, freshest mozzarella cheese. I feel oddly comforted when I frequent the place... the thick Italian accents of the greaseballs who work the counter remind me of my family.

One night I got home from the Suck Hole at 4:00am, exhausted... ready for bed. Only to find my roommate Tony, naked, wearing a dog collar, on all fours at his Master's feet eating Cap'n Crunch out of a dog bowl. "Uh, Hi, Tony." His master said, "You may speak, dog," to which Tony replied, "*Arf!*" I knew his Master was a recent Leatherman titleholder... "Mr. Castro Street, 1995." He was all puffed up with pride... but to me, he was just another queen with a sash.

Went to a "pre-wake" wake last Saturday. Billy, who has AIDS, and has only a few months to live (according to his doctor... but what the fuck do *they* know?) gave it. Billy invited everyone who would attend his wake so they

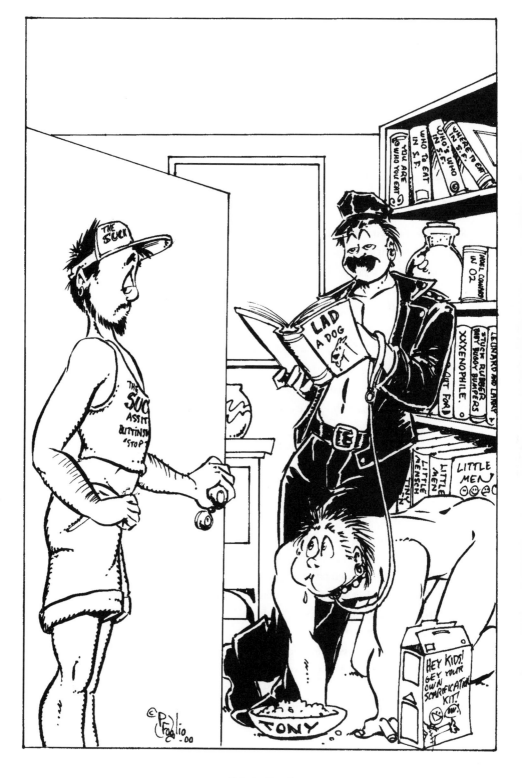

... *"Uh, hi, Tony."*

could get to know one another and feel more at ease when it came time for his actual wake. Self-indulgent perhaps? His family was there, being very sweet, accepting and Northern Californian, "Hi... I'm Billy's mother, Caroline," mixing with the S&M leather crowd (Billy has had many masters), "Hey, I'm Jake, this is my partner Ron, and our Dog-boy-slave Larry (who, of course was *not* allowed to speak... but *was* allowed to eat from a dog bowl) and meeting the pierced, tattooed mid-20s crowd, "Hello, my name is Wormwood and this is my friend Olive Twist" (Olive happened to be a cute boy in a sun dress and straw hat). It was enough to make you scream with laughter. I wandered around the gathering having an identity crisis, not knowing where the hell to fit in. Should I change my name to Bat Guano? To Burr Gurr? Also... I don't want a master. I've got too many control issues. And I *won't* eat out of a dog bowl.

Love, Sal

1 May 1995

Dear Tim:

Ya *gotta* have a sense of humor when you work in a sex-club. When "Uncle Ed" opens the club for the evening, he calls out to the staff, "OK men... *time to make the blow-jobs.*" God love him.

I worked Sunday night. When I started at 11:00pm, I walked into the water sports bathroom and saw a guy sitting naked in a puddle of piss next to the urinal. Another guy walked in to take a leak. The guy on the floor started moaning and licking the urinal. The standing guy obliged and pissed in the guy's face and in his mouth. All night, I walked through the club and passed through that bathroom every fifteen minutes. Each time I walked in, someone was pissing in or on him. 4:00am approaches... we're closing. I walked into the bathroom with Jay (who was training me). Jay saw the piss worshipper and said, "George! I didn't know you were here tonight! Have you met Sal?" He said, "Hi" and held his hand out for me to shake. I pulled my hand back and said, "*Charmed*, I'm sure."

The third Thursday of the month is Leather Pals night at the Suck Hole. I worked the door and took in tons of cash. Leather Pals is a much more intense event than other evenings. A leather dress code is *strictly* enforced. Also, fucking and fisting is allowed. Almost everyone entered carrying a paddle, riding crop or whip. It's easy for me to pretend I'm Loretta Young receiving

my guests when I don't see what they're up to after they enter. After my shift, I decided to tour the club. Everyone was beating the crap out of each other. A guy was chained to a St. Andrew's cross (it's X shaped). Another was chained to him and was fucking the hell out of him. Their master was whipping both of them, urging the first boy to fuck the other boy's "pig-pussy" harder.

Love, Sal

15 May 1995

Dear Tim:

I've been spending my evenings off exploring my surroundings, taking long walks through hip, busy North Beach (desperately trying not to look like a gawking tourist) and climbing the cliffs of Russian Hill. The crest of almost every hill affords an incredible, romantic view of the bay. It makes my heart leap to live in such an extraordinary city. In the '50s, '60s and '70s, artists flocked to these neighborhoods because of the magnificent vistas, inexpensive rents and the proximity to downtown. Today… these areas are frightfully expensive and filled with boring, straight yups… the only ones who can afford the astronomical rents, I imagine. The area is still charming and beautiful (especially at night, when one can hear the mourning sounds of the foghorns from ships on the bay), yet I feel removed from where I want to live. I feel lonely here. Is it because of the area… or because I've just arrived in San Francisco and I miss everyone in Chicago? Ah, I'd rather live closer to the Castro. It's too much of a hassle to get around from up here.

I've been having an incredible time, it was a great choice to move here. Each day feels like an adventure. I'm having intense mood swings from being homesick and hungry for the familiar… to dizzy excitement and laughing from tearing down hills on my bike praying I don't get "doored"… being sick with worry and anxiety over getting a job with health insurance… being overcome with faith I'm on the right path and feeling such gratitude for my life and my experiences.

I rode my bike to Golden Gate Park, visited the Conservatory and sat on a bench trying to calm myself and get perspective on things. What will my life be like? Will I get a good job? How will I survive? I'm not sure where I'm going, but for now it seems OK. The past ten years in Chicago had been busy, stressful, hard work. It's good to chill for a bit. And my perspective on being HIV-positive has changed. I used to think, "Hell, I'm gonna be just fine. I *don't*

accept the fact I will progress to AIDS and die. I am the ultimate creator of my universe, and I choose to be healthy." Well… maybe it just don't work that way, babe. Sure, it's important for me to think positively, to take care of myself in terms of rest, diet and exercise… but I may get sick. I may die. It may be in twenty years, five years. A year. I just don't know. Hey, this isn't to alarm you… I'm fine now. I'm simply accepting and looking at what may happen. It makes me very sad, scared, vulnerable. I see how important my choices are at this time. What experiences, what people do I want in my life? Do I become a drag queen? A boy slave? A partner. Is it time to seek a partner? Can I push myself through my intimacy terror and be with a partner because I may die of AIDS in five years? What if I push myself through those barriers and allow myself to be intimate with someone… and I *don't* die. All that intimacy *wasted*.

During Leather Pals the other night, I went into the sling room and watched an older guy (about 60 and very fat) drag a razorblade up and down his arms, producing shallow cuts. He stood in the corner, bleeding, with a leather hood on, and whipped himself. Are people *that* bored?

Later, I was walking through "Yellow Hanky Land" (the water sports playroom) and saw two hot daddies pissing on a guy lying in a bathtub. I stood next to them, pulled my dick out and started whacking off. I figure, just like when I worked as a waiter… I'll be damned to leave the place "hungry." A guy to my right started pulling on my nipples. I thought, "Cool. I'll get off in about two minutes and get back to work." The guy starts humping on my leg… and I felt something… a warm, spreading wetness. The shit-head pissed all over my leg. I had to work for the next four hours with this asshole's piss drying in my boots.

Still later, a hot, sexy daddy pulled me into a booth and started working me. He was someone I wanted to play with for a while so I told him I was on shift and I'd like to get together another time. He agreed to it and told me I "may suck his dick and get myself off so's I'm not frustrated all night." Gee, thanks, Sir! As I sucked his rather large cock, he talked dirty to me, "Yeah boy, Daddy's gonna take you home to service his dick. Hot, slick boy-throat for Daddy's cock." *You* know the scene. "Dad'll take you home and stick needles in your boy-dick. Nail your balls to a board." "Uh… un huh." I got off quickly, he left, and I went back to work. "Needles in my dick? My balls nailed to a board?" I don't think so. *Sir.* Called him and told him he was way out of my league. *He had no idea what scared me off.* I told him it was the "needles and

nails" thing. He assured me it was just talk and we didn't have to do anything I didn't feel comfortable with.

So. I'm seeing him.

Sex is intense. Nothing I can't handle. Lots of bondage (with me as the bondagee, of course). It's kinda hot... I call him "Dad" or "Sir" (his name is Bob, by the way). He calls me "son" or "boy." Sexy... in a twisted incest sort of way. When we go out, I'm on a leash... yet he treats me well. He doesn't abuse or humiliate me. He's very gentle... yet strong. In Chicago, I played Daddy/Son, Master/Slave scenes at times, but just during sex and it's over. This is a way of life for this guy. He is a Leatherman Dad. Before we got together we set ground rules. No means *no*. He promised he'd never do anything I didn't want him to and would stop immediately when asked. I've already tested him and he does. Not sure why, but I'm drawn to him and the play we're getting into. I trust him and he certainly knows what he is doing. I think what I ultimately didn't like about these relationships was that the boy was perceived as *less* than, as a punching bag. Dad doesn't do that. I've never let anyone tie me up before. A total lack of control in the hands of someone I trust.

An incredible vulnerability.

Complete insanity? Perhaps I'm attracted to this because it's so outrageous. Perhaps it's because I feel vulnerable here and having a Dad is comforting. It's so sexy/satisfying to lie in his arms and call him "Dad." Yeah, and kinda fuckin' weird. Perhaps this is the ultimate relationship for me. Dad allows me my own life... I'm not his "slave." So, who knows? But, hammers and nails and needles... *oh my!* Well, if he doesn't require that of me... Of course, his gentleness could be a ploy for me to eventually trust him enough to let him *crucify* my testicles.

Love, Sal

18 June 1995

Dear Tim:

I got a job. A *real* one... and damned quickly too, I might add. I'm the Project Associate in a Clinical Research facility on Cathedral Hill where we run trials on new and current drugs for the treatment of HIV. Sound impressive? It's really not. I'm doing a lot of paper work, semi-secretarial work for my boss and keeping track of client visits. It's kind of boring, but

pays well enough and I have great health insurance coverage. I *do* feel like a sell-out though. In Chicago, I would rail on and on against "poisonous" antiretrovirals… yet here I am drinking coffee out of a cup with an advertisement for AZT on it.

I also work with a bunch of cool queers and dykes. One dyke (Sher) works in the next office. She had a friend of hers inseminate her and gave birth a few months ago to a beautiful girl named Max. Max has the softest blond hair and the brightest blue eyes. Now, you *know* I usually don't like babies… but when I hold little Max, she just settles into my arms as if she belongs there. Since I've gotten here, I've felt so stressed out and frightened. It all melted away and I felt such peace as I held that little baby.

And I discovered something fascinating about Sher. She *only* relates to her butch side… even though she gave birth and is a frikkin' mom. I called her "cute" yesterday and she flipped… couldn't look at me and stormed out of my office mumbling. Fran (my dyke boss) was there and said I had "insulted Sher's masculinity." So now I call her "fluffy" and "twinkie" every chance I get.

I quit working at the Suck Hole. I did give them notice though… no sense in burning bridges… especially here where everyone knows everyone else. I had fun teasing some guests before I left though. The whole "ultra-butch" image they strive for got on my nerves. One of the promotions "Uncle Ed" thought up is to hand each guest a coupon for $1 off their next admission (they're called "*SuckBucks*" of all things). When I worked the door during my last few shifts, I took great pleasure in asking the *most* masculine, toughest looking guests, "For an extra 'SuckBuck'… can you tell me what taffeta is?" One overblown daddystud decked out in leather looked *very* put out. I could *tell* he knew what taffeta was… but wasn't about to admit it… it simply would have *wrecked* his butchdaddy façade.

Ah. And about DaddyBob. *Over.* Oh honey, it got way too crazy too fast. He started demanding more and more of my time, saying we fit so well together, how tremendous the sex is (it was… *interesting* anyway) and that he was falling in love with me. How can you fall in love so quickly? Our relationship was based on fantasy and desperation. He was pushing for a seven night a week "slave-boy-sucker-hole." That's what he used to call me… isn't *that* romantic?

His last boy, David, died of AIDS in January after he and Bob had been together for six years. That was why things felt too rushed/forced. Bob seemed

desperate to replace David. It was a bit creepy too. David's pictures were *all* over the house. Not to mention that David's ashes were kept at the foot of the bed in a leather box held closed with leather straps and cockrings with a pin on it that said "in training."

What really caused me to end things with Dad was a rather twisted evening of sex we had. Don't worry… it doesn't involve me getting my balls nailed to anything.

I hope you've got a strong stomach. Dad ordered me to eat a light lunch and nothing else the rest of the day (*What?* Skip *dinner?*) We went to a cocktail party that night thrown by two dykes who live in a cloyingly overdecorated townhouse in the southeastern part of the city. I made my appearance, led in on a leash and collar. The freaky thing is… the dykes had three pet lizards they allowed to roam freely throughout the house. At one point, I had to hold back a shriek as one of their "pets" slithered over my booted foot. It simply would not do for DaddyBob's butch boy-slave to scream like a schoolgirl. There were delicious-looking snicky-snacks tastefully displayed on ornate silver trays I was *not* allowed to enjoy. Just warm water to drink. Later, we went to Dad's house where he had me drink two large glasses of warm salted water in rapid succession. Then up to the bathroom, where, in the bathtub, he proceeded to shove his dick down my throat quite forcefully… gagging me, causing me, yes you guessed it… to vomit all over his crotch. After horking up all the water in my gut, he kept gagging me, causing me to choke and puke up sticky streams of sour bile. Which he masturbated with. Hey, how sexy is *that*?

What was I thinking? We proceeded to his bedroom where he put a leather hood on me, shackled me to the bed and mummified me with saran wrap and gagged me with dildos of varying sizes. Afterward… he fixed me a snack. Gee, *thanks,* Dad.

I felt so weak, cold, empty. I could hardly think, talk, react. We went back to bed where he held me. I was lost, frightened and knew what had transpired was incredibly destructive/harmful to me. I didn't tell him how I was feeling because it would have made me even more vulnerable and would make *him* more powerful. I sensed this is what he tries to achieve. So, I played "contented boy," snuggled next to him, slept and went home the next morning.

I spent the next two days in a terrible state. Weepy, depressed, vulnerable. Revolted by the time spent with DaddyBob. Revolted by him. By myself. I called the next day and told him I didn't want to see him any

longer… that this type of relationship is neither healthy nor appropriate for me. He was crushed and shocked because he thought I was way into it. And was hurt because… *he loves me*. Honestly, *some* people. Ya know, I actually struggled with ending the relationship because I thought, since I was no longer working at the Suck Hole, not seeing DaddyBob would leave me no "social life," no "fun." I then realized I *don't* consider vomiting on someone *fun*.

Why did I do it? A learning experience? A dare to see how far I'll go? Trying to fit in with the leather scene? Where's the love? Where are the normal people? But… I'm not interested in the normal people. Anyway… happy that's over. Now I don't have to worry about wasting any dammed intimacy.

Love, Sal

12 July 1995

Dear Tim:

Pride Day - San Francisco. One thing's for sure… these West Coast queers sure put our Midwestern Pride Celebration to shame. It was the first time during a Pride celebration I truly *felt* proud. Chicago's Pride parades I've seen and been in have left me feeling… sad, wanting, frustrated. This was a much more political parade… and sexy in a not banging-it-over-your-head way. Few people were obnoxious and drunk. It was… respectable… *adult* in a way Chicago misses. It was a four-hour extravaganza! Started out with over two hundred, severe "dykes-on-bikes"… some of the hottest leather-dykes on motorcycles I've ever seen. Then group after group of politicos, HIV/AIDS agencies, S/M groups, organizations for cancer treatments/research, church groups, on and on. Everything from "Parents and Friends of Gays" to "Gay Cat Lovers." One contingent that moved me consisted of one lone woman, walking along in a red leather strap "dress." The dress was simply leather straps, so you saw everything. She was carrying a sign that read "More money for cancer research." Her left breast was bared and her right breast was… missing. Gone. Surgically removed. Where it should have been was a twisted scar. She walked silently. Stopping from time to time to show the crowd her sign. People got really quiet when she came by… not an uncomfortable silence, but rather a reverent, respectful one. I was struck by her bravery, her dignity. Another group that touched me was a "mock" funeral. Hundreds of people, led by eight pallbearers carrying a coffin. They were carrying signs with names and pictures of people they've lost to AIDS. I thought of my good friend Frank San Miguel who died in '92 and my heart ached… he would have *loved* this. I miss

him so. Yes, and of course, there were also plenty of drag queens, leather queens, and every other in between queens. My *favorite* group of this extravaganza was the self-proclaimed "Obese-Dyke" float. Five 300-pound dykes in revealing, silky lingerie, surrounded by pizza, candy and other snackies on a huge bandwagon, who took turns singing, "There's No Lesbo Like A Fat Lesbo" to the tune of "There's No Business Like Show Business," while gyrating sexually, eating and throwing caramels to the crowd. *Not* to be believed.

I've been hanging out in the Castro a lot lately. Though I must say… after hearing for years the Castro is queer central in a town that *is* queer central… it was *such* a letdown to find out "the Castro" is a few short blocks long crammed with card shops, juice joints and bars. On the other hand… I've never seen so many open, "in your face" queers in my life. Young, old, men, women of all shapes and sizes. Many couples were holding hands, or had their arms around each other. It has street carnival energy any time of the day or night. Thin, wispy, girly, young multi-colored haired queerboys mingling with older tough-lookin' dyke mamas rubbing elbows with big hairy hulking leatherwearing beardaddies alongside punky, young pierced dykes. *Wow.*

One evening, when I was still seeing DaddyBob, he and I were to hang out at a bar on Castro Street with some friends of his visiting from Seattle. Bob showed up late, handed me a small paper bag and said "Hold this, boy, I gotta run to the pharmacy." I asked "What is it, Dad?" He said, "Just some of David's ashes." (They were in a condom, no less.) "I want to give them to Mark and Mike so they can scatter part of him in Seattle where he was from." Bob left on his errand. I was sitting there feeling quite creeped out when a guy sat next to me and started talking. It turns out he saw me with Bob and came over to get the scoop. He used to have three-ways with Bob and David. He said to me, "Damn! Bob, David and I used to have *incredible* times. Hey, I haven't seen David for a while! Where is he? How's he doing?" It was *so* difficult *not* to pull David out of the bag.

I celebrated the Fourth of July in San Anselmo, where my roommate Tony's master owns a home. Just as we arrived, I spotted a guy on the side of the road who looked suspiciously like DaddyBob. I thought, "Oh, *c'mon!* He's *got* to be going somewhere else." *Nope.* It *was* DaddyBob. This is *such* a small town. We got to the house and talked to AIDSBilly (the guy who threw a pre-wake wake for himself so "my beloved friends and family won't be uncomfortable at my funeral because now everyone knows each other"). I've

named him thus because he's made *such* a career out of dying. As it turns out, AIDSBilly is now seeing DaddyBob and invited him. When he found out I dated DaddyBob, AIDSBilly asked me for dish on him. I didn't know what to say. I knew AIDSBilly has had Masters, I just didn't know how far he went. I told him, "DaddyBob is fairly intense and into some heavy scenes." AIDSBilly said, "What? Like putting needles in my dick? Nailing my balls to a board? That's not too bad, as long as I get to say where the nails go." I told him, "You'll get along famously." He looked at me with a "world-weary, oh honey, I've done *everything*" glance and said, "One time, a master of mine gagged me, tied me to a wheelchair, lit me on fire and sent me rolling down a hill." I ask again... can people *possibly* be that bored?

Sex with others has been quite unsatisfying lately. Do you wonder why? Last weekend, I hit SoMa with a vengeance and trashed around the bars. My first stop was The Eagle, where many tough-looking daddies were posturing in full meticulous costume. I hung out on the patio, felt awkward and smoked. Too polished and somber for me. Then went to the Lonestar. It was full of bears and bear-chasers. Less attitude, but I felt like a skinny little clean-cut queen. Went to My Place, where serious pickups happen. Everyone was drunk and disgusting. Went to the bathroom where a guy begged me to let him drink my piss. When I ignored him, he knelt at my feet and whimpered. Boring. Then to the Hole in the Wall. A packed, severe, intense crowd. Actually, this was the crowd closest to me... 20s to late 30s, slightly to radically hip and alternative. Many shaved heads, tattoos and piercings. It was pretty wild there... I spotted four people walking around completely naked. My only thought was, "*Where does one keep cigarettes?*" Was still having an identity crisis... *where* do I *fit* in this city? I left and had bad pizza next door at Pizza Love. After fifteen years of numerous anonymous sexual encounters, of cruising bars, bathhouses, bookstores, bathrooms, parks, beaches, malls and theaters, have I finally seen the futility of it all? I mean, how many times can I wake up on Sunday morning with the taste of some old leather daddy's armpit on my tongue?

One of the last times I went to a sex club, I had sex with someone who turned out to be a sex trainer. We had great quick sex... he was a typical heftydaddy... big, bear-like and hairy. He gave me his card, "Ross Jacobs, HIV Counseling, Safer-Sex Tutoring, Sexual Relations Training." *Sexual Relations Training?* I asked my friend Ben about him who reported he's a great guy, and yes, a quite famous sex trainer in San Francisco. He's had great success

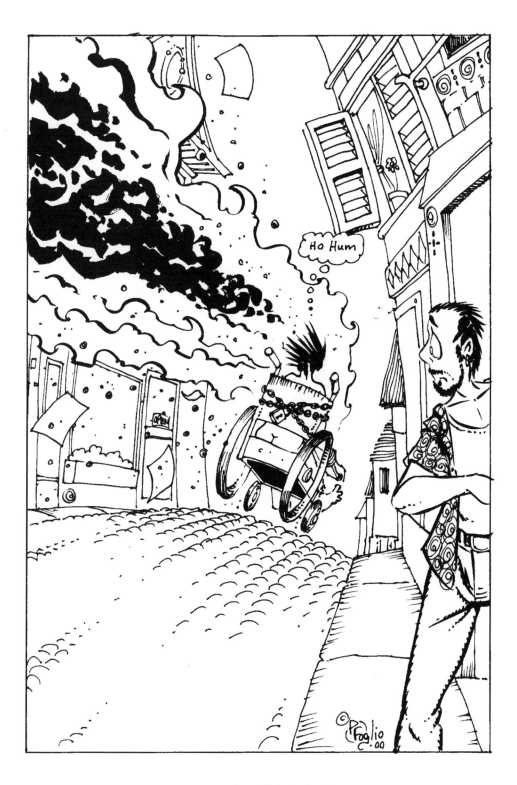

... can people possibly be that bored?

helping people get in touch with their bodies and enjoying passion again. I thought "*perfect*"... just what I needed... to feel comfortable with sex again. A gentle, strong man to guide me through my fears. To make me feel whole, to make sex a loving, passionate experience again, to lead me to new heights... *blahdeblahdeblahdeblah, blah.*

Called him and went over to his apartment a week later (pictures of him with famous porn stars on the walls, him in various leathery drag, straps and whips lying around, *there was a knife on the bedside table*). I was *so* tense and intimidated by him... ("What is he thinking?, he's a sex trainer, he *knows* what's going on in my head, he's figuring me out, he's sensing my hang-ups, the guilt and Catholic shame ingrained in me, I'm *really* fucked up, I'm *too* fucked up... *and what is that knife for?*") I couldn't get a hard-on. How could I with all that screaming going on in my head? I told him "I think I misread my energy. I thought I wanted sex, but what my chakra centers need are nurturing." (*Ugh*, I can't believe that tumbled out of my mouth). He said "... sure." (Those goddamned trainers/leatherdaddies... it's so difficult to get what they are thinking). We just cuddled and massaged each other a bit. Was nice but I felt desperately uncomfortable. Christ... *how* humiliating. I was impotent with a sex trainer.

My favorite bar to hang out is Twin Peaks. It's affectionately known as "The Glass Coffin" because of the big picture windows and the fact it's an "old man's bar"... a bit of ageism here in all-accepting California? It's a great place because people are fairly well behaved and there are a lot of Bette Midler, Barbara Streisand and show tunes on the jukebox. I can sip coffee peacefully and chat with a friend. There's a balcony with tables to sit at, to overlook and critique the crowd and the passing, seemingly never-ending thronging masses on Castro Street. My friend Ben and I call them the bitter-tables. Oh good Christ, I clicked my heels, found myself in San Francisco and have become a bitter old queen. Wait a minute... I was a bitter old queen in Chicago. Well, at least the views are prettier here.

Love, Sal

9 August, 1995

Dear Tim:

My friend Dan from Chicago is visiting for a week. It's amazing how much my perspective has changed in giving him a tour around. I'm looking at the city in a fresh way again. Jeez, I've *only* been here four months and

already I need a fresh perspective. I'm seeing the city through his eyes and remembering why I moved here. San Francisco is an exciting, beautiful, colorful, safe (relatively), clean, fun city. Yes, there *are* a higher percentage of flakes... what of it? Really having fun with him, and am relieved to love the city again.

Saturday, we rented bikes and rode through Golden Gate Park. We pissed and moaned over the beauty of the trees and flowers in the Conservatory and in the Botanical garden. The vegetation is astounding and so prolific. Plants I grew in small pots in Chicago, grow as big as *trees* here. Huge flowering hibiscus trees, towering bougainvillea bushes, there's even a Fuchsia Dell. *Astounding*. What I like best is, when in the park, one is surrounded by trees. You can completely block out the city. We rode through the park to the ocean, sat and watched the fog roll in. Then stumbled across an area I'd heard about behind "Queen Wilhelmina's Tulip Patch" where scores of men were cruising the bushes. Ah, San Francisco, something for everyone... a comedy tonight.

Am about to live out a fantasy. We're touring Alcatraz tomorrow and I'm hoping to find a secluded area or jail cell where I can have a quick wank.

Love, Sal

20 August 1995

Dear Tim:

Alcatraz... *mission accomplished*. Oh baby.

Took a grueling six-hour bike ride last weekend. Went through Golden Gate Park where the Hare Krishnas were having a celebration. There was much wailing and banging of drums and ringing of bells and jumping up and down singing *"Hare Krishna! Hare, Hare! Krishna, Krishna! Hare, Hare!"* You know the song. (I really knew I was in Northern California. Sometimes, I forget where I am and am smacked in the face with a Northern Californiaism.) Anyway, I was struck by their... dedication. Their faith. Their joy. They seemed to be a big, happy, loving family. Not to worry, I am *not* considering becoming a Hare Krishna. I would look like a Creamsicle in those orange and white robes. Not to mention how ridiculous it is to jump around in the hot sun. *And* the horrid haircut. I was simply enthralled with their excitement and felt my life is just... missing. Sometimes I feel as if my life is as dry as a second-rate scone.

I rode to Queen Wilhelmina's Tulip Patch and beat the bushes for a while. Met a guy who goes to the beach every weekend and for exercise, throws four Frisbees into the wind at a time, runs and catches them when they're blown back. How did I *ever* stay in Chicago when *this* kind of excitement and stimulation is available here? Rode down the coast along the ocean then inland to the top of Mount Davidson… the highest point in San Francisco. The view from there is spectacular and also, at the top is an enormous cement cross (bathed in glowing white light at night). I schlepped and schlepped and did it. Stood in the shadow of this 50-foot cross and looked out over our modern-day Sodom. I would have whacked off but I had already taken care of things earlier in the bushes with the Frisbee-thrower.

My dog-slave roommate ran into AIDSBilly last weekend in San Anselmo. Apparently, AIDSBilly and DaddyBob are still seeing each other. They *did* sound well suited for each other. AIDSBilly *is* concerned DaddyBob is *so* "into" blood though because he finds it kinda boring. To "spice up" their sex play, DaddyBob is going to perform "surgery" on him and enlarge his pisshole. "Because," said AIDSBilly, "the urethra itself is rather large, it's the piss slit that's too small. Just *think* of all the fun things we can shove up there… fingers, tools… *sounds*."

Love, Sal

1 October 1995

Dear Tim:

Guess who's developed an ulcer? Leave it to me to move to laid-back, chilled out California to get a fuckin' ulcer. My doctor wants me to lay off so much caffeine, which, actually, I had. Have *you* tried to drink ten cups of coffee a day with an ulcer? And she wants me to minimize stress (yeah… *right*). She's a great doctor though… an older, hip bubby. To start the examination, she placed her hands on my heart chakra and did energy-work on me. Now that's *my* kind of physician.

Something else is going on. Although my ulcer pain has abated somewhat, a new sharper pain has ensued over the past few weeks. *Numbing*. Pain in which I lie around crying. Trying to sleep to escape. Energy sapped. Can't eat because anything I take in causes *excruciating* pain. Eating ice cream, at times my only salvation, absolutely ravages my system. I'm losing weight. So much so, my big Italian butt sags. *I'm so afraid*. My doctor thinks

it's a bowel obstruction. Doesn't it just figure? I've had a procedure in which they shove a tube with a tiny light source at the end of it down your throat (one is pleasantly stoned during this) to photograph and to hopefully remove any obstructions. They found that my sphincter was blocked. The cause of the obstruction was a pesky parasite called cryptosporidium (fucking *gross*… I have *parasites*). Crypto is something anyone can get (it's in the goddammed water supply) although people with HIV are susceptible to it. It's easily treatable… when one is *healthy*, of course. The thing is, cryptosporidium is one of many AIDS-defining illness. Therefore… I have *technically* progressed to AIDS.

I feel great now, the procedure helped, my energy is back. I'm still waiting for my blood counts. My doctor says I'm quite healthy. I'm the same as I was before, except for the parasites. Still, technically… I've been diagnosed with AIDS. Odd. It hasn't affected me emotionally yet. *Should* it? It means nothing really. Oh, of course I'm joking about it with friends… asking for PWA discounts at restaurants, joking with my friend Ben (who is also positive) that "*I won, I got AIDS first!*" But I'm doing so to keep the seriousness of it at bay. OK… reality check... crypto is all I have wrong with me, and it's treatable at this point. I am *not* wasting. I am *not* struggling with a host of other illnesses. Well, I suppose it's better to get AIDS like this, rather than through a *truly* debilitating illness.

Still. *AIDS*. The average life expectancy for someone with an AIDS diagnosis is two years. *Two years*. I must have more time than that. The two-year marker is simply an average. Those figures are based on many things rather than *one* illness. But… *I'm afraid*. Interesting. I thought getting an AIDS diagnosis would be crushing, life changing, terrifying. It's not. It's... confusing.

Evenings, I stroll over to the top of Nob Hill and sit alone in the small park across from Grace Cathedral. It's normally a short ten-minute walk… but it usually takes me a half-hour or so… I'm moving rather slowly. I feel very weak most of the time. I sit wearing a warm jacket (the evenings get very chilly up on this hill), smoke and think. Have I moved halfway across the country to die? I wonder how bad the chilly, foggy night air is for my lungs. Probably not half as bad as the Marlboro Reds I refuse to give up.

A month ago, I committed to catering a reception at a leather bar my friend Ben manages near the Castro. The timing turned out to be awful… the party was scheduled right in the middle of this body-crushing illness. It was a

celebration of the opening of their new back room (which is nice and dark…
allowing for much groping of crotches) and the viewing of a mural borrowed
from the San Francisco Gay & Lesbian Historical Society. The mural is from
The Bulldog Bathhouse, a popular late-'70s club that has since been shut
down. Any excuse for a party, I guess. It was a pain in the ass though. And
quite ironic/funny being dressed in combat boots and a jockstrap with my
flabby, flatulating ass hanging out (flatulating because of the crypto and my
blocked sphincter), trying to look sexy and butch while cutting vegetables and
cheese cubes, doubled up in pain.

Love, Sal

10 November 1995

Dear Tim:

Got the results of my latest blood counts. Things are a bit more serious
than I had thought. My t-cells have dropped from over 500 to 100 and my viral
load came back completely off the chart. They don't even have a test that
tracks it that high. I attribute it to having been so sick with Cryptosporidium. I
decided to go on AZT. Me, "Mr. No Way Man, I'm *never* taking western
medicine" decided over the course of a day to go on it. Ya do what ya gotta do.
Took two weeks off work to adjust to it. It wasn't too bad… minor nausea,
fatigue, headaches. I've been going to Qi Gong classes twice a week (it's
rather like T'ai Chi), which helps to boost my energy. Interesting. For most of
my time here, I've struggled with deciding what to do with my life. Suddenly,
shockingly, my struggle is what to do to stay alive as long as possible.

I told my family what was going on and my mother decided to come and
visit. *For two weeks.* The day she arrived I was feverish with headaches and
chest pain. The next day I was much worse. Went to my doctor and she
diagnosed me with pneumonia. What a *fuckin'* drag. My mother came racing to
California because she's worried about me. I wanted to show her I'm OK… yet
the first thing I did was get hospitalized in the very hospital I work. "Welcome
to San Francisco, Ma. I'm just fine!" Spent the next four days with my mother
at my side in the hospital.

Believe me... there are *easier* things in this world.

Got better pretty quickly. It was actually comforting to have my mother
with me even though she made me nuts half the time. The evening I got out of
the hospital, she and I were having dinner in my apartment. My "dog"
roommate was upstairs in his office. Someone called for him… some Master-

Daddy apparently because he answered the phone saying, "Hello, Mr. So and So, this is the dog" and proceeded to bark into the phone. I became very interested in my plate of food as my mother looked at me as if we had both gone crazy. I told her I'd explain later.

Showing my mother around San Francisco was fun. We rode cable cars, held hands while walking along the street, and laughed a lot. I took her downtown, then to the Castro for lunch because she "wanted to see where the gay people live." That woman gets more accepting every year. We were on the Muni train, heading for the Castro when she asked me about "this dog business." As diplomatically as I could, I explained that my roommate Tony is a "dog-slave," has a Master, is subservient to him and to a multitude of other Masters. She thought about it for a moment, and as we exited the train surrounded by fags and dykes, she asked quite loudly, "So Tony only gets fucked in the ass then?" *Where* did my mother get such a mouth?

That evening, she wanted to go shopping and insisted I take her to Fisherman's Wharf. *I despise Fisherman's Wharf,* as do most San Franciscans. It's crowded, dirty, expensive and a tourist trap. When I'm there, I don't even feel as if I'm *in* San Francisco. I made the mistake of going while being hungry. My doctor had put me on Prednisone... a steroid that is an appetite stimulant (I had lost 20 pounds due to not being able to eat because of stomach pain and then having pneumonia). Prednisone did increase my appetite, I was hungry *all* the time. Unfortunately, it is *the* most volatile substance known to man. It gives you a false sense of energy and one is prone to horrific mood swings. It made me nervous, shaky, extremely angry and emotional. And I was around my mother for the sixth day in a row. And not smoking. *And* shopping on Fisherman's Wharf. After an hour (that seemed as if it were an eternity), I said to her rather abruptly, "I'm hungry, I need to eat *now.*" She told me she was almost through. I stormed out of the store swearing. I was able to calm myself down after I bummed a cigarette from a passer-by (*fuck* the pneumonia). When she finally came out, I apologized and told her I was feeling shaky and needed to eat. She decided since we were on Fisherman's Wharf, she wanted lobster. The only place I knew wasn't a rip-off was five blocks away. We walked. Finally, we got there to find lobster on the menu... for $35.00. She said, "Well, I'm *not* spending $35.00 for lobster." I blew up at the host stand in the crowded restaurant and yelled, "You are on Fisherman's Wharf in San Francisco... how the fuck much did you think it was going to cost? *A dollar and a quarter?!*" "Fine, let's eat here," she said, trying to calm

me down. "No," I screamed. "I'd rather *die* than eat here." The frazzled hostess seemed quite relieved to see us go. We ended up eating at a TGI Friday's. I was so shaky and felt I had no control over my emotions. I knew I had overreacted and scared the shit out of her. I apologized (again). She started crying and told me I've changed... that I'm so angry, mean and upset all the time... even my face had changed. Because of the weight I've lost, it makes me look meaner, gaunter. My features sharper. My eyes glaring, staring. I thought... hell *yes*, I'm angry and upset. I've been diagnosed with AIDS, just got out of the hospital with pneumonia and have spent the past two months in pain. I was furious and had every right to be. Plus the drugs I was taking were making me nuts. I tried to explain this and also apologized *(again)* for taking it out on her. To her credit, she understood... mostly... although, she did keep saying I had a "mean look in my eyes." *Whatever.*

Actually, all drama aside, I'm doing much better now. My health is returning and my weight is up. I feel good.

My roommate Tony moved to New York and I've decided to get an apartment with my friend Ben in February. The woman I work with (Sher) needs a roommate and I can share her apartment in Bernal Heights till then. The thing is... Sher has two dogs and a seven-month-old baby. Hmmmm. Sher's baby Max is a well-behaved critter, but still... a dyke, two dogs, and a baby?

Love, Sal

9 December 1995

Dear Tim:

My sex drive is returning. Perhaps it's the testosterone shots my doctor gives me every three weeks. Bless her heart. Went to a new sex-club (The Playground) in a huge warehouse. A three-story extravaganza of creative play areas. The basement was set up like a bombed-out hospital with lots of doctors' offices, wheelchairs, examination rooms and tables. The second floor was set up as if it were a campground. Fake trees, bushes, teepees and tents. Sorta bored with it all. Had sex with someone in a teepee. Was hot but felt so stupid because people kept peeking in. And he asked me my name. *During.* I *hate* that. Like he needs to know my name to suck my dick in a fa'crissakes fake teepee. After, elated with great sex, he said, "Oh, you're so wonderful, such a nice guy, I feel like we have great energy together!" Oh, knock it off. We only

had *sex*... it's not as if you *know* me. You know nothing about me. I'm so tired of the sex and love fantasy game.

Then went to the Suck Hole. I haven't been there since I quit in June... good Christ that place fuckin' *rocks*. George the piss worshipper was there, still in position, still begging for piss. I refrained, again, from pissing on him (and from shaking his hand). You know, I've been here long enough to not be anonymous when I go sleazing. One's face (and other body parts) becomes familiar pretty quickly. I ran into a friend who knew I had been sick, so he asked about my bout with pneumonia, the crypto, and what my latest cd4 count is. *Not* the type of conversation I wanted to have at that precise moment. Later, I was on the catwalk getting a damned great hummer. Three different guys I knew stopped by to chat. To *chat*. Excuse me, *I'm busy*. People here are too casual about... *everything*.

There is a drug here the serious party-queers use a lot called Crystal. It's real speedy and makes you *excruciatingly* horny. People take it and stay up for *days* partying. AIDSBilly and DaddyBob got together in San Anselmo, where Bobby lives, and took Crystal in anticipation of a weekend of freaky sexcapades. Unfortunately, they got into a fight and AIDSBilly kicked DaddyBob out of the house. AIDSBilly was *so* wrecked on Crystal and *so* horny he shoved a dildo up his ass, opened a can of dog food, put it in a dog bowl, pissed in it, ate it, then pulled the dildo out of his ass and licked it clean. I dunno... I ain't *never* been that horny.

I moved in with Sher last weekend. It's amazing watching her with her baby girl, Max. The other evening we were chatting as she cradled Max in her arms, breast-feeding her, sweet lullaby music playing. Max's little eyes got drowsy, and she put her tiny hand in Sher's mouth. Sher gently sucked on Max's fingers and rocked her to sleep. It was so... intimate, loving, nurturing. The other morning, Max was really crabby... she's teething or something. She would be OK for a few minutes, then start crying again. I was on my way to work and stopped in Sher's room to say good-bye. Sher was doing her best to comfort Max... to no avail. I knelt down and tried to help. I'm still pretty new to Max, so she just sort of stares at me in wonder. Max grabbed my finger with her chubby little hand and stopped crying. It's amazing to watch and to be a part of Max's learning and experimenting with life and her surroundings. She has such a sense of wonder and newness about everything. Something I feel as if I've lost. It's incredible to see them together. To be a *part* of it... if peripherally.

It's trippy experiencing these anonymous sexual encounters… and juxtaposing them with witnessing and being a part of this tender, nurturing relationship at home.

I have wanted things very badly in my life. Things I have not gotten. I wanted them because I thought they would make me happy. Or so I thought. I was always postponing happiness, contentment. Planning to be happy in the future as the result of some attained goal. Waiting for that thing or things to happen. Maybe I didn't get them because they *wouldn't* have made me happy. Has going through being sick taught me anything? I think what's most important in life is to be happy… in whatever form it may take. Have joy now. Especially after being so sick, can I *afford* to postpone happiness? Can any of us?

Love, Sal

22 December 1995

Dear Tim:

Oh, the baby! The crazy sex I've been seeking and participating in most of my adult life seems cheapened by the baby's open quest for love and exploration. The baby's sweet energy is that much sweeter when compared to the desperate search for anonymous sex. It's *so* healing to be around Max.

I can't wait to come home from work to play with her! It's much more exciting and comforting to be around that little love than to hunt and find empty, mindless, emotionally numbing, anonymous sex. *Numbing.* Of the mind, emotions, spirit. Rather than stimulating, fulfilling. Which is what I feel at home now. Happy. Pleasant. In the light. Not down-n-dirty, desperate like the quest, the *obsession* for anonymous sex. Ultimately, aren't I looking for love? Acceptance. Peace. Security. A feeling of belongingness, of being wanted, desired. Worthiness. A happy, toothless smile and laugh I get from Max means worlds more to me than the cruising smile/leer of a potential sex-partner. What do I get from being around Max? Something I'm looking for, needing. What am I giving that I *need* to give when I'm with Max rather than some stranger? Intimacy. Trust. Acceptance. Wonder. The wonder I feel from Max is so much more intense and rewarding than the wonder I get from sex. Does that discount the sex? Discount *me* when I'm in the pursuit of and the act of anonymous sex? *I* discount myself when I put myself into the search and participation of it. As I discount and objectify others. As *they* discount and objectify *me.*

This morning, holding the baby while she rested her head on my shoulder was bliss. The world stops. It's as if all that matters... all that *should* matter... is in that single moment. The moment of comforting her.

For a few months, I had completely lost interest in sex because I was so sick. Now with my new, improved health (and testosterone shots every three weeks), my sexual appetite has returned. Spent a good part of this past weekend looking for sex and did partake in some mediocre trysts. It was boring, frustrating and I was left feeling angry, frustrated, alone. It was easier *not* being interested. Recently, someone I know (who is absolutely not interested in sex anymore because of illness and HIV medications he's on) asked me how it felt to have interest in sex again. I replied, "Disappointing. And a pain in the ass. It's just one more goddamned thing to take care of."

Went to a mall in San Bruno last weekend (just south of San Francisco) with Ben to take care of some Christmas shopping. It was decorated in typically cloying mall-fashion Christmas stuff with lots of huge potted palm trees surrounded by poinsettias. I'm not sure about a lot of things, but one thing I *am* sure of is Christmas decorations look ridiculous in California. Went to the employee party at work. It had a tropical theme... "Calypso Holidays '95." Lots of bright, tropical colors, a huge light-up Santa on a surfboard being pulled by reindeer dressed in Hawaiian shirts. The hired band massacred all the traditional Christmas songs in a funky Calypso beat. Oh, *cut it out.*

What is my responsibility to my friend Ben? Part of the reason I'm moving in with him is because he's not too well. He's not sick now, but his cd4s are low and he won't do anything about it. He has very little energy and doesn't seem to be getting better. He and I have committed to each other we'd be there for the other if one of us got sick. It was iffy for me a scant two months ago... but now, I'm feeling great and I know I'll be well for awhile. Of the two of us, I'm sure Ben'll go first (I know... morbid, morbid. *Whatever.*)

Anyway, I need to be there for Ben. To take care of him. He has no one else to see him through it and I'm willing and able to do so. It just feels right. If I get sick, I know I have people to help me... for which I am very grateful. I know (as does Ben) he doesn't have that. He wants to stay here till the end of his life. He truly feels San Francisco is the end of the rainbow. *Yeah. Color my world, baby.*

Love, Sal

12 January 1996

Dear Tim:

Found a new apartment to move into with Ben and it's in a perfect area... lower Hayes Valley. I'm walking distance from work, the Castro, SoMa and downtown. And the apartment is very upscale, white-girl. It's ridiculously small (by Chicago standards) but livable. The saving grace since I have to have a roommate is that it has two floors. The main floor consists of a tiny kitchen and a living room. Two bedrooms and a bath are upstairs. Still no view (doubledamn). It's a new building, so it's very square, boxy, modern... and painted white. I tried to spruce things up with fabulous window treatments and such, but there is *only* so much one can do. Yeah, I know, completely *not* my kind of place... but hell, the market is fiercely tight... we were lucky to get it. I'm sure gonna miss the hell out of living with Max the wonder-baby though.

I've gone to a lot of parties the past few weekends... the holiday "thang" you know. My favorite thing to do is find the boys who are HIV-positive or have AIDS (it's not difficult to spot them in a crowd... they're usually the ones who are smoking, while the HIV-negatives look on in disdain). We discuss medications, our illnesses and disability. I can talk about that stuff for *hours*. It reminds me of when I was a little boy, sitting in my mother's kitchen at a family function. The men would gather in the living room watching TV or playing cards. My mother and her sisters would get together in the kitchen, smoke cigarettes, drink coffee and talk about their illnesses, their heartaches, operations and pregnancies. It felt so comfortable and womb-like in those smoky, fragrant, warm kitchens with coffeecake on the table, listening to and sharing in their miseries.

Love, Sal

5 February 1996

Dear Tim:

My latest fantasy is to get fucked by a butch muscular dyke wearing a strap-on dildo.

Magic. I need magic in my life. In the form of creativity or... *something*. Also, I'm tired of going to clubs and other places looking for sex... it's such a waste of time. I want a fuck buddy. No strings attached. Just someone to get together with once a week so I don't have to spend much energy in its pursuit. I've placed a personals ad in one of the queer papers:

WANTED: DADDY FUCKBUDDY

Me: 35, 5'7," 160lbs, Italian, HIV+, healthy, bottom (usually), sexually aggressive, smoker. You: 35-50, hairy (facial hair a plus), HIV+, top, masculine. No commitments. No drugs. No booze. No Black & Decker tool fetishes.
Love, Sal

19 February 1996

Dear Tim:

I'm having the time of my life dating the sweetest, most loving, kind man and having outrageous, nasty, crazy, daddy-master/slave-boy sex. Unfortunately, it's not with the same person...

I met a guy whom I like a lot. He's kind, intelligent, funny, generous, and relatively well adjusted. And he's *not* a native Californian. A big plus, believe me. His name's Blake, my age, and an art director at an ad agency. We have a wonderful time together... he has a great, twisted, campy sense of humor. I enjoy kissing, holding, sleeping with him. Talking and being with him. He treats me to fabulous dinners and shows. But. Sex isn't a turn-on for me. I go out and have wild, passionate sex with strangers... and feel so unfulfilled. So empty. I go out with Blake with whom I have a delightful time, holding hands, laughing, being sweet. Genuine. Yet, when it comes to sex, I'm just not into it. He's understanding and knows I'm attracted to and am having sex with others. Big, beastly, nasty others. I'm attracted to Blake emotionally, intellectually, spiritually. Why can't I be attracted to him sexually? Why should it matter he's not a huge, dominating, nasty top/freak? *Dammit.* I want to have it all with him.

A week later, I met this *other* guy. Trouble with a capital "T." PapaPete. He's 49 years old, 6 foot 1. A huge, dark bear of a man with salt-n-pepper hair, a close-cut beard and piercing dark brown eyes. Actually, ironically, I met him because of my straight brother who called me from Chicago and asked me to send him a type of lube he can't find anymore, and to look for nipple-cuffs for his girlfriend. Ben and I went to a sex shop in the Castro to find them. PapaPete was shopping there and was all ears when he heard the purchases were for my younger brother. I was thinking of getting a ball stretcher for him as an added bonus and asked PapaPete if he thought a straight boy would know what it was. He said, "Probably not" and asked me if I'd seen my brother's

dick recently (for fitting purposes, of course). I replied, "no." He said, "Oh yeah? I've always wanted a younger brother to dominate and to have him suck my dick." I responded, "I've always wanted an older brother or daddy to service." Ben (who is *no* stranger to such things... he manages a leather bar fa'crissakes) turned pale, said "I'll just wait outside, boys" and politely left the store. There wasn't any air left to spare anyway what with all the all the testosterone raging.

Well... we've been getting together and having wild, nasty, crazy sex. He's as nasty as the nights here are cold and damp. I'm learning though. I told him I do not want to carry this insane sex out into the real world. I'll be his "younger brother/slave/boy" during sex. But that's it. After sex... curtain comes down... the show's *over*. I don't want to date him. I told him I'm seeing someone else. I don't want a full time master. I will *not* call him "Sir" outside of sex.

Actually, that makes him crazier than anything because *he's* used to being the boss. Who am I kidding though? He's been at this a helluva lot longer than I have. I think he's intrigued because I'm fighting for control and setting strict boundaries. *Oh, those pushy bottoms!*

Love, Sal

26 February 1996

Dear Tim:

Just *who* was I kidding? Me? In control of someone who has been doing the master disaster thing for over twenty years? I wasn't fooling him. "Oh, here are my boundaries, Sir, please don't cross them." He played me fast and furious and I was hooked within a week. It got to the point where he would call, leave a message and I would shake simply hearing his deep, commanding voice. I would lose all control, all thought. Wanting, needing him so bad. Wanting to give everything to him. Had to end it. I was just in it for sex. Right? *Right*. His kick is to play huge, mind-fuck power trips over his bottom slave boys. I thought it would be a fun challenge and all I had to do was be a hot, sassy, smart, bottom. That it would just happen during sex. *Nope*. He wanted it all, and was stopping at nothing to get it. He said, "Sure, son, we'll just play," and I believed I was in control enough to keep it at that. Oh no, honey. He worked hard at beating down my barriers, working my insecurities, getting into my mind, finding out my weak points. Using them against me,

gaining control. Making me more and more dependent on him. Being at his beck and call. Losing myself. I told him from the beginning I wanted to be dominated physically. *Not* mentally or emotionally. I have worked too goddamned hard over the past fifteen years to gain myself back to hand myself over to a power-hungry, energy-sucking Master. But *oh*. How I still want him. I can't. *I won't.* It stopped being fun and got ugly and obsessive… *real* fast.

The other night he went too far. After hours of teasing me with mind games and very little actual sex (at his apartment up in Diamond Heights, near Twin Peaks… they *always* like to play on their own turf) we got ready to leave. He grabbed me, shoved me to my knees, face fucked me, and shot all over my shirt and jacket. Then sneered and threw me a towel, laughing. And didn't give me permission to cum. *And* I had gotten a testosterone shot from my doctor that afternoon. How *dare* he? That dirty-pool playing, underhanded, manipulative bastard. He bites my neck till I'm faint, spanks my ass… hey, it's fun, it's all in the game. But. Don't you *dare* not allow me get off. I'm Sicilian, remember? I was utterly livid… but didn't let on. I've been around the block a few times myself. I kept the game going, smiled and said, "Thank you, Sir!"

He was spending *way* too much time fucking my head instead of my body. It's over. I knew I had a few cards to play myself. I knew he thought I was attractive, sexy, smart. And I can be a hot slave-boy when I want to be. He thought he had me completely under his power. I called the next day and told him, "I've decided to end things. Things are going in a direction I didn't want them to." I did *not* say, "You're too intense for me." I did *not* say, "I can't handle it." That would let him think he "won"… that *he* topped *me*. I wanted to end it and didn't want to give him control or an ego stroke when I did it.

Nothing crushes a Daddy's ego faster or harder than having a boy dump *them* in a calm, controlled, powerful way when they're hooked into you, thinking they have you safely under their thumb. My big, tough, powerful Master was putty in my hands. I hung up with him sputtering "but but but…" I topped that motherfucker good. Whipped around and topped him so fast he didn't know *what* the fuck hit him. Don't you *dare* pull that head-fuck shit on *me*. There ain't nothing colder than a pushy, angry, horny, Sicilian bottom.

The last time I saw my doctor I asked her if I should cut down on my testosterone shots. I've been rather, shall we say, *aggressive* lately. She said she'd check the levels on the next series of blood tests but hesitates to cut it because it was so low before and testosterone is an excellent way to build lean

muscle tissue. In fact, she's increased my shots to once every two weeks. *Good leaping Christ.* No Master in this goddamned city will be safe.

My personals ad came out. One called that sounded interesting so I made plans to meet him in a bar on Polk Street to discuss interests. He said, "I'll be the one with a shaved head, goatee, wearing a leather jacket with miniature boxing gloves hanging off of it." OK... *whatever.* We met. He wasn't in as good shape as he professed to be. He said he goes to the gym five days a week. I thought "... oh *really?* Did you consider *working out* while you're there?"

He didn't seem to be a freak... and not into the complicated mind fucks like my hot (but crazy) recently dismissed Papa. We walked to his apartment downtown where he told me he has a playroom set up in the basement. We went down, he opened the door, turned on the light. He had set up a storeroom space as a *boxing ring.* Complete with mats, posts with ropes strung with pairs of boxing gloves, a bell and huge posters of cheering crowds hung on the walls surrounding the ring. I felt as if I had stepped into Rupert Pupkin's basement in "The King of Comedy." I turned to him and said, "I am *not* boxing with you. I'm wearing contact lenses." "Well, how about wrestling? I bet you'd look great in wrestling gear." Hmmm, I *have* been working out pretty hard. And the outfits *are* pretty sexy. He went to a wooden box against the wall filled to the brim with butch drag and pulled out a red and white outfit for me with matching socks and shoes. He chose a blue and white one for himself. I got into the ring as he went to a tape player set-up. Atmosphere music? *Nope.* The tape started. *DING-DING-DING!* The sounds of a crowd roaring, cheering, yelling. The voice of an announcer. *It was a recording of a boxing match.* Goddammit. I just wanted to get laid. No loonies. No scenes. He jumped into the ring and we began wrestling. He was pretty good and pinned me twice. Well, then I got pissed. I turned around and pinned his ass to the mat. (Maybe you should be going to the gym *six* days a week. *Sir.*) I flipped him on his stomach and to test him said, "Are you gonna let your boy fuck you, Dad? *Sir?* Gonna let *me* top *you*? He moaned, "Oh yeah!" *Wrong answer. No! Me!* You fuck me, dahling! Top *me* goddammit! The operative word in my ad was *top,* sweetie.

I'm thinking of having my testicles removed.

Love, Sal

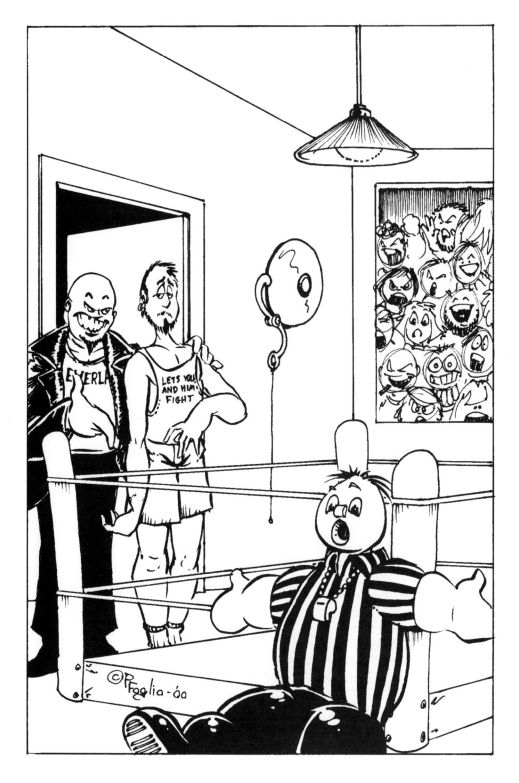

He had set up a storeroom space as a boxing ring.

4 March 1996

Dear Tim:

I had a huge boner over dumping Papa and totally got off on topping him. That lasted for two whole days... then I crashed. Bad. Missed him. Wanted him. Obsessing. His touch, his voice, the excitement, drama, passion. The insanity. Thinking I'll never find anyone so exciting, challenging or crazy. Knowing I'd be lost if I saw him... *wanting* to be lost. Papa called and left a message... I burst into tears just hearing his voice. Wanted to call him back, knowing I shouldn't. I waited a day and tricked myself into calling, thinking, "I need to call him and end this." Bullshit. I wanted to be sucked into it, into him. We talked for an hour about what I thought was so awful/sick/abusive. He kept hitting home how hot it was, how great we clicked. That he *really* liked me. And the fact he *really* liked me sucked me in. *Yeesh*, how Sally Field of me.

He kept pressuring me to see him. Just to talk. *No.* If I see him, I'm lost. Yet I'm so drawn to him.

I knew he was out to dinner with friends Friday night and would probably be boppin' around the Castro afterward. I went in and out of bars in the area hoping to bump into him. He wasn't around so I headed home. And on the way... I called him from a gas station on the corner. *From a goddamned gas station on the goddamned corner of Market and Sanchez right outside 18th Street Services... a 12-step club.* Told him I wanted to see him. "Don't move, I'll be right there." (*Hello...* what *is* this insanity?) He raced up in his sexy, black pick-up truck and I got in. He stopped in the middle of fuckin' Market Street and we were all over each other. Started going down on him with people all around us beeping and yelling to *move the goddamned car.* (Oh, sickroom drama) (Am I that bored?) (I have *never* been so crazy with someone) (Or, have I?) He took me to his office because it was close. Sex was incredible. Yelling. Crazy. Growling. Painful. Everything. *Bliss.*

The feelings I have for Papa and our sex-play remind me of the dynamics in the novel "1984." Winston, is caught, arrested, subsequently interrogated and tortured. No matter how much Winston was hurt and humiliated by his interrogator... *he went right into his arms afterward to seek comfort.* Brainwashed? No matter what Papa does to me... I'm warm putty in his hands and seek his pain-giving and his warm (loving?) comfort... to steel myself to take more and more. For him. For me. To prove my manliness?

Toughness? Strength? Him biting the back of my neck until I can't bear it is... mind-boggling. I leave my body. I leave my *head. That's what it is, I think.* I stop thinking and get into animal mode. Survival. Struggle. It's like when you're exercising and the stupid worries and obsessions that bounce around in your head are forced out because of endorphin rush. It's a high. And I want more. *More. S*o, I'm seeing him. I just couldn't let go. Unhealthy? Probably. Crazy? Yes. Hot, insane, painful sex? *Oh*, yes. *Yes*. And the killer is... I'm still seeing Blake and having a very sweet time with him. No drama. No insanity. I do need to be better about timing though. I can't see Blake right after Papa because of the bruises and teeth-marks. Can I keep this up? I *cringe* at the thought of accidentally running into one when I'm with the other. I gotta remember... this is a *small* town. My solution is to absolutely refuse to see Papa socially, which is making *him* insane. He keeps asking, pushing, trying to get to me but I'm as emotionally unavailable to him as possible.

Blake and Papa are so completely different. It satisfies my lust for a double life. As a child, I was fascinated by the double lives superheroes led. I was enthralled that superheroes were able to live and bring to life two completely different sides of their personality. And one part *never* had to answer to the other. Meek versus Bold. Gentle versus Rough.

Papa is 50, rough, dark, muscular... a redneck from Montana.

Blake is 34, gentle, slender, and from upper-middle-class Florida.

I love lying in bed with Blake, laughing and talking, taking catnaps.

I've never been in Papa's bedroom. We fuck at his office (when closed of course) (sometimes, actually, when it's *not* closed) or stay in his living room.

Blake comes over and hangs with Ben and me, watching movies. Ben and all my friends adore him.

I won't tell Papa where I live and all my friends detest him.

I took Blake to a work party... he was wonderful, gracious, perfect.

I won't tell Papa where I work.

Blake and I go to theater, movies, dinner, for walks, shopping.

I won't even go for a cup of coffee with Papa.

Blake and I have wonderful, interesting conversations.

Papa and I spar... with me constantly ducking his jabs.

I dress up when I go out with Blake and wear fun, colorful things.

I wear old clothes for Papa. He has a habit of ripping them off me.

In bed, during sex, Blake tells me how beautiful and wonderful I am and laughs when he orgasms... because "it tickles."

During sex, Papa tells me I'm lucky he's letting me suck his dick and growls when he cums.

I am unavailable to Blake sexually.

I am unavailable to Papa in every way *except* sexually.

Part of why I'm drawn to the drama and excitement of Papa *is* the escape. From my thoughts. From reality. I'm worried about Ben. He's been suffering with stomach pains. He's losing weight, giving up hope, getting weaker. His doctor doesn't know what's causing the pain and has suggested a procedure that will check for MAC or internal KS. Ben's angry. So angry. And I don't blame him. I'm steeling myself up to take care of him if it comes to that. But oh, I can't bear it. I'm heartbroken, worried, frightened. I'm ready to do everything I can, but I'm so sad and scared of what may come for him. And that's perhaps why I want out of my head.

Love, Sal

8 March 1996

Dear Tim:

Blake and I may just become friends, which is more important to me than a lover/partner/whatever anyway. No matter what happens, he wants to stay in contact and we could be theater buddies. We talked about sex not working for me and he told me he doesn't mind I don't get into "bumping purses" with him.

I'm wanting, needing Papa more and more. The intensity between us is incredible... better than "Soma" (the escape/drug in the novel *Brave New World*). I think of him constantly. His arms around me. His smell on me. Desire. *Oh*, the desire... the escape. I'm considering going further and seeing him socially. My hesitation is I don't want to feel like his "boy," his "fuck-pig" with him in control outside of sex. He says it's possible and I need to give him a chance. Also, if his "power," his "control" comes from playing head games with me... the less time I spend talking with him and sharing what's in my head, the better. And, actually, honestly, it's part of *my* game. To resist him. To put up my walls. That is *my* power. "*OK, motherfucker, you want inside of my head? Try it. See how far I'll let you in.*" I've set strict boundaries with him; yet, he keeps pushing them... which, he says, is also his thing. To push me to the limit and past where I want to go. Sexually. Emotionally. I don't trust him.

How can I trust someone who's into such gameplaying? He keeps asking me to dinner, events, benefits. I refuse. He tries to trick me, manipulate me into going out with him. Picture him like a bulldog worrying a bone, guarding it jealously, growling, pissing in the corners, not wanting to let go. And I'm fuckin' loving it. The *intensity*. The escape. I'm fighting for control of my boundaries and to keep my "Soma" supply intact.

When Papa and I have sex, at some point during it, he grabs my face and makes me look into his eyes. He asks, "You love me?" The first time he asked, I laughed and said, "No. Oh *no*, Sir." He liked that… said it's a test to see where his sex partner's head is. Last night, he asked me as usual and… I hesitated. (I think I'm falling) (Or *is* it just animal, incredible lust) (*Shit*).

He said, "Answer me."

I said, "No, Sir. I don't."

He said, "Yes."

I said, "No Sir."

He said, "*Yes*."

I said, "*No* Sir. Papa… you love *me*?"

He said, "Yes. And I'm going to marry you. You are mine."

Well now. I find myself in an interesting position, eh? *He* loves *me?* If it's true… he's crazy. Also, I don't love him and it sure puts me in the driver's seat. If he's lying… trying to suck me in… pulling a whopper of a mind fuck… then that's *really* sick and twisted of him.

Addicted to the intensity...

What is it about Papa, about sex with him that has me hooked so? The passion. Danger. Pain. What is it about the struggle, the *fight* that has me so drawn? If anyone else did the things he does to me, I'd bite their head off. After sex with others, usually anonymously, I feel… empty, sad, frustrated (even if it is "rough" or "fun"). After a heavy S/M session with Papa, I feel full. Spent. Satisfied. Quiet. *Quiet*. My brain at rest. Which is what I want. To quiet the yammering, complaining, worrying thoughts running incessantly through my head, refusing to give me rest. To be at peace. His way of pulling me to him (well, *one* of the ways) is to cause me pain. To assert power and control in that very physical way. And to have me give in to it. To *him*. One of the things Papa does during sex is he will lick my neck or my nipples and then bite. Hard, hard, harder. If I struggle, it makes me tense, it hurts more, I get afraid, claustrophobic, smothered and I can't take it. I pull away from him. If I focus during it, during the pain, and breathe, rise above the pain, I let go of the

pain, go to him, relax, take the pain, feel past it, past my thoughts, my fear, my fear of being hurt. I feel… as if I open up somehow. A huge release of energy? Fear? Blocks? Then the pain is… enjoyable somehow. An insurmountable struggle overcome. And he is the one who helps me there. And when the pain stops, he is there to comfort me proudly because I took it. Because I was able to get past it and he was able to help me there. Because I *allowed* him to help me there. I let go of my control, my "walls," and completely give in to him. Physically, anyway. His demands, his desire, his need become mine to fulfill. It brings me to new heights of passion… I get a huge rush of energy after and feel so "full." And end up wanting him more, to take and to give more. *Or, I'm nuts and this is all a testosterone-induced disaster.*

And yes… still trying to escape from the fear I have about Ben being sick. I took him for his procedure the other day. They found nothing. They don't know what's causing him so much pain. He wakes up in night-sweats, can't sleep, has bad stomach pain and cramps. I was hoping they'd find something wrong… so at least we'd know what it is and treat it. The not knowing is hard. Waiting. Watching him go through such pain, losing weight, losing hope. Despair. The poor guy is so weak and depressed. Angry. And I feel powerless to help him. *To heal him.* The best I can do is to take care of him. Cook and clean for him, change his sheets, get groceries. Listen to him.

Love, Sal

12 March 1996

Dear Tim:

I live in a city where Emergency Survival Kits that contain freeze-dried food, candles and batteries are sold in the goddamned Walgreen's. What more needs to be said?

Part of my attraction to Papa is that I never know *what* the fuck will happen. A loving caress? A painful bite? "I love you"? "Give me your head… it's mine to have and I want it"? "I'm going to take you to places you've never been to before"?

Sher lent me her <u>Lesbian S/M Safety Manual</u> to read. Interesting… a lot of my thoughts on why pain can be so pleasurable were right on. The concentration, the rush. One aspect I didn't mention is the fact of how *good* and intense it feels when the pain stops (although I guess it would be pretty obvious). Your head pounding, blood rushing. To be simply touched softly

afterward is bliss. Your body so wired… every nerve singing… a soft caress on the cheek makes you shout out in ecstasy.

I went to Papa's house Friday evening to spend the night. I knew it was against my better judgment to spend time with him, but I do want more. I want to sleep with him, to curl up next to him. We were hungry so I consented to going out to eat. I hate the area he lives in. I feel as if I'm in the middle of a boring suburb. And it's always frikkin' cold and foggy. I call it "The Addams Family" neighborhood… much to his dismay. He didn't want to leave the area (to get on my nerves?) so we walked to the corner to a tiny hole-in-the wall Chinese restaurant he goes to occasionally. We were in the middle of bum-fuck *nowhere*, in a deserted restaurant, talking about piss scenes, fucking in the underground Muni tunnels and god knows what other fantasy/disaster/sex insanity… and in walk two queens I know from Chicago from *Incest Survivors meetings*. Two guys who know about my sex addiction, my abuse issues… *everything*. My teeth hit the goddamned floor and I turned as white as my ass. Papa turned to see what I was gaping at and in walked a third guy to join the two guys I knew… some "boy" Papa played with last year who dumped Papa because he was just too nuts.

Busted. I was *fuckin'* busted. *Jesus Crucified Christ.*

I was absolutely squirming in anguish. Of course they *had* to sit and chat with us. I soon found out what the relationship between Papa and the "boy" was and that my friends knew all about it. *"Oh, so this is the 'Pete' we heard about!"* As soon as Papa figured out how much they knew about *me* he was beside himself with delight. The two guys I knew went on and on, "What are you doing now? How do you *like* San Francisco?" How could I not answer them? I tried to be as brief as possible… but it's *just* not possible with queens in recovery, *goddammit*. And what was I *supposed* to say anyway? *"Listen you guys, I'd love to talk to you but I'm in the middle of recreating incest fantasies with this insane top/master/daddy and I don't want him to know anything about me he can use to his advantage so do me a huge favor and shut the fuck up"?* One of them pulled me slightly aside and with an obnoxiously concerned look in his eyes *only* a recovery queen could have asked, "Really, Sal, how are you? I know you stopped going to meetings in Chicago. Do you go to them out here? Are you keeping sexually sober?" I glanced at Papa, laughed and said, "Oh *honey*… look across the table, *there's* my program. Don't *make* me take you there." Later in the conversation (that felt as if it went on for *centuries* but was probably only ten minutes), one of them (who is the King of Incest

Survivors and can't *not* talk about his goddamned issues for more than five minutes) started talking about incest. Papa interrupted him and said to me (and to all) in a sexy-sleazy voice, "Incest. *Cool.*" They got up to go shortly after.

Max's first birthday party was last weekend. Lots of dyke moms, their offspring, queer-boys and one straight couple (the husband did energy work on Sher's dog who has kidney problems). It's interesting seeing the similarities and differences (in comparison to the straight world) in which they are raising their kids. One Dago-dyke-mom talked about how her three-year-old son insisted on getting a Cinderella dress and wants to wear it all the time. In fact, she has sent him to daycare in it. She said none of the other children noticed, but the teachers did and commented on it. Even in the hippest circles in San Francisco... stereotypes, sexism and sexist roles abound and are invariably, heavily enforced on kids. Is there no getting away from it? Anyway, Max was delighted. Adorable and adored. Throughout the party, little Max was overwhelmed and would only stay with Sher or myself. As much as I didn't want to (even though, by this point, Max's face and hands were covered with gooey birthday cake) I kept handing Max off to others to let them hold and fuss over her. She wouldn't let go, insisting on staying firmly seated in my lap. *She is so alive.* Helping her try her first steps, listening to her babble, trying to talk, holding her and letting her cry, comforting her, making her laugh. It's so... simple. Uncomplicated. I feel so honored to have such a sweet baby in my life who loves and trusts me so much.

Sher, Max and I went to an art opening a friend of ours from work put together. Many people assumed Sher and I were a couple and I was Max's father even though Max and I look nothing alike. I took great joy in confusing the hell out of people. A fairly hip, 30ish straight woman walked up to coo over Max (whom I was holding with Sher at my side) and asked me, "Is this a boy or girl?" (Sher dresses Max fairly asexually.) I said, "A girl. Her name's Max." The woman asked, "Oh... is that short for Maxine?" I said, "Nope. Just Max." The woman had had too much too drink and was being *so* pushy. Max obviously wanted nothing to do with her attention yet the woman *persisted.* I felt like a protective parent. Plus, Sher was squirming with discomfort. She *hates* going through this with nosy people. I say... if you're going to name your female child "Max," then you'd better have the balls to be belligerent about it. The woman said, "Well, you are a lucky couple, you both have a beautiful little girl." I said, "Actually, we're not a couple." She, nosily trying to figure out our relationship, said, "Oh?... then you live together?" I said, "Well,

yes we did for a month or two, but then I moved in with my best friend." The woman looked completely confused (heh, heh, heh). Sher, who couldn't stand it any longer, said, "*Look*. I'm a dyke… this is my queer friend… Max is my dyke baby. I had another queer friend, we did artificial insemination, and he tweaked because he couldn't handle fathering a child. *OK*?" The look on the woman's face was priceless. Much more entertaining to see than the bad art on the walls.

Love, Sal

15 March 1996

Dear Tim:

Simply walking down the streets of this city can be entertaining. I was on my way to work one morning wearing a Walkman. (It cuts down on the number of street people asking for money… although some of them do shout at you because of it.) I was about to dash across the street as the light was changing and a woman standing there saw me looking to cross. She said something and looked fairly sane so I removed my music-buffer to hear. She said, "Watch it! The drivers in this city are ruthless." (Ah, a bitter, kindred spirit.) I said, "I know, I've never seen such crazy drivers." She said, "Yeah, especially when it's thundering, lightening and pouring rain like it is now!" It was 70 degrees, with a beautiful clear blue sky. An absolutely flawless morning. I said, "Oh… un huh. I know what you mean. Well, uh, stay dry." On went my music-buffer again before she could hit me up for some money.

An accreditation bureau is heavily scrutinizing the medical facility I work for, something all facilities go through every two years. Everyone is frantic, ensuring we're up to code on everything and all employees are clear on what to do in case of a disaster… fire, earthquake, bomb threats, mass casualty. I'm the contact person in our department in charge of gathering information and drilling everyone on protocol. My boss, in all seriousness, has given me the title of "*Disaster Coordinator*." The irony is *killing* me. Sher has taken to calling me, "Disaster Coordinator Girline-Thing." I reply to her, "That's *Miss* Disaster Coordinator Girline-Thing, *thank* you."

Spent another night with Papa on Saturday. He assumed I would stay with him all Sunday but I had plans the next morning. He was angry and jealous. I got pissed and told him, "Listen… *sex* is *all* you're gonna get from me. No *romance*, I just came to dance. You can have my body… that is *all*. You can*not* have my head. You cannot have *me*." That incensed him. He said,

"Fine. *Just sex* is what you'll get." And he roughly took me. He threw me down on his leather sofa and fucked me. At first, I thought it was just par for the course... but he was purposely, coldly, hurting me in a way he hadn't before. In a way I hadn't *let* him hurt me before. He fucked me hard. Painfully. Like a machine. I told him to stop... he was *really* hurting me... yet he wouldn't. He rammed himself inside me like a red-hot poker. It hurt... emotionally. He "used" me... which was what I was asking for. To make me see I do want more than just sex with him. I pushed him off, stood on shaky legs, crying. "I thought that's what you wanted, boy. Isn't it?" Is that what I want? Someone to push and push and *push* me? He came over to me. His cock erect, standing straight out... and started jerking off. Jerking off as tears ran down my cheeks in fear and pain, my heart beating frantically. He put his arm around me, telling me "I love you."

Everything is telling me to *run*, not walk away from Pete... but I can't. I won't. Why? I don't trust him and at times I'm afraid of him. Sometimes I don't think I even like him. He's arrogant, mean, frightening. Then I think, well, he also has a loving, caring side. Which he does show me... when I let him. And *I'm* playing as many games as he. He says he doesn't know where I'm coming from much of the time and feels every time I see him it'll be the last. And *then* I think of how it is with him. How incredible it feels. I've decided to try going out with him. We're having our "first date" Saturday.

I *am* feeling stretched a little thin. The other evening after work, I rushed home to change because Sher was stopping by to pick me up. I had offered to baby-sit Max that night while she got out for a bit (the poor woman is *so* stressed out). Pete called while I was changing and told me to stop by his office afterward. Sher arrived, we picked Max up from daycare and went to their house. Sher gave me completely anal-retentive instructions on what to do to take care of Max and get her to bed. I finally kicked her out and fed Max dinner. Called Ben to hear the results of his procedure and he told me he was diagnosed with internal KS. *Christ.* Entertained Max for the next two hours, and got her ready for bed. Changed her diaper (*ick*), dressed her, gave her a bottle and rocked her to sleep. That in itself was so amazing... having such an angel making comforting groaning, sleepy noises in my ear. Did Sher's dishes. Went to meet Pete... and had sex with him in his office... *woof.* Afterward, I met Ben to walk him home from work and to see how he was dealing with this new news about his health.

Well… it's my anniversary of moving here. It took a year, but I've successfully enmeshed myself in a number of intense, fascinating, codependent relationships. And I was worried it wouldn't happen.

Love, Sal

23 March 1996

Dear Tim:

Pete and I went on our first date Saturday night. He took me to a very pricey restaurant in the Castro… Ma Tante Sumi (sort of Asian with a French flair). We were surrounded by queer men on romantic dates. When I'm with him… I feel challenged… heightened. Yet, I just don't trust where he's coming from. Does he love me? Care about me? Or is he gonna pull a huge mind fuck? When I'm with him I'm *a bitch*. I went to the restroom in the middle of dinner where there was a large mirror behind the urinal. I caught a look at myself and burst into laughter. I was sparkling… breathing heavily… my eyes glowed, my color was high and I had an evil glare in my eye. High-bitch-priestess. I love sparring with him. There's still a lot about him I don't like but I find quite against my will (and my better thoughts) that I'm really starting to like him. And he's lightened up a lot. Oh, but getting pulled in, pulled in, pulled in. Deeper and deeper. And deeper. He's in my blood, always on my mind. In my head. When I'm not with him he's all I think about. The last thought I have before I drop into slumber. The first thought I have upon awakening. Am I… *in love*? *How* can I be? Ben says I'm showing all the symptoms of it. Oh, good Christ. I couldn't have found a more inappropriate person to fall in love with if I hired a detective to find one for me.

Part of the reason why I'm so attracted to Pete and why my interest isn't waning as I hoped it would (as it had with all my other relationships) is because… he *is* a prick. And is completely unpredictable. Almost every other man I've been with has been sweet, spiritual, sensitive. And to tell the truth, easily malleable by me (jeez, I sound like such a cunt). And I get… bored. Turned off. Smothered by their love for me. With their predictability. I can't manipulate Pete so easily. It's rather like my relationship with my father as I was growing up. Was frightened of him. Never knew where I stood with him. Didn't trust him. Yet loved him so much.

Sher picked me up in her car the other day to drive me to work (there were torrential rainstorms) and we drove Max to her daycare center. I got in

the car, turned around and gave a kiss hello to Max who was in the back in her car seat. Max gave me a huge smile and said... "Dada."

Ben's not much better. Last weekend he had bronchitis. It barely cleared up and then he came down with pneumonia. Christ. It's not bad enough for him to go into the hospital so he's staying home, is on more mega-drugs and is taking the week off work. Actually, it's probably better he's staying home... he detests hospitals.

Love, Sal

29 March 1996

Dear Tim:

If there is one thing I am tired of... it's dealing with this whole goddamned AIDS thing. My grief. I've lost so many friends, acquaintances, clients. *We all have.* So many talented, loving people. And how much longer? How many more? Of course, my feelings are intensified because of what's going on with Ben. Regardless, I am so burnt on this whole fucking issue. And angry. I have huge *anger* about this. And it does seem more intense here. So many more are sick. I see so many people on the street who are obviously wasting away. Thin faces, vacant, hollowed eye sockets. But, yes, yes, yes. It *is* getting better. More effective drugs and treatments *are* now available. We are making headway into making HIV/AIDS a manageable disease rather than a death sentence. I actually feel very confident I will be around for that. But Ben? Will he be around? I don't know if he can or *will* hang on. And I can't bear it. The waste of such a talented, great guy. Another friend. The loss of someone *else* I love. Someone else I couldn't help save. Like Frank. Dear, sweet Frank who was kind, talented, strong and vibrant. Yet... who wasted away to a skeleton... a shadow of his former self. And if I do make it through this... what then? After such shell-shocking year after year... what will we be like? What will life be like? What will I be like?

Ben is getting better, though. The pneumonia is clearing up, his appetite is much better and his mood is improving. He's on major opium-based pain pills to stop the (*still*) inexplicable pain in his stomach. But what's next for him? Maybe he *will* bounce back as I did after this run of illnesses. Or not. Maybe they will diagnose his stomach pain as nothing life threatening. Maybe the KS in his stomach will be easily treatable and he will choose to do so. Or, maybe not. At this point it's a waiting game... and I *detest* waiting. So, I

obsess. Worry. Take care of him. And get into insane, angry, sick messes with Pete...

Never, never, *never* have I had such a volatile relationship with *anyone*. Except maybe my parents. The other night Pete and I went to the opening of the San Francisco Gay and Lesbian Library Center... a very "A-Gay" function. It was quite fabulous with inspiring speeches, delectable snackies and a great dance party afterward. The library, which is gorgeous by the way, a new structure in the middle of the Civic Center, was filled with snazzed-up queers. Pete and I dressed up and looked quite handsome together. But I did have to tell him to stop grabbing at me as if we were in a leather bar. He said I worry too much about what others think. He didn't get my point, the asshole. As we were about to leave I happened to lock eyes with a very hot daddy, which Pete was quick to notice. Pete was incensed, grabbed me by the arm and pulled me away. I pasted a strained smile on my face and told him to hold it till we got outside. When we did, we laid into each other. And actually scared a crowd of street people away. I told him if he ever grabbed me again I would kick the living shit out of him. It started a marathon three-hour argument about sex with others, cruising, and fucking with each other's heads. Issues we've argued about this entire relationship. His stand is I can't have sex with others yet he can if he wants to because he's "the top." *What???* I warned him not to step out behind my back. I haven't been having sex with others and don't really want to... but *don't* push me.

We finally got to bed and *as he was holding me* he asked, "What would you do if I had someone suck my dick?" I replied, "I don't know." Silence. Then he said, "Someone sucked my dick at my office today." I went into an absolute frenzy, pushed him off me, jumped out of bed and tried to leave. He wouldn't let me. I was so furious I couldn't speak. I slept in his spare room and through the night he kept coming in to apologize (I kept screaming at him to get out). Eventually he told me he had lied. He told me he had sex with someone *to see how I would react*. I lie fuming for hours... then at about 4:00am, got my voice back, stormed into his room and woke him from a sound sleep to scream and swear at him. I yelled "You mother-fucker, you son-of-a-bitch, you're fucked now! If you did have sex with someone today you *repulse* me. If you didn't and lied to me about it, you really *are* a sick dirt-bag!" I went back to the spare room and he followed apologizing, begging (but not enough, no, not nearly enough). To get back at him, to hurt him, I had sex with him. He thought because I let him have sex with me, I forgave him. But I got myself off

quickly, pushed him off me before he came, and said, "Thanks, I left my butt-plug at home and I couldn't sleep, you asshole." *I think I'm possessed by Joan Crawford... hide the ax.*

It's so fun being cruel to him. I think of crazy, hateful ways to hurt, crush, to get back at him. Then, I miss him and want to be in his arms. It's as if I'm in a train wreck watching it from above in slow motion. But I'm not quite ready to end this... it's too... interesting, fascinating. To see how far things'll go. To see how far *I'll* go. Besides... how many opportunities in life does one have to be a stark raving bitch-cunt?

We met for dinner two nights later to talk about what the hell is going on. We both admitted to being scared and protecting ourselves in very sick ways. He accused me of trying to emasculate him (*cool*, I've never been accused of *that* before) and I accused him of emotional, romantic terrorism. We then joyfully made plans for our upcoming trip to Vegas. *Oh l'amour, l'amour.*

And, actually, I've been gleefully planning my end-game revenge. Pete can be fairly racist. Another issue we argue about... it's something I find hatefully unforgivable. He's told me a number of times, if he *ever* catches me with a black man, he would go ballistic. Of course, the first thing I did when I got to work Monday morning (after that insane Saturday night) was to call one of the nurses in the hospital (who is African-American) up to my office... someone who has been after my ass for awhile. He came up, I closed my office door and was on my knees sucking his dick faster than you can say "evil revengeful bitch-cunt."

Recently I said to my therapist after I went off during the entire session about all the insanity I'm involved in, "Well, what about your *other* clients, don't they have drama like this in their lives? I mean, this *is* San Francisco, right?" He sort of chuckled and said, "Uh... No, Sal. You're a bit more intense than anyone I've ever seen. My other clients are *not* having this kind of drama in their lives." Humph... *who knew?*

Love, Sal

5 April 1996

Dear Tim:

Las Vegas! Hoooo-*baby*, that place is a *trip*. I flew in at night and as the plane landed, I burst into laughter at all the flashing, glittering, crazy lights out

in the middle of bum-fuck nowhere. They threw every grand piece of architecture together then sprinkled them with overdone, flashing, gaudy lights. It was too much... even for me. Well, what did I expect? This is a city that immortalizes Liberace. Oh, the glitz, the tackiness and faux-glamour! So many people to gawk at! Such high, greedy, heterosexual energy. And me on the arm of my Papa. Pete goes a few times a year to participate in slot machine tournaments. My job was to stand by him, light his cigars, and cheer him on. *So* sexy. The best thing about Vegas is you can fuckin' smoke *everywhere*. We hit a few rough spots... arguments... clashings... but surprisingly, we had mostly a relaxed, good time. And lots of great sex. *Great* sex. Seems like anything goes in Vegas but in a very different way than in San Francisco. In San Francisco, there are a lot of different types of people off on their own crazy trip who wear their freakiness on their sleeve, out for everyone to see. In Vegas, people are off on their own trip, but they seem... straighter, less "hip," more conservative.

At the end of the tournament, the participants were invited to a celebratory dinner where they announced the winners. Pete told me it was a "theme party" and to dress "Australian." I wore green army shorts, boots, a green cutoff shirt, a bulky cream-colored bush jacket and draped a bullwhip artfully around my shoulder. He wore khakis and a flowery shirt. He gave me a look as if to say what I was wearing wasn't appropriate so, of course, we argued about it. I said I'd change if he wanted but he said to dress as I had planned. I decided the whip was perhaps a bit over the top... and left it behind. We went to the reception... to find everyone *in formal dinner wear*. No one dressed "Australian." I wanted to *kill* him. We entered the room of 200 people where the median age was 60, with my hot Papa... and me looking *way* too obviously like a kept boy. Thank *Christ* I nixed the whip.

One evening over dinner, Pete asked what I thought about having a relationship with him. I responded, "I think the same things I always had... that the basis of an S/M relationship with you would be inherently unequal and unhealthy. The sex we have is incredible but it is also quite twisted and probably is doing emotional damage to us both. Having S/M sex with you and intertwining incest fantasies throughout it simply can*not* be the healthiest thing to do on this planet. I also feel uncomfortable around you when you drink. *And*... I don't trust you. I still don't trust you and in the back of my mind, I think you will ultimately pull a destructive mind-fuck when you tire of having sex with me. And what shall we have for dessert?" He glanced over the menu

and said, "I'm what you need in your life. We're perfect for each other and have been since the beginning. And I make your dick hard." *Oh, he's so romantic.*

That night in bed, as he was fucking me... he looked into my eyes and said, "You got something to say to me, boy?" Without missing a beat, I said, "I love you, Papa," and he said, "I love you too, boy. I'm gonna marry you."

Fuck. I've fallen in love with him. I'm completely surprised by it. But in retrospect... no. I was in love with him weeks ago. I fought it for so long... from the moment I met him. But. For now, it works and I want to be with him. I'm trying not to see too far into the future on this (especially with my track record) (not to mention the insanity between us).

As an example of how goddamned *small* this town is... the afternoon Pete and I got back from Vegas, we took a taxi from the airport to his house. As we got out of the taxi, who should pull into the driveway *directly across the street*, but Victor (the nurse I sucked off in my office). Imagine *my* surprise. Victor saw me and shouted hello. Victor's boyfriend lives there and he was picking him up to spend the day with him. They've been together for three years and Victor comes by quite often. Lucky for me, Victor knew what was going on and didn't drop any beads. (No... I haven't told Pete about it... I'm saving this particular nugget for the perfect time. *Just* in case.) But god*dam*mit, this town gets smaller and smaller and smaller... I feel as if I can't make a move.

And gratefully, Ben is *so* much better. He got over his bout with PCP very quickly, is eating like me (a horse), is gaining strength and weight. And his outlook is much better. I'm so relieved, happy, proud of him. And grateful he is well... or rather, on the way.

Love, Sal

12 April 1996

Dear Tim:

Drained. Emotionally exhausted. The constant bickering/games/oneupmanship bullshit I get into with Pete is just too much sometimes. There is very little "down" time we have with each other. Spent Saturday early evening through Sunday afternoon with him. And I am completely drained. No big drawn-out fight happened. No big screaming drama. Simply spending time with him can be so trying. Always being on the defensive. Deflecting verbal blows. Flinging them back. I'm filled with malice and am angry so often. On

edge. Yet, I'm afraid to leave him when I want him so badly. I've never felt so tortured in my life. Hell, it's *exhausting* trying to emasculate him.

My excuse for seeing Pete as an escape from my pain about Ben being sick is no longer valid. Ben is fine now. The sole reason I didn't want to get to know Pete and to see him socially is because I *know* it's nearly impossible to keep the dominant/submissive, master/slave, daddy/boy part of this type of a relationship with him limited to sex. The dynamic bleeds throughout our relationship. A lot of what we argue about is me asserting myself... trying to *not* be his "boy." Yet he keeps forcing the issue for me to give him total control. I keep fighting it/him and am still treating it as if it's a game. Little things like him glaring at me for walking through a doorway in front of him. Him *telling* me to do things instead of asking. Him being angry because I made plans to see a movie with Sher (on the only weeknight he happened to have free) (which I didn't know) and giving me grief for not checking with him first. We argue about his mind-game playing all the time and I fear I'm losing the game (at the moment anyway). I allow him to treat me like his boy when we go out (at least I'm able to keep it to bars and such). I will (soon) allow him to shave my chest (something he's wanted to do from the beginning... something I don't mind happening... but don't allow because he wants it so much). I participate in these stupid, exhausting, circular arguments. Arguments that leave me insecure, vulnerable, angry, determined to top him (just like my father).

... then I speak to him... or see him... we have a great time with a minimum of games and he's charming and sweet. Thoughts of ending this go right out the window and all I can think of is being with him again. What happened to that hard-ass motherfucker you knew in Chicago who'd 86 someone for looking at him cross-eyed?

Sher and Pete are so alike in some ways. Either out of insecurity or control issues or both, they are constantly on a oneupmanship sort of a thing with me. And in a "pissing contest" with each other although neither one realizes it. Also, they gotta know more than the "dizzy" bottom. They gotta be in control at all times. For example (they *both* do this and it drives me *nuts*) one of them will ask me something ("did you check this?" or "what time does the movie start?" or when parking the car "am I close enough to the curb?") and whatever my answer is, they will ask, "Are you sure?" I *hate* it. I am not an idiot. "*Yes!* I'm motherfucking sure!" *Honestly.* Ya know, when I fantasized about what my life would be like when I was deciding to move here...

struggling with two pushy, argumentative tops who treat me like a ditzy blond twink was *not* one of the scenarios I had in mind, thank you very much. Sher told me to get over it because that's the way she is with *everyone*. In fact, when she gave birth to Max, the nurse said to her, "Congratulations, Sher… you have a beautiful baby girl." Without hesitating, Sher asked, "Are you *sure*?"

Max has started to walk overnight. I went to Sher's house and when I arrived she said excitedly, "Watch this!" stood Max up and said, "Say hi to Sal." Max laughed, held out her hands and ran into my arms. Max was so excited she was giggling madly. *I was so proud.*

Love, Sal

19 April 1996

Dear Tim:

Is Pete fucking with me? I struggle with him being *so* undemonstrative (just like my real father). It feeds into my insecurity. *Does* he love me? But then (again, *just like my real father*) if I stop and think… he "tells" me, shows me in many ways he does love and care about me. He's just so goddamned… *uncommunicative* about it. (And yes, that *is* part of the attraction.) When I've asked him, that at times, I'd rather he was tender with me on the street, he responded, "Well, what about the time I bit the back of your neck in front of the Castro Theater? *That* was tender."

Ben is sick again, goddammit. He was on an upswing after the bout with PCP but now he's vomiting, can't keep anything down, has diarrhea and is losing weight. What now? I thought this was over. *Son-of-a-bitch-mother-fucker-shit-deal.*

I think I do get off on highly charged, dramatic, overblown situations in my life (like, *duh).* Can't I just be happy or satisfied with a calm, easy, stress-free existence? What is this emptiness I feel when there is no huge disaster going on? Why does everything have to be so tortured? Why does it make me feel so alive?

Pete and I started a game while we were in Vegas called "Guess What?" I was lying on the bed, resting, fully dressed, after we had been in the casino all afternoon. He quietly crept up and pissed on me. I protested… but the tent that appeared in my linen shorts betrayed my feelings. Throughout the weekend, he kept sneaking up and pissing on me. I finally said, "Listen… you gotta cut it out… *I'm running out of clothes to wear!"* He said, "OK, boy. From now on I'm gonna say 'guess what.' That's your cue I'm gonna piss on

you. If you don't want what you're wearing to get it… move. *But* you have to let me piss on you *somewhere*… even if it's just your hand." Sounded fair to me. We've continued the game… in private usually… but it has happened in public a few times, mostly in bars or such places. *Oh, baby.* Does it get any better than this?

Love, Sal

26 April 1996

Dear Tim:

I love the wide spectrum of things Pete and I do. One evening last week we attended an art exhibit opening at the San Francisco Museum of Modern Art in SoMa and a fabulous dinner-party afterward. We were all dressed up and played "A-Gay," although he did piss on my hand in the men's room (*oh, Papa*). The museum itself is *magnificent* and unfortunately, overshadows the art collections. The opening was a showing of the works of Frida Kahlo. It was the private collection of someone who seemed to only collect Frida's calmer, subdued pieces. No "The Wounded Deer," no "Broken Column," no blood, skeletons, gore, angst. *I was robbed…* I wanted to see her tortured work, dammit.

The next night we went to the Mr. Bay Area Leather Contest where I wore Papa's chain and lock around my neck and his old leather vest… which *reeked* of poppers and sleazy '70s sex. We went to Cliff's Hardware Store in the Castro on Thursday evening to fit me for the chain. Papa told me he wanted me to wear it around my neck to symbolize I'm his. It's a sign of ownership… sexual ownership. I wore it to work and the gym on Friday. Hardly anyone batted an eye. *I love San Francisco.*

It's so… comforting? sexy? to wear his chain and lock. The leather community's symbol of marriage. Wearing a chain like this is a sign the wearer is someone's "boy/property/slave." The *great* thing is (and Pete warned/ threatened me about it) other leather tops will constantly try to fuck with you, to see if you'll play around on your "master/daddy/owner." Rather like a pissing contest… so to speak. And he was right. Suddenly, leather tops were all over me, eyeing me, testing to see if I would fuck around on my Papa… which would mean a coup for them… to "have," to "piss" on someone else's "property" without the "owner's" permission. Hell, if I'd known this *years* ago, I'd have fuckin' bought *myself* one.

Because I was in full costume that night (chain, lock, vest) and at Pete's beck and call (he managed the event) everyone was curious about his new "boy." To give Pete credit, he never introduced me as his "boy"... it was always "boy*friend*." The thing is, I look at this as theatre and was playing a part. Which, as I always do, threw myself into it completely and gave a great performance. Everyone was impressed and complimented Pete on how "well-behaved" and "obedient" I was... as well as being very attractive and sexy. Why, *thank you*. But... they take it seriously. It's *not* just theatre to them. What was I *thinking* when I consented to wearing Pete's chain and lock? It's *not* play-acting. How much control does he have?

Well, at least Pete doesn't go as far as most others... or does he?

I asked him the other night about our "relationship/whatever" and he said, quite matter-of-factly, "I *own* you now. You are my boy. What do you think the chain *means*?"

The next evening, we went to a benefit dinner for the AIDS Emergency Fund held downtown at the Hotel Marriott... a new modern steel and glass monstrosity that looks like a giant jukebox. We were in "average" drag that night (suits) and wearing fabulous new ties we bought each other the weekend before at Macy's. I saw many people I recognized from the contest, still in leather getup. Pete doesn't carry the leather drag thing too far as so many do. He simply wears a leather vest or jacket when the occasion calls for it... not the whole "giddy-up" as he calls it. Many commented and asked where my chain and lock was. I replied it was there in spirit. We sat at a table with friends of Pete's, including a porn star... "Iron" Mike... whose video and magazine images I've whacked off over for *years*. Something, regrettably, I mentioned to Pete. After dinner Mike came around the table to me, said, "let's go smoke," and I excitedly hopped up. I was thrilled with the prospect of everyone seeing me chatting with hot "Iron" Mike. Pete was *out* of his mind. Someone else from the table ran to tell me Pete was furious with me for *not asking permission to leave*. I, naturally, got pissed... *"ask to leave"?* How *dare* he expect me to? I excused myself to hot, hot, hot "Iron" Mike (who, much to my dismay, was cruising to find a top himself so he could drink his piss) and went to hunt Papa down and lay into him. Papa feels and demands I ask his permission to go off with some other top... *especially* with someone I'm attracted to. Even if it's just to smoke and chat. OK, to be fair, I *knew* it would piss him off if I jumped up and left with Mike... that's why I did it. To test Pete and stir up some shit. I think I'm a little bored. Things are going too

smoothly between us and I don't *want* him getting used to me being a "perfect" boy.

And he knows how to piss me off too. Like when he bites my face. I've told him more than once not to do it. But sometimes in the middle of a scene, when I least expect it... he'll bite my cheek. It infuriates me and makes it difficult to trust him. Which is exactly what he wants... to make me vulnerable and then take control. Oh, *Papa,* as if it were that easy.

Ben remarked to me at dinner the other night that I've changed... I'm not the "joyful" person he knew months ago (joyful? *me?)* and I've been extremely distracted lately. He feels we don't do as much as we used to before we lived together and he attributed it to me seeing Pete. He thinks being involved with Pete is draining me and I'm obsessed with him. Truth or illusion? Perhaps partly so... I *have* been obsessed with Pete and much more serious lately. Quick to anger. Less likely to let loose and laugh. But I also attribute it to Ben being so up and down with his health. I worry and think about it much more than I let him know. And Ben and I haven't been *able* to do much together... he's been too sick. I think he's afraid of me leaving him.

I feel as if I'm on AIDS-time. Don't get me wrong, *really*... I feel just fine. My cd4s are rising to almost 400, my viral load is down to 28,000. I'm simply feeling a bit of an emotional pinch. I can't help but be pissed about it. Yes... all these drugs I'm taking are (probably) adding years to my life, for which I am *tremendously* grateful. I ain't ready to go nowhere yet... not by a long shot. But, still, goddammit, I hate dealing with this sometimes. And I hate the fact my life may be shortened (piss, moan, bitch). I hate taking these fucking drugs that won't save my life anyway. I've always felt pressured by time, doing enough, being enough, and now it seems even more intense. *OK*... enough with the self-pitying bitch-fest. I am very healthy and trust I will be for years. Unless, of course I get creamed by a speeding Muni train.

Love, Sal

3 May 1996

Dear Tim:

Hey. Nothing's going on... no dramatic fight, no huge craziness to report. Just plain ol' run-of-the-mill power struggles with Pete. Him threatening to kill me if I have sex with other beardaddies. Me threatening to burn down his house and rent a car to run him over with if he is fucking blond twinks. Same as usual. Well. We all gotta take a "drama-break" sometime.

To illustrate the complicated intricacies of San Francisco life...

An older guy at the gym was cruising me and in the shower, we whacked off staring at each other. Turns out he's the building manager across the street from where I work and does a lot of work for the hospital.

The pissiest, most arrogant doctor who works in the hospital I do (who is *so* snotty to me) showed up at the Mr. Bay Area Leather contest in latex led in on a leash. It gave me great pleasure to say to him, "Hello, little boy."

Blake's boss (who's in advertising) knows my boss and told Blake, who told *me* my boss is quitting soon.

Pete and I were out to dinner the other night where Victor (the black nurse) and his boyfriend were seated at a table right next to us.

Ben's piano teacher, a sweet, gentle, "earthy-crunchy," California-type, who looks as if he's been eating nothing but brown rice since the dawn of time, supplements his income as a hustler. His specialty is fist fucking and calls himself "Handy Randy." *Oh, those long, piano-strengthened fingers.*

The beat cop in the Castro (a hugely muscular, dark, daddy-type) is a pushy, rude, arrogant bastard who wears the *worst* toupee in this solar system. He is also a regular at The Suck Hole. I would see him there often, on his knees, with his toupee askew, getting slapped around by wiry, feminine black men. Our pet name for him was "Pig-in-a-Wig" and we all *loved* to hate him. Whenever he was there, one of us would invariably ask, "Has Pig-in-a-Wig gotten beaten up by a black girl yet?"

Ben can't bear the sight of Pete. I had Pete at our apartment the other night while Ben was at work. The next morning Ben asked me if Pete was over... Ben said he "felt" and *smelled* him. And I won't let Pete and Blake meet. Blake, Pete and Ben *all* work out at the same gym.

I saw my therapist the other night and afterward, stopped at the porno store. Pete happened to be there getting lube. We were at the back shelves of the store where he was humping me and biting the back of my neck when my therapist walked in to purchase lube and porn.

Someone Ben works with knows the nurse manager I work with. He told me the nurse manager was fired from his last job at San Francisco General Hospital because of inappropriate behavior with patients... he was dating them. I saw our nurse manager the other afternoon in the Castro, hand in hand with one of our new patients.

I went to see a film the other night with Blake and had my arm around him. A friend of Ben's (who also knows me) saw me there, called Ben and

asked him if that was Pete because he didn't look or act like Ben described him at all...

... and a friend of Pete's called *him* and told him he saw me out with another man and that I had my arm around him.

Baby... in this town you betta *watch yo' back.*
Love, Sal

10 May 1996

Dear Tim:

One of the ways I'm reliving scenes from childhood with Pete is through sex. Our current favorite is for him to spank me while I jerk off. Can I be any more of a textbook case? The other night as I was going down on him, without missing a beat, I slipped his belt through the loops of his pants down around his ankles and handed it to him. He proceeded to strap my back as I sucked him off. The beating raised a number of welts and left me black and blue for days. Yelling, incredible, frenzied orgasms for us both.

It sure raised eyebrows in the gym locker room the next day. Two Asian twinks in the shower room were aghast at the obvious strap marks on my back and butt and couldn't keep their eyes off me, heh, heh, heh. And you'd think it *would*... but it *didn't* hurt that much. Well, maybe a little. Mostly, the pain feels... incredible. Sexual, scary, sensual, warm. Sadomasochism. Am I a masochist? It's not as if I want *anyone* to do these things to me or walk down the street hoping *anyone* will give me a crack across the mouth. It simply clicks this way with Pete. Pete doesn't do anything I don't want him to (note... *I handed him the belt*) and I can stop things if and when they get too far... that's the basic agreement in sexual play such as this. Is it stimulating because it's taboo? Because I was strapped as a child by my father and it was one of the only ways he was physical with me?

I asked Pete the other day if he thought I was a masochist. He looked at me incredulously and said, "You get off when I beat your back with my belt. What do *you* think?" *Honey,* I can be *really* thick, can't I?

I read somewhere the masochist is a true martyr. But... Sick? Twisted? Damaging? I dunno. It sure gets me off though. I'd been in therapy and going to Sexual Compulsives Anonymous and Incest Survivors Anonymous meetings for years and years, going over and *over* my abuse, sexual addiction and childhood issues. *Ad nauseam.* Yes, it gave me great insights into my

personality and psyche. Yet, here I am reliving and participating in some of those same scenes and dynamics. Again... is it OK because I know what I'm doing and why I'm doing it? *Whatever.* I'm sure having a helluva lot more fun dealing with those issues in *this* way than through therapy or recovery meetings.

By the way... there are few things in this world funnier than 300 gossiping, smoking, shrieking queens, packed into the basement of a queer church in the Castro, playing Bingo. *Trust me.* Most people go every week so it seems as if everyone knows everyone else. The winner of the first game is dubbed "Bingo Queen," is applauded and provided with a rhinestone crown to wear for the remainder of the evening. Drag queens preside over all. 0-69 *always* gets a big cheer. *And* I won $250.00. Life is grand.

Love, Sal

24 May 1996

Dear Tim:

Here I am at the three-month mark with Pete. The point at which I usually tell whomever I'm seeing to get lost. Because of boredom. Because they suffocate me. Because they've come crashing down from the pedestal I put them on. But... I'm still as interested/obsessed/in love with Pete as ever. Is it because he's so emotionally unavailable? Is it because he is such a prick? Or... is it real *(this time, this time, baby)*? If he treated me like every other man I've dated (emotional, easily manipulated, demonstrative) would I be over him?

Last weekend was Pete's 50th birthday (probably why he was a bigger prick than usual) and we went out to dinner on Friday. I was looking forward to seeing him all day (as I always do when I'm going to see him) but when he picked me up he was in a pissy, angry mood. I just snapped (in my head anyway), thinking how tiresome it is, how *frustrating*. Started down the "dump Papa" trail of internal dialogue. Smiled at him over a very expensive dinner while thinking how gratifying it would be to give him a smart crack across the mouth. Felt distant and angry with him all night. Considering ending things. Then kept thinking... was this my "three-months-then-dump-them" syndrome rearing its ugly head? Yes, probably. But also... he *is* a prick and is getting more demanding... And sex is getting more intense and painful. It's mostly about causing me pain and I'm enjoying it. It frightens me that I enjoy it so much *and I ask him to do it.*

That evening we went to a performance of Ben's (which was actually very gracious of Papa... he knew it was important for me to go and we went because he wanted me to keep peace in my family). I was so concerned with the two of them being under the same roof... I forgot to tell Pete that Blake would be there. *Oops.* Blake showed up and Pete was pissed because he felt I should have warned him so he could be "emotionally prepared." At the same time, a hot leatherdaddy was checking me out. I kept stealing glances at the leatherdaddy, which Pete caught. When I turned to look at Pete... he was glaring at me. It was excruciatingly uncomfortable. I thought he was pissed about Blake but what he was mostly furious about was I dared to "engage" the leatherdaddy in eye contact. I crossed over into fury myself and told him, "I'm sorry you're so insecure you can get bent totally out of shape over me looking at someone else."

We went to his place, had a huge fight and I ran out on him. I left him on his goddamned 50th birthday... *"Happy Birthday Papa, you asshole"* (I am *such* a cunt). I walked, weeping, through his quiet, subdued neighborhood for over three miles to get to the bus stop. Feeling conflicted and weary of this merry-go-round of a relationship... yet, still wanting... *needing* him. Hoping even as I left he'd come racing after me in his truck because the thought of being without him made me think of how much I do love him. And would feel vulnerable... *alone*... without him. Even though he *is* an asshole at times. Then realized I didn't even have a fuckin' *dollar* on me to take the fa'crissakes bus. So I called him (I had to use my Pacific Bell calling card) and asked if I could come back. I went walking slowly back up the hill to his house...

... and told him I came back because I do love him. Hating my passion, my desire, my *need* for him. Hating *him*. Yet loving and wanting him. Just like my father. And after all that... I feel as if I love him more than ever. Baby, I got it *bad.* Do I need him because I love him or do I love him because I need him?

The next night, Papa had chartered a yacht for a three hour cruise/tour on San Francisco Bay and invited a volatile collection of twenty-five queers and dykes (half of whom despise the other half) (I think he did it on purpose to watch the fireworks). A friend of Pete's and I took bets on who gets thrown overboard first. It turned out to be a lovely, calm, fun evening... and I felt such pride in the beauty of the city... such pride I live here. From a distance, the graceful, light sprinkled hills of San Francisco looked so timeless, so *elegant*. The moon was full and the sky fogless for once. I was standing next to Papa as we sailed under the Golden Gate Bridge. I cuddled next to him (the ocean air

was chilly), looked up at the moon, the bright rust color of the bridge and felt at home. Everyone was on his or her best behavior... except for one leather "Daddy" dressed in a sailor outfit (who says leathermen aren't drag queens?) who came on to the very hot (but straight) captain of the boat. I think San Francisco is built on an ancient, haunted, Native American burial ground and it causes people to go nuts when they're on it. Maybe that's why everyone was so calm when we left land. I put together two tapes of music for the cruise with a wide variety of tastes for the wide variety of ages. It was deliciously funny watching the over-40 crowd singing and camping along to "It's my Party and I'll Cry If I Want To" by Leslie Gore. The captain and crew took it all in stride... as if they are quite used to twenty-five leather clad queers and dykes riding their boat every day. Perhaps they *are*.

I've been thinking a lot about my relationship with Papa... and about relationships in general. Isn't there an element of sadomasochism and domination/submission in *all* relationships... certainly sexual ones? I mean, consider the concept of making love (fucking, whatever). The person who is fucking is certainly in a more dominant position. That person is (physically, at least) "invading," conquering someone else's body (space). The person being fucked is certainly in a vulnerable, compromised position... their body (space) is being penetrated by the other person. So then, can't one assume that a dominant/submissive quality is inherent in all sexual behavior?

... And another thing. I tend to bitch about the control a top has and how I hate to relinquish that control. Well, I *like* to relinquish control during sex; I just ain't so crazy about it in other ways. But, ultimately, sexually, a bottom *is* in control (and perhaps is in control throughout the relationship as well). It's the top's role to push the bottom to his/her sexual/emotional limits. It's the bottom's role to go as far as he/she can go within comfort levels. In a healthy S/M partnership, both partners should discuss limits and boundaries for their sex-play. What makes the play safe, tolerable and allows both parties to go further is the trust in the other person. There are clear guidelines as to what is of interest for both partners. And that things won't go too far. That one will stop if the other is uncomfortable. In most S/M sex relationships there is a "safe" word both partners agree upon and when the word is uttered, play ceases. Therefore, the bottom is in control (because there is rarely a reason for a top to stop the play) by the fact he/she can stop the scene at any time. The bottom ultimately sets the limits. And the top should be strong and sane enough to care for and be supportive of the bottom after such play. To make

him/her feel safe. And to show it was just play. Which Papa does... *usually*. Except for the occasions the fucker "forgets" and bites my face.

I was in my boss's office and we had a minor earthquake (it was "only" a 4.7 on the Richter scale) that lasted for about 5 seconds. But... the earth fuckin' *moved*. It sounded as if a freight train was coming... then the table I was sitting on shook. The shade on the lamp on my boss's desk swayed. I was sitting still and the room moved around me. My heart leapt into my throat and I couldn't even *think* of what to do. I was *not* amused. *Not* a fun experience for a control queen like myself. Since then I can't bring myself to get on an elevator (even though I work on the 4th floor and I go to the 12th floor accounting department at least twice a day) and I have to fight off panic attacks when I'm taking the underground subway. By the way... who's fuckin' *brilliant* idea was it to build an underground subway in an *earthquake zone*?

Love, Sal

31 May 1996

Dear Tim:

Papa and I spent last weekend in Reno where we got into a good-sized fight one night. We were in the hotel casino all Sunday afternoon when I took a break and went for a run outside (I simply can't stay in that fake environment the whole time, I need a reality check). When I left, Pete had been drinking. On my return, he was still on the same draw poker machine... and actually was winning a lot of money. We played for three more hours until it was time for dinner. In that last hour Papa had quite a lot to drink. He didn't show it (he never slurs, gets sloppy or abusive) (well more than he usually does anyway) or get too loud. If anything, he gets more loving and open. It just pushed my buttons and I panicked. Freaked out he drinks and to excess. I had an emotional flashback to childhood and felt the same as I did around my father when he drank. Which was often. And when my father drank, he would get abusive, ugly, loud, and I would, at times, in public, be humiliated by his behavior.

I went up to our room to calm down. When Papa came in I laid into him (dumb move... *never* confront anyone about their drinking after they've been drinking all day). He understood my issue with drinking but felt I had no reason to have any issue with *him* because he doesn't get out of control. Off we went to dinner and had a miserable time... and an awful time the next day where he lost a lot of money (tough shit, *fuckhead*). I'm not quite sure how to

handle things. I'm willing to let it slide. Even if he is an alcoholic (is he?)... is it so awful because I'm not "negatively" affected... because he doesn't get obnoxious? Because he doesn't "hurt" me in any way? Or is it affecting me simply because of my issues with it? Just one more similarity between Pete and my father. One thing I *am* certain of... I will *not* repeat the behavior pattern my mother got into with my father. Her caretaking him, worrying about his drinking, trying to control it. The behavior my parents engaged in caused them both a lot of pain... not to mention the pain my brother, sister and I absorbed.

Then back to San Francisco, our queer promised land. Promised land? Let's take it easy... San Francisco is OK... but "promised land" its not. It's insanely expensive to live here, filled with homeless street people, and the California attitude is enough to make you run screaming in the streets. Not to mention the goddamned earthquakes. But... driving back from Reno last weekend, I felt such *excitement* crossing the Bay Bridge into San Francisco. My home. For now, anyway.

Because of the not-so-great time we had in Reno *last* weekend, we're going again *this* weekend... to "do things right." Hmmm.

Love, Sal

10 June 1996

Dear Tim:

Reno revisited... oh, *baby.* Just when you thought it was safe to go back in the water, I've discovered one more thing to be addicted to.... . *gambling.* Oh joy, oh bliss, oh *shit.* Pete and I got along famously. One of the cocktail waitresses overheard me calling Pete "Papa" and said, "I didn't know you were father and son! It's sweet you get along so well and do things together." *Honey,* if she *only* knew.

We arrived Saturday evening, had a wonderful dinner and hit the casino at 11:00pm. At about 1:00am, Papa hit the jackpot on a video poker machine and won $1,000...

... we immediately sat down at another set of machines... And we played. And we played. Two shifts of casino employees came and went. And we played. Guests arrived, freshly showered, shaved, made their way to breakfast. And there we were... two of those legendary, pathetic souls who stay up all night gambling. The sobering part for me was I completely lost track of time. I looked up at one point, saw the sun rising and said to Papa, "Good Christ, it's

6:00am... we should give up and go to sleep." He replied, "Go if you want, I'm staying." Well, I really didn't want to go to bed... *I wanted that goddammed jackpot.* Besides, Papa hands me money to dump in the machines. If I lose... it doesn't bother me. Two packs of cigarettes, fifteen diet cokes, one huge migraine, eleven hours and *$2,000* later, the older woman sitting next to me *won the fucking jackpot.* Papa was beside himself with greed, anger and overexhaustion. But I didn't care... it wasn't *my* money.

I'm not doing *that* again. Well, at least not for thirteen hours straight anyway. After all, we *do* have a trip to Vegas planned in two weeks.

I think I've found my match and I want to spend the rest of my life with him.

Love, Sal

14 June 1996

Dear Tim:

Beautiful, warm, sunny mornings and evenings with hot afternoons have given way to gloomy, cold, damp, foggy mornings and evenings with cool afternoons. *Summer in San Francisco has arrived.*

AIDS, my friend, has become a big business. I'm seeing it in San Francisco as I had in Chicago. Most HIV/AIDS organizations began as small grassroots operations... conceived and run by people who simply wanted to provide their friends and loved ones with services, hope and support. Few earned a living at these organizations and many worked full-time jobs in addition to their work at these endeavors. AIDS has become a *huge* business. From drug companies to agencies to T-shirts. Millions, *billions* of dollars are involved. People are making a career out of something we didn't even know existed fifteen years ago. And so many people are trying to grab a piece of the pie. It's ugly, wasteful, and I fear, *I know,* many people who need services are not receiving them. There is such waste of money, time and energy I can't even believe it at times. Perhaps things will change for the better. Perhaps agencies will survive these growing pains and offer services to more people. But because many of them have gotten so big, full of red tape, inflated salaries and egos... while people suffer and die... will they ever be the same, homespun, wonderful places of love and nurturing they once were? I don't think so. Many of the revolutionaries of the past, who fought for government attention, money, drugs, research, are gone... dead or burnt out. Even more horrifying, people are simply tired of AIDS. Tired of hearing about it, of donating money and time. Tired it is still here.

I'm wearing my chain and lock full time now. Why not? It goes well with most outfits anyway. Although it *is* a hassle at the airport when one is trying to go through security because it sets off every alarm in sight. And security guards don't understand when I tell them I can't take it off because I don't have a key.

Wearing it is more of a sexual statement than a representation of ownership (or so I argue with Ben). But actually, it *is* a sign of ownership... sexual ownership. I am Papa's sexual property rather than being his slave. Which is fine with me. Besides, I *do* look damned sexy in it. Anyway, part of the fun is to watch other people's reactions as I walk down the street. Leather queers, of course, get it. And I think leather tops, who might have been attracted before, pay even more attention to me to see if I'll react. Young punky grunge queers (and straights) think it's a hip fashion statement. Straight Black people... *especially* men... freak out when they see it and look either angry or horrified. When my boss saw it she asked, "Oh. Are you doing your chain link fence imitation again?" One brown rice hippy dude saw it and said to me he "appreciated the political statement I was making about how we are all slaves to the country and democracy." Yeah, *whatever.*

It's hard to believe, but a whole year has passed since I knelt in DaddyBob's bathtub and vomited on his dick. *My*, how time flies when you're having fun.

Love, Sal

20 June 1996

Dear Tim:

Papa went to Montana to visit his family. He was gone for a week and I missed him like a *son-of-a-bitch*, but... I was also slightly relieved. I needed a rest and I'm sure he did as well. Although I enjoyed myself visiting Sher and Max, going out with Blake... I missed Papa so much. Blick. I never get this way. Usually, if someone I'm dating/seeing/fucking goes out of town... it's "party out of bounds" time. When Papa was gone I kept having to force myself to do things and sleeping was difficult. I feel safer for some reason when he's around. He's fatherlike. Mentorish. A protector. As much as I hate to admit it, part of me always wanted someone to fill those shoes because my real father never did. I always wanted someone to take care of me, to be strong for me.

Ben's been more and more difficult to deal with. Partly because of the strain between us about him *despising* Papa. But, also, the strain between us is

about how he absolutely refuses to start antiretroviral therapy. He's actually doing well right now, putting on weight, exercising, looking good. He simply doesn't feel as if he has anything to live for. His unhappiness is mostly centered on the fact he doesn't have a boyfriend and hasn't had one for a long while. Yet I see him as being so creative right now... he's working hard on his composing, and is always busy with one project or another. I tell him if he starts taking and is able to tolerate antiretrovirals, he may be prolonging his life (*Christ, I sound like the fucking AZT poster child*) but his response is, "I am miserable. Why on earth would I want to prolong this dismal, dreary existence?" *Oy.* Interesting. All he wants is a boyfriend... which I have. All I want is to be creative... which Ben is doing. Both of us feel a lack in our lives. Both of us want what the other has. And we both think if we had what we wanted, we'd feel "fulfilled," "happy," "alive," "purposeful." There *must* be some lesson in that somewhere.

I had my eyebrow pierced, something I'd been thinking about doing for awhile. Papa had commented to me that he thought it was sexy so I did it to surprise him. Although it pissed him off I did it without him present... in control. *Asshole.* Anyway, it's a fun new "toy" and I unnerved a woman at my gym. She saw it and asked, "did it hurt?" I grinned at her and said, "Not as much as I had hoped." What a *dumb* question. Helloooo... someone stuck a rather large *needle* through the skin on my *face*. What do *you* think? Of *course* it hurt.

One of the nurses I work with mentioned to me she had to see her doctor (about some girlie thing) and was bitching because she probably had to have blood drawn and hadn't yet met the deductible on the insurance so she'd have to pay for it. *Christ.* I met the deductible on my insurance on January 5th. Gee. Doesn't everyone in their 30s need to see their doctor at least once a month? Doesn't everyone have their liver functions monitored to check how it's processing a multitude of toxic drugs? Have blood drawn to measure viral load, cd3s, 4s and 8s, amylase, bilirubin levels? Have their eyes checked for CMV-related blindness? Have their stool checked for cryptosporidium? Get testosterone shots in the ass to build muscle tissue? Swallow *seven* different pills *six* times a day?

Love, Sal

28 June 1996

Dear Tim:

Las Vegas, Nevada. Population just under 1,000,000. One of the fastest growing cities in the USA. It's estimated the population will grow to over 2,000,000 by the year 2000. Unfortunately, it's *also* estimated the water supply will dry up by the year 2005. Party! Spend! Gamble! Build! Build!! *Waste!!* Run that motherfucker into the ground. After all, that *is* the American way.

It was a reprise of the last trip to Vegas... except it was *fucking* hot. Over 100 degrees every day. One afternoon I went poolside to tan, but it was like trying to relax in a goddamned oven. Hilarious people, unrestrained greed, incredible meals, a suite larger than my goddamned apartment, endless cigarettes, hours in front of video poker machines. Laughter, tears, love, passion, arguments, sex. What more can one ask for?

To break the insanity and high-power greed-energy of Vegas, Papa and I drove into the desert one afternoon. About forty minutes north, there is a national park called the Valley of Fire. It's a huge area of rock formations set in the middle of mountains. They are brilliant red in color and incredibly carved by time, rains, wind and the blasting desert heat. *Breathtaking*. It's like being on another planet; it's what I imagine Mars would look like. We pulled over on the rough dirt road weaving in and around them, walked and climbed through the dusty, crumbling, beautiful formations. When we first got out of the car, my head was buzzing, humming with the over-stimulation of Vegas... flashing lights, the clanging, ringing and bonging of the slot and video poker machines, the jingling of coins, ladies in sequined outfits, men in bad polyester suits and pinkie rings, the noise and gaudy colors, the music from the car radio, the air conditioning. Then utter stillness. Crashing silence. You could feel your heartbeat, hear your pulse. Because of the heat, the area was completely deserted. We were absolutely alone in the still, calming, purging heat. It was perfect. Beautiful. Even in the intense weather conditions, life was prolific... there were tiny lizards, snakes, bugs, cacti, even desert flowers and bushes. Everything dry as a bone. In the 100 degree heat. And quiet. Quiet. We walked for a while, pointing out things to each other, speaking in hushed tones in deference of the lovely peacefulness. In awe of the power and beauty of the land. Then Papa insisted on pissing on me. Well, at least urine dries quickly in the heat.

Then back to San Francisco. From one crazy fairyland amusement park to another in just over an hour. With a 40 degree drop in temperature.

I've been thinking about what I want to do, what makes me happy. Sometimes I think what interests me the most is to be married (you know what I mean) with a house and a flower garden to tend. Yeeesh, *how* 1950s middle America heterosexual of me.

Ben's cd4 count dropped drastically, so under his doctor's advisement (she finally, *finally* pushed him... the numb bimbo), he started antiretrovirals. He also placed a personals ad in the queer paper and is getting tons of responses. Maybe he'll meet a "nice boy" and hang on for awhile.

Well, they've been busy interviewing people for my boss's replacement. My boss told me it's down to two candidates... Irl (an ex-lawyer, activist queer-boy) or Moira (a tough, pushy dyke) (the adjectives are mine, not hers). Gee. I can *hardly* wait.

Love Sal

5 July 1996

Dear Tim:

The San Francisco Lesbian, Gay, Bisexual, Transgender, Pride Celebration, 1996. *Helloooooo...* did we remember to include *everyone*? Christ, *nothing* is simple in this town. Why do we have to go through it anyway? You don't see a Hetero-pride parade. And it's such a non-issue to me at this point... whether or not I'm proud of being gay (or male, or Italian)... it just *is*, you know? It was the longest parade on record on the hottest day on record... 251 contingents and five hours long. In 95 degree heat... which is *damn* hot in San Francisco. Five hours? I dunno. I'm not *that* excited about being gay.

Well, it was great fun anyway. My favorite contingent this year was the Barbie Support Group. Drag Queens, dressed in fabulous, ridiculous Barbie drag carrying signs that said, "We put the "fun" back in dys*fun*ctional!" Papa and I went together and had a great time... although I had to silence him from cheering for the incest survivor contingent. I've been here long enough to know the politics behind many of the groups so it was much more interesting to me this year than last. Stop AIDS San Francisco, for example, is horrifically run, ineffectual, and overstaffed with overpaid incompetents. So, when they were chanting "Stop AIDS," I kept shouting back, "Too late!" I really went off on the people from Kaiser (California's HMO... the insurance company Ben has). They are *notorious* for not treating HIV aggressively, for not offering

viral load testing and having the attitude that people in later stages of AIDS are too costly to support and shouldn't be offered treatments to prolong their lives. The sight of them marching in the parade infuriated me. One of them tried to hand me a flyer. I brushed him away and said, *"get away from me."* The person asked foolishly, "Don't you have Kaiser?" "No, I don't. I have AIDS and I intend to live a long life." Then I lost it and yelled, "How *dare* you march in this parade! You are killing my best friend!" (Ben) He slunk quickly away as I yelled, "Kaiser is killing people with AIDS! We demand viral load testing! *We demand viral load testing!!"* They were *not* amused. But they certainly didn't fight back or defend themselves. The pussies.

The highlight of the parade was when the leather, S/M crowd went past. Papa discreetly tucked his dick into the left pocket of my army fatigue shorts and pissed all over my leg. We were standing next to two queens. One of them looked down, noticed the spreading wetness on my pants running down my leg, shrieked and said, "Wha...? I can't belie... *ohmigod*, now I've seen everything!" We laughed and I said, "No baby, you ain't seen nothing yet."

Papa and I went to Bolinas (that hippy, trippy, never-never land north of San Francisco) for my old roommate Tony's master's Fourth of July "do." That area in Northern California seems to be reserved for the cream of the freak crop. The residents of the area are so low key, are such recluses and so afraid the outside world will invade their privacy; they've torn down all the signs in the area pointing out where it is. In fact, every year, the state dutifully erects direction and population signs. The next day, the entire town shows up, and tear down the signs (probably naked and covered with body paint howling at the light of the moon). Anyway, at the party... a few full body shavings, a few beatings. A very hot muscleboy locked in a stockade. Everyone was calling each other "Sir," "Daddy" or "boy." Business as usual. And actually, was rather boring. Am I jaded already? In just over a year? Papa and I left and took a lovely walk along the ocean with waves white with foam (the Fourth of July... get it? "America The Beautiful"... get it?)

Love, Sal

19 July 1996

Dear Tim:

Control. How much do we have? How much is "planned" out already? How much of an effect do we have on our lives? Our health? Each other? I so desperately want to control things in my life... my health, my destiny, Papa

(*especially* Papa). Everything. And I feel especially at this point of my life... I *have* no control. I hate it. But I also know when I feel this way... stubbornly trying/wanting to control everything... it never works. I need to let go and trust everything will happen in life's perfect way. *Yeesh*... I think I've lived in California too long.

Ben's been in pain a lot again and his doctor finally suggested he have a procedure I had (an endocoscopy) to check for a bowel obstruction. Goddammed Kaiser doctors. He should have had this procedure *months* ago. Ben is scheduled for the endocoscopy this week and his doctor (Kaiser/bastard/ bloodsucker) said there's a 50/50 chance of it helping... and alleviating the constant GI pain he's in. Ben (the eternal optimist) is already making plans in the event it doesn't help. In a way, I don't blame him. He's been in pain off and on since January. How much can one be expected to take?

I've been feeling so grateful to have my life lately. Something I didn't think I'd have now. I feel extremely lucky because of all the treatment options available now. Options not available two years ago. Preliminary reports are coming in from the International AIDS Conference in Vancouver and a lot of study results are showing the incredible benefits of using triple drug combinations to combat HIV. A combination I am on. Something not available even a year ago. I wonder. If I had gotten sick (as I was in October/November) two years ago... would I be alive now? How much is my health dependent upon the drug therapies I'm on? Or wanting to live?

How does it work out like this anyway? Why do some people get sick and others don't? I saw my doctor the other day (whom I *adore*). She had two doctors from Japan observing her. The medical center where they work sent them to San Francisco to learn how Americans are treating people with HIV/ AIDS. They connected with The University of California, San Francisco (UCSF) and UCSF sent them to my doctor because she is so knowledgeable, compassionate and dedicated. My doctor, with my permission of course, reviewed my health history with them. The Japanese doctors looked at me in awe and said to my doctor, "You worked a miracle! This man should be dead by now." (Gee, *thanks* chum. I guess there's no such thing as a "bedside manner" in Japan. *Asshole*.) My doctor, who was complimented... yet worried about my feelings... said, "Yes, he was in terribly dangerous territory seven months ago, but even without the treatments available I wouldn't have written him off." In any case, I *am* doing remarkably well. At times, I do realize how

lucky I am and feel happy. But I feel as if I should be thrilled for *every* moment of my life. I'm not. *You* try to be thrilled every goddamned minute.

I did talk to her about my aggressive behavior that's probably attributed to the testosterone injections. She had my blood tested and results show I'm high normal at my lowest point. She said because I was so sick and weak back in October/November I *deserve* to be overly aggressive right now and anyone who takes issue with it should kiss my ass. Cool. Works for me. But people are starting to mark their calendars in black the days I'm due for a shot.

Papa is such a *mutha* sometimes. We had another blowout the other night. We got an invitation for a dinner party from a friend of his (a fat leatherman pig whom I *despise*). It was addressed "Mr. Peter Dickenson & boy." I completely flipped out. "boy?" *"boy?"* The motherfucker knows my goddammed *name*... and I'm simply referred to... *dismissed* as "boy"? and "boy" wasn't even capitalized. *Power-tripping, leatherdaddy top/asshole motherfucker*. Papa didn't understand why I was so pissed. He said Jake was simply following form... I am his boy and this is part of the package. We then got into our continuing argument about how I didn't want to get into dynamics like this... that's why I didn't want to have a relationship with him... the inequality of "master/slave" dynamics and being seen as and treated as "less than," as *property*...

This whole thing is fucking with my worth issues. Papa assured me that, *of course*, I mean more to him than just property. I averted my face and asked, "What color are my eyes?" Silence. Again I asked, *"What color are my eyes?"* He said, "... brown?" I said, *"No*. My eyes are green. *Sir."* The dirty bastard didn't fuckin' know the color of my eyes. I told him to go blow himself, then I stalked off down Market Street toward home. He says I've raised being a bitch to an art form. And I was worried I wasn't being creative in my life.

Ya got a hacksaw so I can cut this fuckin' chain and lock off my neck?

Was saying in therapy the other day that I still don't feel as if I'm an adult. *I am thirty-five years old*. I find that simply astounding. Am I too childlike? Childish? Is that one of the psycho-emotional draws to this relationship with Papa? Is that part of what makes it so appealing? The loss of control? Responsibility? That I have the illusion of being a boy? A child? *Of course it is*.

Hey, lesbians sure come in handy. At work today, I was bitching to Sher about Papa and that I'm *furious* to be wearing his chain (remember... I don't have a key to the lock). Sher sat me down, picked the lock with a paper clip

I then noticed human toes sticking out of the pile of shrimp...

and hooted triumphantly, "Who's your goddamned 'Papa' now?! *Me,* that's who!" Hell, who needs a hacksaw when there's a resourceful dyke in the next office?

Then Papa called and told me how much he loves me. I wrapped the chain around my neck and snapped the lock closed. But it sure is great to know I can get it off when I want to.

And, of course, Papa and I attended the dinner party I mentioned earlier. It was in a house up on Twin Peaks overlooking the city. My first thought was to wonder how many cows had died in vain to clothe the guests. It was *quite* the extravaganza... any leatherman (queen, boy, slave) who was *anyone* was there. The place was packed with owners of bars, sex-clubs, sexual paraphernalia stores, and more leather "title" holders than one could shake a stick (or whip) at. The cream of the San Francisco leather crop was there so most people knew each other, were friendly and there was a minimum of games. That's not to say games and top/bottom bullshit and posturing *wasn't* going on... it was just at a minimum. It's also nice to know even I can still be shocked once in a while. When we arrived, I, as I am wont to do, made a beeline for the snackie table to see what treasures awaited hungry guest,s and was pleasantly surprised with a lavish buffet table where, artfully arranged, were mounds of fresh fruit, seafood, cheeses and other treats. I arranged a plate and brought it to Papa who was sitting and chatting with a friend. Papa's friend had a boy-slave who was kneeling at his feet feeding him. As I walked up, Papa saw me noticing it (how could one *not*?) and he discreetly whispered to me, "Now *that's* servitude." I sweetly whispered back, "No, that's '*over the top*'. Don't push your luck. *Sir*," and went off to gorge myself on tasty-looking shrimpies. I was at the table, when I noticed the mound of fruit move. My first thought was, "*Cool*... an earthquake. It would be hilarious to see these butch leatherdaddies run screaming into the street." But the floor wasn't shaking... and *the fruit kept moving*. I then noticed toes... *human toes* sticking out of the middle of the pile of shrimp and I had to hold back a shriek. There was a *body* under the lavishly displayed food. (No *wonder* it looked as if so much was there). I watched, fascinated, throughout the evening, as the body was unearthed. The leatherdaddy who threw the party had mummified his newest boy in saran wrap and had the caterer display the food around him.

Sometimes the top/bottom, master/slave thing *is* a drag but at times I groove on it. Especially when I'm feeling insecure, confused, directionless. The roles are all set up. It's comforting. At a time in my life when I need

comforting and a sense of stability. I know what is expected of me and what the rules are.

Love, Sal

30 July 1996

Dear Tim:

... and sometimes, he surprises the hell out of me and does very sweet things. Buys me red roses and in his gruff way says he was thinking of me and loves me. It makes this cold, angry, bitter heart melt. Until next time.

I watched the news the other night... something I almost _never_ do because it invariably freaks me out/disgusts me...

... people in a small town near Berkeley (hippie-freak capital of the world) are up in arms because the fire department wants to repaint the town fire hydrants. Twenty years ago, on the bicentennial, everyone in town went out and painted the fire hydrants to resemble historic figures (Ben Franklin, Betsy Ross, George Washington). Last week, there was a _huge_ fire in which ten homes were destroyed. One of the reasons the fire was so bad was because it was at night, and firemen called in from neighboring towns couldn't find the goddamned fire hydrants _because they were so lovingly camouflaged._

... we are now in brush fire season and there are occasional outbreaks of blazes to the south of San Francisco.

... in Oakland, a woman on a bicycle was struck and killed by a drunk driver. In a gesture of mourning, a thousand people on bicycles met at the site her bike ride began and rode, en masse, along the route she took and ended at the site of the accident... where they held a memorial service... _in the middle of the goddamned street... tying up traffic for most of a day._

... one of the few expressways in San Francisco is being torn down (two blocks from my apartment) because it has been deemed unsafe in a major earthquake. _Duh._ Half of it _collapsed_ in the '89 earthquake. What gave them a clue it was unsafe... _six years_ after the fact? It was never rebuilt because property values skyrocketed in the area. Also, thousands of buildings in San Francisco will face heavy fines on August 1st because they haven't been seismically retrofitted and won't stand another major earthquake. Most of downtown San Francisco is built on _landfill... the_ most unsafe, unstable surface to build on. And, the other day... there was a 5.5 earthquake on the fault running along the coast in the ocean. Am I nervous? _You bet._

... there is a new group emerging in San Francisco... it's made up of manic-depressives who call themselves "The San Francisco Bi-Polar Society." They even put out a newsletter called "The Bay Moods." Sometimes the newsletter is only a few pages long. Sometimes it is quite thick.

California... *yeesh.*

The procedure Ben had hasn't helped much... so far anyway. His pain level hasn't gone down much and his doctor (bloodsucking/Kaiser/bastard) isn't very hopeful. Well, at least Ben is doing a drug therapy to try to rid his body of cryptosporidium (what I think is the cause of his pain). He probably got it (as I probably did) from the goddamned contaminated water supply in this city (as are the water supplies in many cities). He actually seems OK though. Resigned. I don't think he'll give up. Yet.

And Papa. He's only been positive for a little over two years, but his cd4s are dropping fairly rapidly and his viral load is growing steadily. His doctor is pressuring him to decide to go on antiretroviral treatment. And he's being pig-headed about it. He said he'd think about it but he considers going on drugs to be a weakness. He refuses to be sick and said he'd jump off the Golden Gate Bridge before any sickness/weakness/symptoms appeared.

Papa and I are going to Montana for a few days for his parents' 50th anniversary, where I will meet his entire family. Afterward, we're going to visit a friend of his who lives in Alaska. I've never met the family of someone I'm seeing. Probably because I never date anyone *long* enough to meet their family. I jokingly asked Papa if I should call his father "Grandpa." He was *not* amused.

Love, Sal

16 August 1996

Dear Tim:

Just got back from spending a week with Papa in Alaska. Honey, Alaska sure is *butch* country. I've never seen so many hulking, butch, tough, studs. *And those were the women.* I took my most nondescript, boring clothing, Papa took my chain off and still... people looked at me as if I were from another planet. It was a hyper-heterosexual nightmare. Everywhere you turned, there was a cheesy strip-mall that had small storefront churches in it with fabulous names like "On that Day" or "Church of the Living Christ." We flew into Anchorage... the largest city in the state... yet only boasts a population of

500,000. It was like a big ugly suburb. It was rather disheartening to travel all that distance to feel as if I were in fucking Palatine, Illinois. But...

... right outside of Anchorage, it was *incredible*. Marshes, clear lakes and ponds, wild goats scaling the cliffs, snow and glaciers, daylight until 11:00 p.m., and mountains, mountains, mountains. We spent a lot of time alone going thrift shopping, driving through the mountains, walking through the woods. I fell in love with him all over again.

I was leery of spending so much time with him, but all in all it was a great time. And more than ever, I want to live with him. How unlike silly, fickle me.

We went to Montana first for his parents' fiftieth anniversary so there were many parties, get-togethers and celebrations. On Sunday there was a huge bar-b-que at his sister's home, which is on the edge of the woods. After an hour of small talk with straight, conservative Montanans who were dancing the Macarena (*yeesh*), I needed time alone. I found Papa and told him I was going for a walk. He gave me a dirty look and warned me to be careful. It was wonderful to be alone, quiet, walking along a dirt path and wandering in the woods. It was so peaceful. I spent an hour... thinking, looking at flowers, sitting quietly. I felt centered and went back. When I entered the backyard... a hush descended over the crowd and everyone at the party turned to look at me. Then I saw Papa, arms crossed, glaring at me. I smiled uncomfortably at everyone. Conversations slowly resumed as I walked over to him. "Where the *fuck* have you been, boy? I was just about to call the police. You can't be dressed like that and go wandering in the woods (I was wearing a very bright, nellie, '50s Hawaiian shirt I had bought the day before at a thrift store). Are you trying to recreate a scene from *Deliverance*?! Besides... there are bears and moose out there... this is *not* a park in San Francisco or Chicago. Are you *crazy*?" I said, "I was only a little bit away... I think I have enough goddamned sense to *not* go wandering far. And I am *humiliated* everyone here is thinking I'm a foolish, irresponsible city-queen lost in the woods." Then he led me into the bathroom where I pulled down my pants and he pissed all over me. Well... it *was* his parents' golden anniversary.

In the middle of the bar-b-que, Pete handed me one of his disposable cameras and told me to finish the roll. To surprise him, I snuck into the bathroom and took many sleazy pictures of myself with my pants around my ankles and of me pissing. When he got the pictures back, I looked through them with glee to see how they turned out. *They weren't there.* I asked him if

he took them out to tease me… but he didn't know what I was talking about. Then it dawned on me. A number of people at the bar-b-que had disposable cameras… including his mother, his two 70-year-old aunts and many cousins. Papa was drunk at the time I gave him the camera back... it's quite possible he put the camera down, and *someone else picked it up thinking it was their own*. And is having the prints developed. *Shit*. I could just *die* of embarrassment. So much for the great impression I made on his family.

Yet... for all of Papa's butchness, it's a relief to know he can *still* be a big sissy. I was dressing for dinner one evening (a mint-colored, '50s sport jacket, white shirt, bow tie and chocolate brown slacks). He saw what I was going to wear and said, horrified, "You are *not* wearing a mint jacket with *chocolate, are you?*" God bless the queen in all of us.

Love, Sal

30 August 1996

Dear Tim:

Back to Reno. Pete's parents flew down from Montana to put a cap on the celebration of their 50th wedding anniversary. Pete drank too much and it started to make me uneasy. Ya know, I'd been willing to deal with this behavior because of my intense love for him (love that surprises me still). But it's getting so frustrating.

After dinner, we hit the casino. By 3:00am, I was tired and wanted to go to bed… besides, Pete wasn't doing quite so well. He was on a losing streak, had lost about $500 and was drinking doubles. He wouldn't leave the casino, so I went up to our room alone.

At 9:00am, I was awakened by the sound of the door opening. Pete stumbled in stinking drunk, barely able to stand. He tossed a wad of money at me and said, "You shouldn't have left, boy, I won big-time. How much is there?" I counted out $3,600… was relieved and happy Pete had won, but the feeling quickly dissipated as Pete collapsed on the bed. He tried to get me to have sex but I was barely able to handle my disgust and anger. He insisted I get in the shower where he pissed on me. The reek of booze wafting off him was more than I could stand. I got him to bed where he finally passed out. I woke him enough to help him remove his contact lenses and undress, then let him sleep.

I'm deeply attracted to and love Pete more than any other man I've been with, but Pete's drinking overshadows it. I thought about how it would be to

never see Pete again… and the pain of being with him outweighed the pleasure.

I climbed in bed beside him. Pete, even in his heavy sleep, moved slightly and our bodies slipped perfectly into position together, in "our" position. I thought about the time we were flying home to San Francisco from Alaska, looking out of the plane window at the city blanketed with fog and how the cities' lights glowed through it. I thought about walking in the quiet, still desert with him, about walks along the ocean, about the passionate sex we've have. I hugged him, breathed in his familiar smell and ran my hands over his body. Loving the feel of him. Loving him. Yet knowing I had to end it. Hating that I had to.

He finally woke late in the afternoon, sickly hung over (*serves you right*). I decided I wouldn't talk to Pete about ending the relationship until the next day… Pete wouldn't have been able to understand anything in his current state.

The next morning, I called Pete and told him how pissed I was over what happened. That I love him, but it's over. *Click.*

The next day, Pete arrived at work holding a huge vase of roses. He looked fragile, nervous, and vulnerable. I was as well and couldn't meet his eyes. Pete's eyes looked shattered, as if all life had gone out of them.

We clumsily left my office, went for a walk and ended up in front of an apartment building a block away. I sat on the cold marble steps as Pete stood. I told Pete to unlock my chain. At first he wouldn't then said he didn't have the key with him (bullshit… he proudly carries it on his key ring). He saw the hard shine in my eyes and knew I wasn't fuckin' around. He quickly unlocked the chain, took it off, turned, and hurried up the street. I walked back to my office. And even though Pete took the heavy chain off my neck, I felt much heavier without it.

Three days later… I was jonesing for him. Lord, just like someone trying to get off crack. I called him, met him at his office and threw myself in his arms, crying. I love him so much I had to give him another chance. But, I laid down the law and promised Pete (and myself) if things continued in that drinking vein… that surely would be it. I felt oddly relieved and comforted as he wrapped the chain around my neck once more… and snapped the lock closed.

As a side note… Ben was *thrilled* when I left Pete… then, was so angry at me for going back to him… he is barely speaking to me.

Hope all is well with you.
Love, Sal

20 September 1996

Dear Tim:

Leather *Extravaganza*. Leather Pride week is coming up and all that it
entails. Way too many people in leather drag and in various stages of undress
(when they *really* shouldn't be) crowding in and around the Castro and SoMa.
Papa is on a million committees and benefits and I'm expected to participate.
Because Pete has lived here forever and knows everyone, we're invited to the
best, most outrageous parties given by and for many of the "Sash-Queens"
(leather titleholders). My life is *just* so glamorous and exciting; I can barely
stand it...

... believe me when I tell you... *I can barely stand it.* The fact is... I'm
bored with the whole scene, *baby.* The stupid parties, the tiresome posturing
and standing around, the endless chatting and small talk. I love Pete... that's
not the boring part. The grueling part is the endless social obligations of a
Leather community couple.

Truth is stranger than fiction. A few short years ago, I used to joke about
the ridiculousness of some AIDS fund-raisers... the themes, the *theatrics*
around raising money. I came up with a fictional fund-raiser called "Pissing
For Life" in which queers raised money in the style of a walk-a-thon or an
aerob-a-thon (or some kind of 'thon') but instead of walking or whatever they
would... well... you can guess. The other evening at some leather function/
fund-raiser/gathering, I heard two leatherdaddies discussing a benefit they're
putting together... a progressive tour of select San Francisco Leather Masters'
dungeons. For $100, one is led on a tour of the hottest dungeons in the San
Francisco leather community. It's based on the concept of a "progressive
dinner" (where one tours fabulous houses or hotels and has a dinner course at
each place... starting with appetizers at one and ending with dessert at
another). At each dungeon you will witness and if you so desire, be a part of
sex/kink/freak scenes that get progressively more... intense? Ending in an
orgasm at the last stop? *Can "Pissing For Life" be far away?*

Went to a housewarming party thrown by the two guys (who are lovers/
partners/significant others/whatever) who own the premier San Francisco
piercing emporium (with shops in LA, NY and Paris)... Steven and Pat Stone.
When we got the invitation, I said to Papa, "Oh, how interesting... they have

Can Pissing For Life be far away?

the same last name. They must have gotten married." We've argued about this issue. No, not regarding ourselves, but I feel gays should, of course, have the right to be married if they so desire and he feels it would be merely following traditional heterosexual values. Anyway, he said, "No, they are *not* married. They have a daddy/boy relationship and Steve adopted Pat *as his son.*" They have done quite well and Papa and I wandered around looking at the empire punching holes in peoples' bodies built. I was quite awestruck. Besides an incredible house on a hill above Noe Valley, they have the most beautiful backyard Japanese garden I've ever seen, complete with a pond, a small waterfall, a gazebo and hot tub. (Hmmmmm. I wonder if Steve is looking to adopt another son.) Pat is into Paganism (was dressed in a bright red kilt) and had strategically placed huge crystals in and around the garden to facilitate growth and to call on calm, centering energy. Steve and Pat were both gracious and sweet. I liked Pat a lot... he invited me to join his Pagan group and to run naked in the woods to communicate with my nature and animal guides. I thought the party would be a frightening scene with tattooing, body piercing and people strung from the chandelier by their nipples or genitals. Yes, there *was* piercing going on (in the backyard gazebo with incense burning, chimes tinkling in the wind and with the warm, spiritually guiding energy of crystals), but other than that, it was a very calm, interesting, fun, gathering. Very impressive.

Love, Sal

4 October 1996

Dear Tim:

The night of the Mr. Drummer Contest (which was *excruciatingly* boring), Papa and I attended a party (with a bunch of sash-queens, leather bigwigs and celebrants) that ended with a tour of San Francisco on a motorized cable car. That, actually, was the high point of this whole goddamned leather extravaganza week. We tooled around some of San Francisco's straightest neighborhoods on a cable car packed with intimidating, queer men (and a few token women) in butch leather drag, screaming at and terrorizing straight people.

Only in San Francisco can you have a street fair dedicated to celebrating S/M, kink and leather. *Honestly.* Folsom Street Fair from what I hear has been much more intense in the past... but it was still pretty outrageous. Many

people in revealing leathery outfits, hundreds of 'roid queens (*translation…* muscle-bound gayboys on steroids), many pierced/tattooed/scarred freakoids and the obligatory drag queens. It was like any other street fair… except California style. And with a fair number of people hitting each other with whips, floggers or paddles.

Papa and I were leaning against a wall watching the parade of flesh, fetish and freaks when a leathermaster he knew walked by. He was leading his boy on a leash (although "boy" *is* stretching it a bit. The boy in question looked to be around 50 years old) and stopped to say hello. The boy had his hands handcuffed behind his back. His exposed flesh (he was clad in only a jockstrap) was covered with old and new shallow cuts carved into interesting, intricate designs. Sticking out of his left nipple was a solitary needle… like a pincushion. At first glance, I thought it was an acupuncture needle. Upon closer inspection, I realized it was a small darning needle… one with which one would sew on buttons. A lit cigarette dangled from his lips, which his master would remove to flick the ashes off and then replace. The boy saw me pull out a cigarette and light it. His big, soft brown eyes focused on the flame of my lighter, then on my eyes as he asked, "You got a light?" I looked questioningly at his lit cigarette. He saw my puzzlement, expanded his chest, giving me clear access to the needle, and said, "… *there.*" It took everything in me, but to prove my… coolness? My… S/M savvy… I put the flame of my lighter to the end of the needle. We stood, surrounded by flesh, loud music and the frantic/craziness of the street fair… as it all fell away. It was just the two of us… focusing on the flame, the fire, the desire, the *pain* wanting to be born. We watched, hypnotized. As the metal heated up, it began changing colors… violet/orange/blue. First at the tip… then traveling up the needle. The color change… the *heat*… closer and closer to his chest, his nipple. As he started feeling the heat in his chest, *on his flesh*, he groaned and rested his head on my shoulder. "Oh yes," he said, wanting the heat, the pain. Needing it. I was in control… the one about to cause torturous pain/pleasure to someone who desperately wanted it. The color change, the heat was moving closer and closer to his flesh, was intensifying. In sick, vivid clarity, I imagined how his flesh would smell as the hot needle seared his skin. How it would redden… And I couldn't do it. I couldn't follow through. I pulled my lighter away and shoved it in my pocket where it burned like an angry coal against my thigh. The boy took his head off my shoulder, frustrated, glaring at me. Angry at me for denying him pleasure.

I held it together until they walked away and then let myself shudder in horror and crawl into Papa's arms shaking with laughter, disgust and sadness over the disturbing scene. Feeling weak. But… perhaps that's a sign of the true sadist. Denying the masochist the pain he desires.

Love, Sal

11 October 1996

Dear Tim:

One last story from the "Leather" weekend. In the Mr. Drummer contest, one of the things the contestants have to do is stage and perform a "fantasy" scene. Many chose the "S/M whipping, beating" thing or the "Submissive/ Dominant" venue or "the dripping hot candle wax on one's body" disaster (have you *ever* tried to get candle wax out of your pubic hair?). The same old, same old fantasies… that were nonetheless appreciated and greeted with applause, cheers, and much randy hootin'-n-hollerin'. The "fantasy" that really flipped everyone out was performed by "Mr. Washington, DC." He was African American, hugely muscular, smooth, with beautiful, richly dark, dark skin. He was the judges' favorite… up until his "fantasy." He came out to the darkened stage singing an old Negro spiritual tune. In the dim light, all you could see were the whites of his eyes and his teeth. The music hit a crescendo, and as it did… his white, strutting, slob of a "Master" ran out with a whip and started beating the shit out of him. Then they started kissing, and the white "Master" raped his "black" slave. After I got over my own shock at the horrible, ridiculous scene, I spent most of the time watching (with glee) the faces of the audience. Yes… we were at a "leather, S/M event" but we were *still* in PC California… everyone was disgusted, horrified and shocked. At the end of the fantasy, the poor, foolish contestant was met with dead silence. Needless to say… he lost miserably.

Ah… life on the West Coast.

Papa's parents are in town and we drove up to Reno this past weekend (yes, *again*). It was actually OK… he's been "behaving" if you know what I mean. We went to a fabulous dinner one night and at one point, I stepped out to use the restroom. I was met with security officers, paramedics and weeping Oriental women. No one was allowed in the restroom because a man who had lost a shitload of money on Pai Gow Poker (whatever the hell *that* is), went into a restroom stall and slashed his wrists. *Dammit…* I really had to piss.

The floor in the hospital where I work is shared with the Intensive Care Unit. I went to work Monday morning after returning from Reno and found the waiting room (outside my office) packed with shell-shocked, hysterical, 20ish hip, pierced/tattooed/branded/multi-hair-colored women. Apparently, a friend of theirs, who occasionally shot heroin, had overdosed and just died. Welcome to reality, girls.

Branding one's body, by the way, is *bigtime* hip here on the West Coast.

October is usually the best time of year weather wise in San Francisco, but it's been horrifically hot with temperatures at around 100 for *days* now... which is unbearable heat for San Francisco. Many buildings are *not* air-conditioned... *like my goddammed gym*. I was bitching about the heat to someone I work with and she said she didn't mind the heat much but can't wait until the 17th of October has passed. I asked why and she responded that if we are to have a major earthquake, it historically has happened on or around that date. And earthquakes tend to happen in very hot, dry, still weather. Do me a favor... think of me on that date and send posi-vibes as I cower under my desk all day in terror. *Goddammit.*

Love, Sal

21 October 1996

Dear Tim:

Some people move to San Francisco to become more spiritually aware. Some move here to be surrounded by gentle beauty. Some for the free political and lifestyle choices available. Apparently, I moved here to eat lots of red meat, smoke a lot of cigarettes and to piss people off.

I was with Papa last night, walking through the Castro and ran into a friend of mine (Gary... someone I tricked with when I first moved here. Nothing has happened since and we're just friendly to each other). He was rushing home with a butt-plug he bought for a hot thing he had tied up in his bed. I said hello to Gary, hugged him, we chatted briefly, he gave me his new phone number, and he rushed off to fill his trick's butthole with the new treasure he had purchased. Papa was completely incensed. Demanded to know *who* he was, *what* our history was, *how* long it had been since we fucked, *why* did he give me his number, yada, yada, yada. I lost it, yelled that he was smothering me, I've given him no reason to not trust me, and I'm fed up with his controlling, demanding attitude... and I stormed off.

This is one goddamned difficult town to be in if you're in a couple. Temptation is fucking *everywhere...*

The phlebotomist (who draws my blood in the lab of the facility where I work) loves to rub his crotch on my outstretched hand as he needle sticks me.

I was in the hall outside my office and a fairly respectable looking guy in a suit walked by, saw me, stopped in his tracks, said hello and asked me what I was up to as he rubbed his crotch.

I walked into my apartment the other day to find Ben in the middle of a photo shoot in our living room (he fancies himself as an amateur photographer, don't you know). It was a nude photo shoot of one of the hottest, hairiest hunks I've been drooling over since I've moved here. The hunk was lying on our sofa, his tree-trunk legs spread, with his huge dick in his hand. I think Ben purposely did that because he knew I wanted him.

Men in the shower room at the gym are constantly sporting half-hard cocks.

Papa and I went to gay Bingo where I clocked a hot studly daddy-to-be... big beard, dangerous dark brown eyes, hard looking Papa-gut, about my age, sort of... Deliverance looking. *Oh baby.* I wouldn't do anything with him... it's too goddamned risky... Papa watches me like a hawk (What? Innocent li'l ol' me?). And I wasn't interested in Papa finding out, being chopped into pieces and thrown into the San Francisco Bay. But... DeliveranceDaddy kept trying to slyly catch my eye right under PapaPete's nose. (Oh, the *cheek* of it) One time when I looked over, he flashed a sign (he wrote with his goddamned bingo marker), that said, "*Come here, boy.*" Then later, "*Come and sit on your Daddy's lap.*" I was shaking with laughter at the absurdity of it while trying not to give PapaPete any clue as to what was going on. As we were leaving he gave me his number behind Papa's back, which Papa almost saw.

S/M, slave/master, top/bottom... what are the implications... the long-term effects of such a relationship? Yes, I knew all this when I got into it... but what now... over eight months later? Sex for me has changed somewhat. When Papa tries to hurt me physically in some way during sex... I angrily tell him to knock it off. When he tries to do some of the same things he used to do, it pisses me off. I don't want to be hurt right now. Especially by someone I love and who loves me. And I resent it (him) when he tries. I keep trying to turn our relationship into something more.... equal. Less intense. With less top-bottom *bullshit.* What will it be like if I live with him? Has my interest in other

men increased (like my DeliveranceDaddy intrigue?) as these complications with Papa become more pressing?

I've decided I am a sadistic bottom.

Love, Sal

5 November 1996

Dear Tim:

I called DeliveranceDaddy (Jake is his name) and told him to forget about getting together... I would really like to see the year 1997. Jake, as it turns out, is a total psycho, controlling, freaky top. *What a surprise...* I must have goddamned radar for this sort of thing. I told Jake I'm in a relationship, under lock and key, and my partner (Pete/Papa/Master/Whatever) would *not* be amused if I "bottomed" for some other top. Of course, I *also* told Jake I'd love him to fuck the living daylights out of me. A girl has got to have *some* intrigue. *N'est-ce pas?*

My gut level thought is... *leave it the fuck alone. This could be disastrous.* But god*damn*... I'm *so* tempted. Hot sex with a psycho-daddy on the sly with the risk of getting busted. To (in my *head* anyway) prove Pete really *doesn't* have control over my life and my body, goddammit. *Plus* there's the added possibility of controlling another top (Jake the DeliveranceDaddy) and calling the shots. Something to gain from both of them at the same time... with one action. *How* can I possibly turn down such a challenge? Such possibility for drama? And sometimes, especially when Papa is being a huge pain-in-the-ass... which is happening quite a lot right now... I think of DeliveranceDaddy Jake and his sultry, dark brown eyes.

... a bit of advice. *Don't* try to recreate a sexual relationship with a father figure. It ain't pretty.

But past all the bullshit game playing, being in control and topping a top... do I really want to do this? I would *never* scheme, plot and fuck around behind my partner's back. Of course, this *is* a different dynamic/situation. Yet, what about trust? *Honesty?* I claim to want to smooth things out with Papa and try to turn ours into a less complicated relationship. To have a *life* with him. Wouldn't I simply be adding layers and layers of tricks, secrets, lies and deception? On the other hand... it's *just* sex for fuck's sake. It doesn't or won't mean anything and it shouldn't matter if I do spend a few frantic, nasty, passionate (yes, and dangerous) hours in Jake's bed. This is *San Francisco* after all, goddammit. No one expects *anyone* to be monogamous. Ah, but yes

Blanche, yes it *will* mean something more than just sex. Which makes it *ever* so much fun. And tempting.

What is sex anyway? I sometimes wonder if sex (when it is just for sex's sake) is a misguided reaching out for spiritual connectedness. A yearning for a higher experience. Sex is so charged and has so many layers and layers of emotions, symbols and meanings. Is sex, in its simplest form, the reaching out to our God/Goddess beings/selves? Acceptance of our selves and of others? Love in the physical sense? Can the vulnerability and surrender required, in fact *demanded* when engaging in S/M sex as the submissive, be equated to total devotion, love, sacrifice? Or is it simply demeaning and disguised self-loathing? Is the pain and control inflicted by the top, the sadist, bringing the masochist to new heights spiritually and emotionally? Or is it simply selfish on the part of the top/master/dominant partner? Is S/M sex wrought with twisted demands, self-loathing and disrespect?

Part of it is my resentment and growing discomfort/dissatisfaction with being a "boy." I resent catering to Papa because that's my "role." As "boy-wife," "slave," "bottom." I hate being referred to and introduced as, "This is my boy." I hate being submissive sexually all the time. I despise his controlling hardass nature. I've been pulling away from him sexually because I don't want to be "used" (his word) (and that's *exactly* what it feels like lately). Actually... not being interested and not having sex with him has given me some sort of control. The slave/bottom/boy refusing to put out for his master/top/daddy does sway the pendulum of power, does it not? But... this is what I wanted, isn't it? A rough, hard-ass, tough Papa/Master to service? Is my sexual interest in him waning? All the things we used to do that I had found exhilarating, exciting... merely feels as if it's something I have to "put up with" because it's the basis of what we have together. And he's not interested in sex any other way. So... my solution is to do the same thing with someone else? To recreate this top/bottom, master/slave, father/son dynamic with Deliverance-Daddy Jake? How much of a possession do I want to be? Maybe it simply doesn't work for Sicilians.

Just when you think you've seen and heard it all... I was perusing the new wares in a Castro Street porno store. They are a series of dildos made from hot-pour vinyl... many in the shape of animal genitalia. Some of these goddammed things are as big as my freaking *leg*. And they all have names. One of the items is called "Mr. Ed" because it is shaped like a horse's... well, you can guess. As I was looking them over, I noticed a rather unassuming

He couldn't satisfy his urges as much as he liked so he was elated to find these dildos.

middle-aged dark-haired man fondling the merchandise. Papa actually knew him and warned me not to speak to him because he was way too freaky. Well… with a threat like that… I *couldn't* resist… so I immediately struck up a conversation. I asked him (Paulo is his name) what he thought of the absurdly huge, animal-shaped pricks. Unfortunately, he told me in great detail. Paulo was raised on a farm and has been getting fucked by horses since he was a teenager (he's now in his fifties) (I wonder if he has to wear Depends). He recently moved to the city and couldn't satisfy his urges as much as he liked so he was elated to find these dildos. He told me he *still* gets fucked by horses... but not every day like he was used to. The kicker is... Paulo has *never* had sex with a man and is straight as an arrow… with a wife and two kids. Oh well. Why should queers have all the fun? He then stressed the fact that he's a zoophile rather than being into bestiality because rather than deriving pleasure from sexual congress with animals... he wants to give the *animal* pleasure. *How* generous of him. He had started a group with other zoophiles and asked me if I knew of any horses he and his group could... pleasure. He then went into *way* too much detail about fellating dogs (his favorite breed is German Shepherds) and about how he's waiting for the manufacturer to complete his latest projects. He wants to purchase one as a favor for a friend of his to keep him out of jail. Apparently, the manufacturer is creating a *dolphin's* genitalia and Paulo was excited because his friend keeps *getting arrested* for *sexually molesting them.* He then asked me if I knew about rebirthing. I replied I did and had considered trying it with a therapist I trusted when living in Chicago. He got very excited and said he could help me. The other dildo the manufacturer is in the process of creating is a dildo *shaped like a baby.* Paulo asked me if I would like to be the first to "birth it"... *with him as a mid-wife.* I told him I'd have to take a pass.

> *Love, Sal*

15 November 1996

Dear Tim:

Papa and I are "doin' the big nasty" again. My sexual interest in him has returned. I decided that even though it *was* fun to have a bit of control by refusing him sex... the *obvious* downfall of the situation was *I wasn't getting laid either.*

My cd4 count is still rising (slower now, but rising) yet my last three viral load tests show my HIV levels have been escalating even with the "life

saving" miracle drug cocktail combination I'm on. They certainly haven't escalated enough to be alarmed about but blood tests show the sneaky virus is busily replicating in the house I call my body. Under my doctor's advice, I'm mixing and matching new drug combinations to slam it down again. I've stopped taking AZT (and I think I've had an increase in my energy level because of it), and I've started d4t (keeping a close watch for peripheral neuropathy, thank you very much). So far so good. I've also added another Protease Inhibitor (but I have to watch out for pancreatitis) (Oh what fun). My doctor is keeping a close watch on me and I've been having my blood drawn three times a week for tests… I'm beginning to get track marks. I'm nowhere near danger territory, but still, thoughts of my mortality creep in. At the same time, Papa has been having a decrease in cd4s and jumps in his viral load. I'm actually more concerned with him because he works a lot, doesn't eat well, is completely stressed out and wouldn't know what a multiple vitamin was if it bit him in the ass. And he refuses to take to take any "AIDS drugs"… he doesn't want to think of himself as "sick" or "weak." I've been around and have seen enough to know people need to make their own choices about their lives. I've talked to him about different options available and advised him on what I think he should do. And if he won't... he won't. I don't necessarily have to *like* what he chooses to do… it's up to him. I think the notion of losing him (sooner that I thought) (how's *that* for negative thinking?) made me realize how much I do care about him. My thoughts are filled with questions though… "Why?" "How long do I have?" "How long does *he* have?" "There are lot of things I want to do before..." "Please, not now… I'm in love with someone I want to spend time with... let us both be well for awhile..." And I'm sad. Uh, sorry about the self-pitying track...

I saw the re-release of *Vertigo* the other day. It was fun to see San Francisco in the late '50s but frankly, San Francisco in 1996 doesn't look that goddammed different from 1958. Except for the high-rises downtown, it hasn't changed that much… San Francisco has very strict zoning and construction laws to preserve its unique, European flavor. Big deal. Anyway, Ben and I saw it at the Castro Theater, in the *middle* of homoville and the theater was *packed* with straight people. I felt as if I were in the minority… *in the Castro*. I was so shocked to be surrounded by so many people of the heterosexual persuasion it got me to thinking... *I sure live a pretty queer life*. All my friends here are queer. My roommate is queer, the building owner, the manager, the maintenance man are all queer and almost everyone living in my apartment

building is queer. The men who hooked up our phone and cable service were queers. My boss is queer, my *ex*-boss is queer, the majority of people I work with are queer, the majority of our patients are queer. Most of the people at my gym are queer. I live in a queer neighborhood, go to *other* queer neighborhoods, and patronize queer restaurants, queer bars, queer coffee shops, and queer shopping areas. Queer rainbow flags abound. I audition for queer plays and belong to a queer model/talent agency. I go to queer functions, queer parties, and queer fund-raisers. I even go to a queer church in a queer neighborhood to play queer bingo. I read queer newspapers, queer magazines, am concerned about queer rights, go to queer parades, queer street fairs and see queer movies. I dress like a queer, got my eyebrow pierced like a queer and wear a lock and chain like a queer. I eat queer food, buy queer things, listen to queer music and live in the queerest city in the world. I moved halfway across the friggin' country to close myself off into a little queer box. I don't know if it's funny... or pathetic.

Love, Sal

29 November 1996

Dear Tim:

Pete decided to go on an AIDS drug cocktail, much to my surprise. Or perhaps it's not a surprise... he *is* pretty good with self-preservation. But he is *furious* about it. He constantly bitches about how *often* he has to take them, how *big* they are, how *poisonous* they are and that he's an "AIDS junkie" chained to a cloyingly strict drug schedule. After listening to his repeated griping about it... it's taken *everything* in me to *not* say, "Like you're the first motherfucker *ever* to do the AIDS drug 'cocktail'? I know it's a pain in the ass to take them and the situation we're in *sucks. I'm in it too... remember!?* Just shut the fuck up and be grateful we have more options today then two years ago. If taking them bothers you so much... do me and everyone a favor... *don't fuckin' take 'em.* Dearheart." But... I keep my mouth shut, smile and am supportive.

Last Sunday, Sher invited me to take Max to the zoo. I thought it would be a great idea... to heal and calm down in "nature" with my favorite dyke and dyke baby. *Nope.* We went straight to the petting zoo and within minutes I was ready to throw myself on a knife. Scores, *hundreds* of pushy, smelly, filthy creatures running all over the fuckin' place. It was loud, crowded, dirty and exhausting. I was pushed, shoved, pulled, I stepped in shit, and had countless

animals nibbling at my pockets looking for snacks. *It was worse than being at the Suck Hole.* Finally, we left and were walking toward her car in the parking lot. We heard a child crying and a man's loud, angry voice. We looked over. Apparently, this guy had just swatted his boy on the behind and the boy was wailing. The father told him to "shut the fuck up" as he took off his belt to threaten the child with a whipping. I looked away in disgust, in anger, a sick feeling in my stomach. What a horrible thing to do to a kid (and it's actually something *I* experienced as a child). I caught Sher's eye and she was upset as well. I said to her, "That is so awful... I am so disgusted." She didn't say anything... just glared at them. Then she blew up and screamed at them, "Don't hit that kid, you asshole!" They yelled back, "Mind your own fuckin' business." I told Sher to knock it off. *Please.* Threats and insults thrown back and forth. We got to her car as they got to theirs. All three children were crying (I wasn't far from it myself). Escalating tempers. The two men come running over to us. I got between them and Sher. The man with the belt was trying to hit her. Somehow, *somehow* I calmed them down enough to leave us alone. I then had Sher drive me home where I had a minor crying fit into my pillow.

At times I can be a stark raving bitch myself (I know *that's* hard to believe). On my birthday, Pete proudly gave me a stack of presents with a beautiful card that said, "You make me so happy" (or some happy-crappy like that) and he signed it, "With all my love"... something that actually was quite sweet. He can't say it often in person, so a card like that means a lot. Yet. I had the gall, the *insensitivity*, to snottily say, "Oh really?" I realize it was a completely nasty thing to say. Part of it was embarrassment and being uncomfortable over my birthday and celebrating it. I *still* have weirdness about my birthday and would prefer to be alone all day. Well, what I said set a rather tense, shitty tone for the rest of the day. *If* you can imagine. The thing is... I did it completely without thinking about what a hurtful thing it was to say. He, of course, didn't say anything right away... he just became difficult to deal with, distant, short and angry... then *finally* admitted to being pissed hours later. But it has me thinking... again... how much is me? How much of a raving lunatic asshole/jerk am *I?* Is it because *he's* a raving lunatic asshole/jerk? Or simply my response to him?

I don't think I've ever been so unsure of myself... my responsibility in relationships... others' responsibility. Who is at fault? I feel so *guilty* over the distance between Ben and me. We're still friends but not nearly as close as we were because he feels "betrayed and abandoned" by me for my relationship

with Pete. Ben (he's actually said as much) feels I've devaluated our friendship because of the time and energy I've spent on/with Pete. Yes… Ben is in control of his own feelings… as we all are. I don't "make" anyone feel anything. *But*… if my actions are just cause for disappointment… *isn't* it my fault? Isn't it my responsibility because I haven't been a good friend?

Ben told me the other day he was tired of constantly doing things for other people and he needed to be more selfish in his life. Part of what "being selfish" entails is getting his own apartment and living alone. He's moving out at the end of January when our lease is up. He stressed it wasn't me… he simply wanted to be alone. "Fine," I thought. I did want to move in with Pete… maybe this'd work out perfectly. Ben's leaving to be more "selfish" and to "take care of himself," and I'll move in with Papa and everything'll work out for everyone. We could all be happy. Somewhat. So... at dinner on the night of my birthday (after the tense strain of that morning), I mentioned to Pete that Ben decided to move out at the end of our lease… and he asked, "Oh? What are you going to do?" *Not* a good sign, but I didn't take the hint. I took the step anyway... and asked if he thought we could live together... he laughed (*laughed)* and said, "No! I don't think so. Not after today."

Whoa… do I read situations wrong or what?

I thought we would live together. He asked me to fucking marry him. Partners. I was shocked, hurt and sorely disappointed. We talked about it later and he said that before we consider living together, I need to look at why I'm such an antagonistic bitch. I looked him in the eye and told him the reason is sitting right across the table from me. We did acknowledge our love for each other but both admitted to our volatile nature when we're together. So. I don't know. I'm not sure I want to continue seeing him. Let alone live with him. Wounded pride? Childish? Broken dreams, shattered hopes, deflated aspirations. Perhaps it's for the best.

Love, Sal

5 December 1996

Dear Tim:

And...

It's over. *Over*. I'm finally, *finally* fucking done with him. I'm tired of putting up with his games, his nonsense. Tired of my bitchiness, my unhappiness. The ritualistic nastiness.

A few days ago we stopped at a burger joint (Hot-n-Hunky) to get dinner. He'd been nasty and argumentative all day and I'd had it. When we entered the place, Pete was quick to notice a hot young thing sitting alone in a booth. Pete kept leering at him as we placed our order at the counter. I finally said, "Well, if you want him so badly, go sit with him and I'll leave." Pete said to me angrily, loudly enough for *everyone* to hear, "Why don't you stop being such a *bitch?!*" "Fine," I said calmly. "I'm outta here"... and left. I can take a lot... have put up with a lot from him, but I *won't* be humiliated in public. Fuck *you*.

My relationship with Pete has been like my struggle with alcohol (and various sundries of addictions). Things finally reached the point where it simply wasn't worth the hassle. The pain outweighed the pleasure. Emotionally. I hit the abuse wall, so to speak. I reached the saturation point. That one simple incident did it... pushed me over the edge.

My ending it surprised him. Or rather, he *said* he was surprised. And perhaps he was. He's more accustomed to this type of relationship than I. This type of arguing, nasty top/bottom, daddy/son relationship is certainly a recurring theme for him. And I'm not the *first* boyfriend/whatever who has run screaming from him. And the nerve, the *gall* he has... he asked me if "I was sure" I wanted to end this. Subtext, "Are you sure you're not just throwing another tantrum, you silly bottom you?" Just like a typical, predictable top. "Yes," I said. "I'm not sure about many things... but this is one thing I *am* sure about."

This is so difficult. Painful. It's as if I'm leaving a whole life. The death of a relationship, friend. Partner. Parent. My father. The end of an incredibly ridiculous, crazy, intense time. And missing him. "Missing what?" one may ask. Arguing with him? His controlling? His teasing? His nastiness? His jealousy? Our anger? Together and apart? Insecurity? His and mine? Dealing with his hard-ass ways constantly? He freely, *joyfully* admits he is a hard-ass... proudly wears his hardassness like a badge, a banner, proclaiming to the world what a tough, big man he is. (And it's out of insecurity. Out of fear.) Then he follows it quickly by saying, "But I'm worth it." Perhaps he is, *perhaps he is*. He's very generous, committed, bright, determined, loyal.

But he's also abusive, condescending, a compulsive gameplayer, controlling, jealous, possessive, and demanding. But, *oh!* To lie next to him and curl up in bed together. In bed and to hold him was... bliss. Oh what *bliss*. And comfort. It felt like home. *Papa.* My Papa.

But I cannot, will not continue to be in a relationship with someone who is so insulting, disrespectful and hurtful.

San Francisco. Too small, too small. Everywhere I turn, I see men who have his tall figure, his stature, his salt-n-pepper hair, his beard, his piercing, deep brown eyes. His eyes. His lips. And my heart races. In longing. And in fear. In fear because I long for him so. I see these men, my heart beats strongly, then I see it isn't him. I see a sexy, black pick-up truck on every street, in front of my apartment building when I come home, in front of where I work in the morning, in front of the gym every afternoon, and I think it's his. But it's not. I see his daddy-like flannel shirts on men. Everywhere. But it isn't he who fills them.

I think of things we did together, saw together, of places we have been. Together. I think of the icy, blue glaciers of Alaska, of the burning, dusty desert of Nevada and my heart aches. I miss him and I feel alone.

Love, Sal

12 December 1996

Dear Tim:

"Another angry bottom… aisle four. *Bring the bolt cutters*!"

Sometimes this city is just *too* much. I went to the hardware store where Pete and I went to get my chain and lock to get it cut off. Yes, I know, Sher could have pulled out her trusty paper clip again… but I needed a statement. A ritual. I needed it to be *cut* off. I walked to the chain/hardware section to find a clerk. Of course it turned out to be someone familiar. It was Chuck… a bear top-daddy who had done some electrical work for Pete. I thought Chuck was hot hot hot… which Pete knew and was excruciatingly jealous of. (Actually, disappointingly, I found out Chuck enjoys spending his Saturday nights at a very sleazy sex-club, getting fist-fucked. Some top-daddy *he* is.) *Anyway,* thrilled to see Chuck, I asked if he could get a bolt cutter to cut a small padlock off. He looked at me and said, "Ohhhhhh… did you break up*?" This goddamned small town.* Chuck led me downstairs and artfully cut it off. It was obvious that this was not the first time he released a raging wayward bottom from the chains of love.

Clink, chink, *bango*. It was off. I felt remarkably numb. He handed my cut chain and lock to me and said, "Now you have to go right over to his office and *throw* it in his face." I chuckled and said, "Are you kidding? To *Pete?* Would you?" He said, "Uh… you're right, ya better not. And no charge on the

cutting service... you've probably paid enough." *Gee*, I felt so supported. I went back upstairs and asked the counter clerk for a bag. The clerk looked in my hand and said, "Oh, you broke up. Are you OK, honey?" I didn't know whether to laugh or cry.

I feel naked and vulnerable without it.

This has been one of the roughest times I've had in a while... deep sadness, severe loneliness. Missing Pete. Intense self-doubt over ending things. Regret over being so hasty as to cut off my chain (and all it entails and symbolizes) so quickly. I started to think I didn't try hard enough... that I should give him another chance. Relationships take work and patience and if I really loved Pete, I'd stick it out. I'd start missing him... certain sounds, smells, sights would trigger a memory... I'd yearn for him and feel so empty. But what I keep coming back to is the relationship was abusive. And crushing. As pushy and controlling as I am, I couldn't change the relationship into something more equal, more loving.

Pete has actually made it easier to keep my resolve. He's been *hounding* me. He calls constantly; begging me to go back to him, trying to talk me in circles about why I think it didn't work.

But on the other side... I'm feeling really happy. In just the past few days, I've been feeling so much better. And I'm so excited and thrilled about the change in my mind-set. It's as if a huge festering painful wound (that I didn't even realize *how* painful it was) has been removed. I feel lighter, optimistic, hopeful. It's as if the sky opened up. As if the deep syrup I was in washed away, the crushing weight on my back and in my head has vanished. That weight? That cloud? That heaviness? Was Pete. Yes. Yesyesyes, we've had fun, wonderful times together. A part of me does love him still but being with him was so... debilitating. I feel free again, more of myself again. I'm noticing plants, flowers, smells.

I've just had a pretty wonderful couple of days. I met someone on the street a few days ago. He looked pretty tasty... a stocky hairy Dago type a head shorter than me. I really liked the *short* part... how much trouble can someone shorter than me cause? (Never mind... don't answer that.) We exchanged numbers and he asked me out. I was afraid to be seen in public with him because of being stalked by goddamned Pete... sick, ain't it? He came over for what I thought would be hot, nasty sex (yes, meaningless, anonymous, frantic stimulating for genitalic release) (but fun nonetheless)... and mostly, we just lay in each other's arms, held each other and talked. And touched each

other softly, and kissed, and were very... gentle, quiet and... uncomplicated. Yeah, sex happened somewhere in there (specifically selfish male orgasm) but most important to me was the peaceful, loving quiet way we were *nice* to each other, appreciating each other's bodies and warmth. Each other's feelings. Our selves. We lay together peacefully for a long time. After he left I realized it's been so long since I've done that... simply to be myself, to be calm and peaceful in someone's arms. And to talk of spiritual things. And growth. And hopes and fears. Without all the craziness Pete and I had. What I find ironic is... I had to leave my partner (whatever) to find calm comfortable intimacy in the arms of a stranger.

On Sunday I rented a car and drove down the coast along Highway 1. To nowhere in particular. I just drove. I stopped along the way to smell the sharp ocean air and to look at flowers, trees, and the magnificent California coastline. The highway was fairly deserted. Everyone must have been getting ready for Christ-mess and had no time to stop what they were doing to enjoy a breathtaking day. It's been fairly gray and rainy but this past weekend was perfect... bright blue skies, no fog, with a few soft clouds. Because of the heavy, frequent rain, everything was green... *so* green, and fresh. Traveling back up the coast to San Francisco, I stopped to watch the sunset. Something I haven't done for... over a year? Could it be? I pulled over, got out of the car and sat at the top of a tremendous cliff overlooking the ocean to watch the sun set peacefully into the water. I was at a pullout off the highway and a few others had stopped as well. (When you live along the foggy Northern California coast, a clear sunset is an *event*). A little to my right, a couple in their 60s sat in their car watching. To my left, a man and woman stood holding hands. As the sun's warmth left us, the man held her lovingly in his arms. We were all quiet, mesmerized, transfixed. When it set, I glanced over and watched as the older gentleman in the car give his wife a sweet kiss on the lips. They smiled at each other as he started the car and drove away. I stayed and watched the sky turn to brilliant orange, gold, soften to dark blue and felt so happy, so alive, so thankful. *Peaceful.* And to my surprise... not lonely.

I was relieved to not feel lonely, especially after witnessing the sweetness, tenderness and caring of the two couples I shared the sunset with. I didn't have that with Pete anyway, so how could I miss what I didn't have? What I was left with was that it looked so easy, so nice, so loving for them. How sweet they were to each other. The caring they had in the way they related. Now, I know sharing a life with someone isn't always brilliant sunsets

and roses… I know there are compromises to deal with and hundreds of details to work on in a relationship. But through all that… these two couples also shared an intimacy that seemed deep and true. *Loving*. And I thought, at some time… I'd like it for myself. I deserve it. Doesn't everyone?

Love, Sal

29 December 1996

Dear Tim:

Chainless in San Francisco

Ya know, sex without love is certainly overrated and unfulfilling. A rather nice guy (Jim) at the gym has been after me for a while now. He saw my chain of love (imprisonment/slavedom) has been removed and he gave me his number. I went over to his place where we proceeded to have passionate, sweaty, drooling sex. Yet during and after I kept thinking of Pete. *Pete*. Jim was actually very comfortable to be with, yet it felt... so empty. *I* felt so empty. When I left and walked home (during a torrential California downpour) I felt so excruciatingly, incredibly lonely. And thought about Pete all night.

My roommate search is over and it was gratefully short. I had signed up with a roommate referral service where people looking for roommates and people with apartments to share were listed. I was immediately infuriated because many wouldn't live with someone who smokes. There was a question on the information sheet that asked, "Is it OK if your roommate smokes?" and many wrote, "Yes, but only outside." *Kiss my fat, white ass!* How *dare* they? *Of course* I will smoke outside! That *wasn't* the goddamned question. Anyway, I interviewed various freaks I wouldn't want living down the hall in the same *building,* let alone in the same *apartment.* I finally settled on a guy named Kirk. Kirk is in recovery (good… he'll be busy with all that recovery disaster), has AIDS, is on disability, very quiet and serious. And yes, *Kirk smokes.*

Ben met Kirk when he stopped by the other night to drop off a check. As soon as he left, Ben pounced on me and said incredulously, "Don't you *know* who your new roommate is?! It's Kirk Carlo the Calvin Klein underwear model!" I asked Kirk about it and he told me that yes it's true, but it's in his past. Hmmmm, I wonder if Kirk would be interested in doing porn? I'd love to direct a porn film in my living room, starring my new roommate, Kirk Carlo, with "Iron" Mike in "A deco/50s retro-fuck-a-rama."

I've been seeing more of Max lately. She's just sharp as she can be and such a *joy* to be around. She's only a year and nine months… yet is chatting up

a storm, is nearly potty-trained and certainly knows her own mind (just like her mama) (*quelle surprise*). Max has gotten even more attached to me, which completely warms my heart at a time when I most need it. She insists I accompany her to the bathroom when she has to use the "potty," which, I guess, is *quite* the honor. And she pounds on the bathroom door wanting to come in when I'm in there (which I don't allow). One evening I asked Sher, in front of Max, what she should call me, "Sal," or "Uncle Sal." Sher said we should let Max decide. Then, out of the blue, Max started calling me... MommySal. *MommySal!* (couldn't you just scream with delight) (*I* did). I don't think I've ever been so complimented.

Christ-mess eve Pete was trying to track me down like a stubborn bloodhound. Pete's friend told me he had bought three primo, vintage bowling shirts months ago and was going to stop by where I work to surprise me with them as a Christ-mess gift. He thinks if only I see him, everything will be all right and I'll throw myself in his arms. *Again*. And why *shouldn't* he think so? It's happened many times before. I couldn't bear the fact he was stubbornly tracking me down to surprise me, so I sent him on a wild goose chase throughout the city. I told him I was going to be at work... then didn't go. He called me at home to see where I was (Sher had just called me from work and told me Pete showed up looking for me). I was furious he was doing this so I told him I ended up not going to work because I had a doctor appointment (her office is located on the other side of San Francisco). Off he trekked to the other side of the city to my doctor's office while in the meantime I stayed close to home, did errands and cleaning. Feeling hounded. He finally called, hours later, frustrated and looking for me. I feigned not being home and had Ben answer. Pete asked Ben to let him come by to drop off the gift. Ben OK'd, hung up. I was infuriated Pete simply was not going to give up. It would have been much, *much* simpler if I let Pete come by to drop off his gift and I would return it later. But, of course not. I was completely riled up with the emotions of this godforsaken holiday, the full moon and being stalked all day. I felt so claustrophobic... so *suffocated*. I called Pete an hour later and read him the riot act *twice over* for doing what he was doing all day. When I finally calmed down, I felt horribly childish, vindictive and stupid. I called him back, apologized for being an ass, and wished him well.

I've consented to meeting him on Sunday for brunch. I've refused to see him for weeks... yet he won't give up. My strategy is that if I do see him and

don't rush into his arms to resume our mad, *frustrating* dance called a relationship he'll get the idea and call it quits.

Love, Sal

15 January 1997

Dear Tim:

Saw Pete the Sunday after the New Year and it was a little easier than expected. I was quite apprehensive about it but calmed down when I saw he was much more anxiety ridden than I. I told him again what didn't work in the relationship. What was abusive. His response was I haven't given him a chance to acknowledge the issues and to change. But I have, *I have*. He told me he'd have stopped if he knew things were at the point of me leaving.

...and even after meeting him Sunday and telling him to his face to leave me alone... he continues to call and tell me he loves me. I'm starting to think the only way I'll be rid of him and stay in this city is to stage my own death and have radical plastic surgery.

Having a difficult time lately... feeling unmotivated, sad and not interested in doing much. I get to work. I do the bare minimum. I go home to eat and watch TV. Having a difficult time functioning. Being motivated. I've hit a deep funk that's not getting better. I talked to my doctor about it and she suggested I try a "helping hand" to smooth things over for awhile. And... well, well, well. Well. I've joined the growing ranks of antidepressant poppers. She put me on Paxil. I'm actually rather embarrassed. Me. On antidepressants. I can't even begin to express how I feel about it. My reaction about taking them is interesting to me. I'm ashamed and angry. I've been all in favor of others taking them... I've seen people get tremendous benefits from them... yet me? Of course, I can't get *too* upset over taking them... *because I'm depressed.*

Love, Sal

28 January 1997

Dear Tim:

Pete sent a letter and called me... asking if I'd consider going to couples counseling. Pete. And therapy. Part of me thinks this is simply a ruse on his part to get me back. He'd do anything I want to get back to the relationship. The fact he suggested therapy proves it. Months ago I suggested to him we go, to which he laughed and said he doesn't need it. The fact *he's* now bringing it up says to me he's willing to change, to do what we need to do to make it work. Maybe.

But… if I do consent to going, I'd make it clear it doesn't mean we'd get back together. I'd be doing it to see if it could possibly work between us. And yes, I do realize he may only be doing this because he knows I'd want to and it would be a way to get me back… but I'm a therapy *veteran.* I'll be able to tell.

Still feeling, at times, not quite right about the fact I'm taking antidepressants. Paxil. I completely despise having to rely on anything. But then, of course, I *do* rely on cigarettes, caffeine, antiretrovirals. Ice cream. Hmmmmm. I've struggled with sadness and depression a lot in my life and have gotten this far without them but dealing with this Pete thing felt so crushing. I do feel OK about taking them because I still feel connected to what's going on with me. I'd *hate* to be numbed out, and I'm not. Since I've moved to the West Coast, I've struggled with varying degrees of loneliness, sadness and isolation fears. You know… regular "moving across the country away from friends, family and the familiar" stuff. I wonder if taking antidepressants would have helped sooner. When Pete and I first met, ironically, one of the first things he asked me was "Are you happy?" My response was, "No. I'm not." And that was true. I rarely am.

Out of loneliness, sadness, and boredom… rather than true horniness… I've been out sniffin' up sex a lot. In the past two weeks, I got into a heavy shaving scene with a daddy/bottom (who lay under me, frantically beating off as my clipped hair fell on his chest and face). I've been to an orgy with ten other shaved-headed, multi-pierced and tattooed guys where my orifices were simultaneously, multiply paid attention to. I had another beardaddy piss all over me as I knelt before him urinating into a Slurpee cup. Went to an outta towner's hotel room where he pulled my pants down and put me over his knee to spank his "bad boy." God *bless* San Francisco… where you can still be a "boy" well into your 30s. Went to a sleazy sex-club and gave head to a youngish Latin daddy-to-be, who followed me around afterward cornering, panting and pawing me because I gave him the best suck job he ever had and he thought I was just "it." Stopped in a thrift/vintage shop in the Mission where the clerk came on to me, saw my dick rising in my army pants, locked up the store to treat me to a quick blowjob among the vintage '70s polyester disco shirts… and went to the Suck Hole to have frantic, passionate, *amazing* sex with a guy who, when I asked him for his name afterward because he was so incredible, looked me square in the eye and said quite aptly, "*I'm just another one.*" Well… if *that* ain't the truth.

Love, Sal

2 February 1997

Dear Tim:

My new roommate Kirk moved in and my apartment is *finally* getting back to some kind of normalcy. Ben started packing right after Christ-mess so things have been a disaster since. Because of the turmoil in my head it made me extremely uncomfortable to have my living space in complete disarray as well. Kirk's settled in… his energy is much nicer, calmer, sweeter than Ben's is/was. I feel better that at least my surroundings are compulsively neat, tidy and clean. It helps because the inside of my head feels as if it's such a mess.

And I like Kirk. He's fairly quiet, calm and serious. And because he's newly in recovery, he has "life is starting over and full of wonderful possibilities" energy people in early recovery tend to have. Haven't really asked him much about his underwear modeling past except for the fact he doesn't do it anymore and is very glad not to be... but I saw him with his shirt off the other day. Oh *my*. The boy has been *around*. His nipples are the longest, hardest and perkiest I think I've ever seen. Men are not born with such proud, protruding nipples. It takes *work*. And they look as if they have been *worked*. I really didn't think of it before but he's very attractive. He's very lean, tightly muscular and good-looking. Well, you know... *underwear model material*. Gratefully, I don't feel sexual toward him. I'd hate to be pining away and lusting after my hot, humpy roommate who prances around sans shirt, nipples to the wind.

I've decided to give therapy with Pete a shot. I was very clear with Pete and told him I'm going *not* because I want to get back with him *or* I have faith in him changing. *No one changes.* I said I'd go because I think there's a lot of unfinished business between us and it may help us understand what happened better. I also think it would be good for me personally. I told him we should look for someone well versed and knowledgeable in the dynamics of an S/M relationship and I'd ask my regular therapist for a referral. Lo and behold… Pete found one in the "Lavender Pages" (the Bay Area's queer "yellow pages"). His name is Ian and his ad read:

Ian Carlson, Ph.D. Intimacy and relationship issues as they pertain to S/M, Alternative sex and gender concerns. Board Certified Sex Therapist.

Pete called, clicked with him and asked me to talk to him. Ian was easy to communicate with and said all the right "therapist" things. He has a Ph.D.

from the Institute of Human Sexuality, has been a board-certified therapist for almost twenty years and is well known and established in the city. I talked to Blake and he knows him. When Blake first got to San Francisco, he cleaned houses for a living and Ian was one of his clients. (Sometimes, this being a small town pays off.) Blake said Ian's a great guy, very respected, etc., etc. You know… it's really quite Midwestern of me, but I was shocked to find someone like this exists. In my preliminary interview, I simply *had* to ask… "Ian. So, uh… what qualifies you to counsel couples who are into S/M, bondage and domination/submission? I mean… there couldn't be a *curriculum* for these issues… *is there?"* He told me he went through a typical training in human sexuality. But also, in his own life's pursuits he's very involved in S/M. He's bisexual and has had long-term S/M relationships with both men and women. And… now, I just *had* to know… I asked, "Are you a top or a bottom?" "Actually, both. I've owned and have been owned." I just wanted to know I wasn't dealing with another 50-year-old top who would completely side with Pete. I made an appointment.

Oh, yeah… I think the antidepressants kicked in. I don't give a good goddamn about *anything*. Everybody surfin'*, Paxil USA!*

Love, Sal

10 February 1997

Dear Tim:

Kirk and I are getting along as roommates well and still getting used to each other... our schedules, habits, space. It doesn't feel awkward, as I was afraid it might. But I like him... his energy. I sorta pick up sadness though. He's been through some pretty heavy stuff in the last year. He's in recovery from alcohol... and would stay up for *days*, partying, fucking, drinking... running on frantic, nervous energy. Not eating, getting dehydrated. Kirk hit bottom pretty hard and spent two months being constantly and completely smashed. Consequently, Kirk got badly in debt, lost his apartment, had most of his stuff tossed into various boxes and bags by friends and family to be put into storage, and probably could have lost his life. He went into a treatment center, "graduated," lived with a friend for a few months... then we connected.

I sometimes catch an odd sadness around him and I think it's related to the seriousness of what happened and the issues he's dealing with in therapy and meetings. He said something quite poignant to me as he was unpacking. I saw him take a framed picture of a little boy out of a box… it looked as if it

could have been him at eight or so. I asked him if it was and he said with a sad half smile, "Well, I knew this little boy when I was a kid. I lost him somewhere… and now I'm trying to find him again." That's what he seems like… a lost boy trying to find himself. He's a perfect housemate because in many ways, I'm trying to find myself as well.

How do we lose ourselves? I realized the other day I've spent half my life in therapy. Half of my life. *Eighteen years*. I've come so far, yet am still searching. A lot of the time I've spent in therapy is looking at the "why's" of my sexual preference/interests. Why anonymous sex? Why promiscuity? Why S/M? Why are certain acts, sights, sounds, smells and certain physical attributes so appealing? The smell of Old Spice? Cigars? Hairy, big guys? Balding men?

Pete and I had a session with Ian. It went much better than I had anticipated. Ian was wonderful. I really didn't know what to expect… a sex therapist who specializes in S/M, dominant/submissive and transgender/transsexual issues? I half expected him to be wearing a leather harness, fishnet stockings and brandishing a whip. Of course he was not… he was dressed in typical, unassuming 50-year-oldish male therapist slacks, tie and sweater. He was tall, gentle, warm… nurturing. He has wonderful, moist gray eyes, very comforting energy. And sharp as a tack. As he was listening to us individually telling our "story" he was right there listening, taking it all in. I'm sure dealing with two people in a session must be challenging, especially when the two people have energy/issues/egos as big as Pete and I. I don't know where this will lead me/us, but, already, I feel as if it's been valuable.

Pete talked about how surprised he was when I broke up with him and that I didn't communicate enough. I owned up to the fact I am not the world's greatest in verbal communication (sullen Sicilian genes?). I know at times I'm guilty of going through a silent mental process, coming to a conclusion and fully expecting the other person to be on the same page at the end of it without me saying a word. Nevertheless… I know at times I did flat-out tell him what was going on with me.

At one point I did feel quite validated. In the session, we talked about communication (or lack thereof) and about boundaries. Throughout our relationship one of the sexual boundaries I immediately made *loud and clear* to Pete was I did *not* want him to bite my face. Occasionally Pete would "forget" and in the throes of passion, do it anyway. To which I would get furious and pull away. I brought that issue up in therapy as an example about

how I felt I *did* communicate things to Pete, but he didn't (wouldn't) listen. Pete said, "Yes, Sal told me he didn't want me to bite his face... but I would forget," to which Ian replied, "*No.* You *never* forget a boundary. The submissive needs to have complete trust in the dominant for things to work. Setting boundaries is what makes people feel safe and when one crosses those pre-set, agreed upon boundaries... how can you expect them to trust or feel safe with you? The beauty of S/M is that, if it is healthy, boundaries are thoroughly discussed beforehand and *strictly adhered to* during S/M sexplay." Pete, the inexcusable clod, was shocked. He thought he could be forgiven because he *forgot* and said again, "But in the heat of passion, I'd just forget." Ian, *again,* said very firmly, "*No.* That is *not* an excuse for behavior that would make your partner feel unsafe." It took everything in me not to pull my dick out and beat off in complete elation.

At the end of the session after we made one more appointment for the following week I said I wanted to lay down a boundary. I told Pete I didn't want him to call me *at all* during the week. I didn't want to hear from him for any reason until I saw him in session next Thursday. I requested it partly because I want and need it, but also, truthfully, to see if Pete will respect it. At first, Pete sputtered and struggled with it but when he saw Ian looking at him expectantly, Pete knew I had every right to ask for it and for it to be respected. So he agreed to stick to it. *We shall see.*

You know... when I look at Pete... when I see him... oh, my heart still leaps. Still so in love with him. But during therapy and now... a few hours later, I'm filled with anger, resentment, frustration. And still convinced more than ever it's not right to be with him.

Love, Sal

12 February 1997

Dear Tim:

I've been playing flirty-flirty with Jon, the resident nurse at my doctor's office. I'm hot to trot for him but for the longest time did nothing about it or encouraged him because I was with Pete. Well, about a month after I had Chuck the beardaddy take a bolt cutter to Pete's version of a wedding ring, I started responding to Jon's playing up to me. We exchanged numbers and talked on the phone about how attracted we were to each other and began snorting and panting (just like typical males) about how we couldn't wait to be pawing at each other's crotches and sticking things into each other's orifices.

He told me he was leaving his job as resident nurse at the end of this month to figure out what he wants to do with his life. For the sake of good boundaries we decided it would probably be a good idea for us to wait to get together until he left. And to *not* mention it to my therapist... you know how *they* like to make an issue of every damned thing. Well, after this past session with my therapist, where I talked about "boundary" issues almost the whole goddamned time, I stopped by my doctor's office to gab (and flirt) with Jon a bit. As he and I were talking by the reception desk, he backed/led me into an unused office... shut the door and we jumped each other. We passionately kissed and panted into each other's ears as we rubbed our stiffening dicks against each other's legs for a good old-fashioned dry hump. To see if we do have a connection behind the spark we feel and sorta just to tease each other... knowing we certainly couldn't carry through. At the moment anyway. Especially with a waiting room full of people right outside the door. Yow... when we do get together... it sure is gonna be a good ol' time if the frantic, passion kiss/slobber is any indication. We pulled off each other, pupils in our eyes dilated with lust, breathing heavily, adjusting our dicks in our pants so it didn't look *completely* obvious... and opened the office door to see my doctor standing right outside. Oops. *Busted.* So much for "good boundaries." I slunk home horrified. Told Kirk about it, who of course, knows Jon and goes to 12-step meetings with him.

Valentine's Day 1997

I left work with a whanging headache and got depressed thinking that, again, I spent most of the day pursuing this thing called "good health." Had to dash over to the other side of the city to my doctor because I have "pinkeye." She prescribed eye-drops and I went back to work to finish the day. Grateful to not have a tumor but slightly nauseated by my headache, I walked slowly down Van Ness Avenue toward home. En route, I passed scores of people bearing bouquets of flowers, tender smiles and excitement to bring to their beloved.

On the way, I stopped at every donut and pastry shop, buying a goodie to nosh upon as I made my way down Van Ness toward the next one. In one embarrassing instance, I was chewing and wiping the jelly and sugar off my chin (from the donut purchased at the previous bakery) as I ordered my next little nosh. I knew nothing short of a raging fire or an earthquake registering 9.0 on the Richter scale would drag me out of my apartment this evening, so I made it a point to stop at Walgreen's to pick up my favorite duo, Ben and Jerry,

for a much needed three-way later. In this manner was I able to make it to my front door.

As I entered my postage-stamp living room, I noticed the immense floral arrangement, proudly displayed on the very '90s curved glass coffee table Kirk owns. The arrangement was for Kirk, given to him (he told me later) by the man Kirk chose *not* to go out with tonight… because Kirk already had a date. I immediately snatched the tulips I bought to cheer myself up with the other day and threw them down the garbage disposal, relishing the sound as the delicate tulips become so much pulp in the drain.

Went upstairs to find Kirk getting ready for his evening's date with James… a very handsome dark-eyed muscular boy/man who is completely devoted to Kirk.

Went to the kitchen to prepare dinner. Decided on a tomato sauce. As I was putting pasta into boiling water, James arrived for Kirk. They stood in the doorway discussing their plans and the best way to get to the restaurant they were going. Kirk turned to me as James cuddled up to his back with his arms around him. "Sal? Why are you cooking? Aren't you going out?" I silently counted to five, valiantly struggling with throwing the pot of boiling water at them. And won. Instead of scalding them with water, I said, "No. I'm not feeling well and canceled the plans I had because I need to get some rest." They wished me well as they bounded (as *only* gorgeous muscleboys can do) out the door to a delicious dinner and romance on this beautiful, balmy, San Francisco evening.

So. There I sat. A cold computer's screen and keyboard as my evening's partner. Listening to the busy, frantic traffic on Franklin Street, as hundreds, if not *thousands* of couples passed my apartment on their way to their festivities. Eating pasta with homemade tomato sauce, eyes leaking viscous fluid, listening to Kirk's cell phone ring incessantly.

The highlight of the entire day (and probably this weekend) was the fact that because Stacy our nurse was out today, I asked hot Doctor Lambert to give me a testosterone shot. I find it pathetic that the most romance I will experience this weekend is baring my butt for the staff pharmacologist, so he can place his clinically gloved, (but strong… *oh*, so strong) hands on my quivering naked ass to give me an injection.

Now, if you'll excuse me, I need to take an antidepressant. You don't know my pain.

Love, Sal

24 February 1997

Dear Tim:

Pete and I went to see Ian the other evening for what was to be our "closure" session… yet I couldn't end it. I wanted us to meet again the following week and for Pete and I to meet outside of Ian's office. I couldn't bear the emptiness I'd feel if Pete finally, *finally* stopped pursuing me. It would mean giving up the faintest glimmer of hope I *still* must covet.

And to be absolutely honest, it gives me *tremendous* pleasure to be in therapy… to bring up shitty, manipulative stuff that Pete did/does… have Ian *agree* with me… have Pete admit I was right… and *apologize. And* to top it off… watching Mr. "Watch Every Penny Pete" fork over $80 for each session, which I know *kills* him, is *completely* satisfying.

Kirk and his stereotypically blond/beautiful behavior is becoming a bit of a nightmare. *Twice* I've gotten up in the mornings to find he neglected to lock the front door the night before. He left for LA for a few days on Wednesday morning and I came home from work that evening to find one of the gas burners on the stove turned on… *unlit.* The apartment was *filled* with the reek of gas fumes. I was grateful I didn't come home *smoking* because I'm sure the building would have blown up. It took two hours to clear the smell out. He had told me he wouldn't be back till Saturday… so on Friday night I thought nothing of bringing a hot manthing home for sex and leaving my bedroom door open. The hot manthing was sitting on my bed as I was lying across his lap, pants around my ankles, getting a good spankin'… as Kirk appeared at the top of the stairs outside my bedroom door saying, "Hi! I'm back early!" I wanted to *kill* him. Probably *my* fault I left the door open… but, honestly, phone first, you knucklehead. Poor Kirk… another case of, "Pretty House, No One Home." And if he doesn't knock it off… *there won't be a home to go to.*

It's the "Bear Rendezvous" gathering in San Francisco this week. Men from all over the United States whose only claim to fame is being fat and hairy converge on this ridiculous city to crowd the streets and bars to admire one another's hairy man-bellies. Sound surprisingly sarcastic coming from me? You bet. I'm tired of the whole tourist thing that goes on here. Scores of queers converging on San Francisco at different times of the year to bask in the glory of our "Gay Mecca." I guess my distaste comes from the fact it's all so overblown and ridiculous… *Hello queers*… this is *not* the end of the rainbow,

OK? It's all a myth. Well, as you know… I *am* attracted to the whole "bear thing"… but am usually rejected because I'm "skinny." Who knew life would come to this?

Rather than dashing out in pursuit of the hirsute, my friend Peter from work and I went to Kabuki Hot-Springs, a health spa in JapanTown offering steamrooms, whirlpools and saunas. I was excited to do something new and "exotic," away from the teeming homosexual population in the Castro. I imagined relaxing Japanese music, and fat, unappealing Japanese men lounging around in towels taking in the vapors. *Hello…* I was bitchslapped back to reality right quick. The young Japanese woman receptionist greeted us at the entrance wearing a hideous god-awful '70s polyester outfit that has become so hip lately, in between bites of her *Spam* sandwich. Peter and I found our way to the changing room where two very cruise-y queers gave us the once over. One of them turned to me and asked, "Are you in town for the Bear Rendezvous weekend?" I looked at him incredulously and said, "No, we live here… and if I were interested in bears… why in hell would I come here?" "Because the place is packed with them!" he answered gleefully. Normally I would have been into it… but I simply wasn't in the mood. Sure enough, the place was crawling with big, fat, hairy men cruising each other and pulling on each other's wieners in the steamroom.

Again… this is a ridiculously small town. Was walking through the Castro the other day doin' errands and ran into Ian, my couples counselor. Ian, who I'm used to seeing in somber, nondescript tweeds, was decked out in full leather regalia and was in "bottom-boy" mode wearing chaps, harness, leather collar and cap… his nipples and navel pierced, proudly being led on a leash by a tall, statuesque Dominatrix. I tried not to let my jaw drop out of my head as we passed and gave each other a sly wink. You know… he's a wonderful therapist and I'm getting quite a lot out of seeing him… and I do understand the "*of course* he has a life" thing… but did I really need to see that? I must say, bless his heart, he wears it well.

Love, Sal

1 March 1997

Dear Tim:

I've decided to see Pete outside of Ian's office… all his talk about how he can change needs to be put to the test. We went to get a bite on Sunday with

It's the "Bear Rendezvous" gathering in San Francisco this week.

no expectations on either of our parts. I certainly don't feel as if I'm rushing back to him and he's actually backed off quite a bit. Ever since he thought we were going to have our last session last week and he'd never see me again he seems to have disengaged. Going out with him was like… getting to know someone new. Still not sure about sex with him though… at the end of Sunday's "date," we kissed. Passion grew, penises swelled and, well, the sex always *was* pretty hot so I shouldn't be surprised. But… I burst into tears. Told him I was confused and I didn't want sex to go any further.

I'm feeling a lot of fatigue lately that's not going away even with increased rest and sleep. I have started some new drug treatments and I am getting off a pretty bad cold/flu but it's taking a long time to feel better. Saw my doctor the other day and she suggested I take two weeks off to go on "short-term disability"… to listen to my body and see what it wants me to do and maybe go on permanent disability. I'll try to take things easier but I really don't think I need to go on disability. Nor do I want to. I do think she tends to overreact but then again… she was simply offering options.

Shortly before Kirk moved in, he had sold his life insurance policy to a viatical settlement company and received quite a hefty sum of money. He very responsibly invested some of it… then went on a mad shopping spree. Within a week, he frantically purchased a cell phone, two TVs and VCRs, a computer system and a car. Two weeks after that… he seemed rather glum. When I asked what was wrong, he answered, "I thought buying all those things would make me happy… and they haven't." Like *duh.*

Love, Sal

7 March 1997

Dear Tim:

Had a "date" with Jon (the resident nurse at my doctor's office) last week. The date is in quotes because I just went over to his apartment for some red-hot lovin'. What a sweetie. Funny… talked to Ben about it, who knew of the long-awaited consummation. The first thing Ben asked was, "OK, what scene is *he* into?" Ben knows all about my sexcapades with the various weirdo role-players in this town. I told him, "No scenes. No Master/slave stuff. No spankings. No kink." Ben said, "You mean just hot, passionate, regular old sex?" "Yeah," I said. "Oh," he replied, "… so you didn't like it that much." The thing is… he was right.

I met with Jon again… once for lunch and again the other night for fuckin'. Had talked to him a bit about my feelings and fears to which he was very understanding and supportive of… but I'm still dealing with nervousness and insecurities. He's a real angel about it. At one point, I was on my stomach and he started massaging me. He began… softly singing to me. It felt so sweet, loving and caring… I started crying.

It's getting to be a real drag to keep bursting into tears each time a man touches me.

I'm still very much pulled by the Pete-type personalities, yet am getting less and less willing to deal with what they offer even though the attraction is still there. Yet, when Jon and I were together having sex… we weren't playing power games, neither of us played "top" or "bottom." It was just the two of us and I felt very vulnerable. Vulnerable to be having sex and not hiding behind the mask of "boy." The same applies when I'm engaged in anonymous sex. When I'm with an anonymous partner, I'm not myself. Well, really, of course, I am… but it's with a complete stranger who knows nothing about me and… I feel safe. To be in an intimate sexual situation with someone and to simply be myself is very threatening. When having sex with Jon, I feel insecure, unsure of my attractiveness, unsure of my sexuality. It's easier and more exciting to be with someone I don't know at all or with someone who is in a position of power.

And I *am* taking some time off work. Nothing awful is going on physically… I'm just fatigued a lot and my doctor suggested I take two weeks off.

Love, Sal

10 March 1997

Dear Tim:

I'm in the middle of two weeks off of work for R&R. Am kinda groovin' on it. Up late, relaxing mornings. Errands, lunch, working out. A girl could get *used* to *this*. It hasn't been *all* fun and games though. My doctor had me undergo another endocoscopy. My latest labwork and blood values showed something's not quite right in my liver and it's giving me colongiopathy. I've been having occasional stomach pain and she attributed it to a blockage in my bile duct. The endocoscopy procedure is something I had done a year and a half ago when I started getting sick and it helped a lot so I'm hoping it will

help again. I must say I'm getting a bit tired and frustrated having to deal with all this. I had the procedure the other morning, came home grateful not have to spend the night in the hospital and have been resting a lot. I'm pissed that *again* I'm faced with "shaky" health. But it's not nearly as shaky as before. And I'm taking pains to not let myself get there again. But… OK. I have to deal with it. And I am. And I will be well, healthy and strong again.

I'm experiencing a lot of frustration and confusion dealing with Pete and Jon. Jon is sweet, supportive and it feels "brotherly" with him. Then there is *Pete*. He wants to "get on with it" and get together again. I'm oh, so afraid to resume our relationship. We met last Sunday for brunch and I noticed myself being rather… biting. I kept saying nasty, mean things to him. I admitted to still being angry to which Pete replied, "How *long* are you going to be angry at me? I thought you were going to go at this fresh?" To which I responded, "I will be angry as long as it takes… it's easy for *you* to go into this 'fresh'… you *have* no complaints about the relationship. I'm the one who feels screwed, abused and taken advantage of." Then we both cried and hugged each other.

Exhausting. So *enough.*

Pete asked me if I'm fucking around and I've told him I have. Of utmost importance to him is whether or not I've been having S/M sex. That above all else would threaten him the most. More than if he knew I was seeing Jon occasionally. Pete can accept me having anonymous sex. He can accept me having sex occasionally with the same guy. *But…* if I were to be having S/M sex with someone… *that* would piss him off/threaten him more than anything because I would be "serving" someone he would consider his equal. The *ass.*

Jon and I are having fun together. In my meandering, I stopped at a spiritual/crystal/gift-shop and bought him a set of Native American Medicine cards. He was quite delighted. And we had a lovely talk (in between snuggles and sex) about how easy it's been for us to be together and to not, as he put it, futurize anything. He knows my struggles with Pete, understands it and is very supportive. We talked about how we're both in a sort of transitional time right now (he with his career uncertainty and me with Pete) and how nice it is to have someone to share with. When I'm with Jon, I'm not nasty. I'm kind, loving, calm and peaceful. You know, he paid me the greatest compliment today. One of his friends asked him to describe me and Jon said he described me as "brave." It took me awhile to take it in… but I thanked him and felt it. He is a gift.

Love, Sal

14 March 1997

Dear Tim:

Just when I feel frustrated I have "no control." Something happens to show me exactly how much control I *don't* have. *Earthquake!* The other evening at about 10:30, I was in front of my computer working... and the monitor started shaking. I stood up, then because of the shaking, sat back down. I watched as a picture fell off the wall... as the '50s vintage lamps on either side of my bed shook and the shades swayed... as another picture fell off a table... as the floor felt like a trampoline. Heart beating, eyes bulging, the hair on the nape of my neck standing up. It stopped. It was very brief... only seconds in fact, but felt *much* longer. I calmed myself... breathed... then it happened *again*. This time there was a sharp jolt... as if the earth sank an inch or two beneath the building. I envisioned the floor to my bedroom collapsing, cursing myself for stubbornly erecting my disastrous glass block and marble bookcase monstrosities. Again, after a moment, it stopped. That night I slept fully clothed with my cigarettes, wallet and keys in my pocket. Shoes and a packed bag by my bed. Worrying if a major earthquake would happen and the electricity went out... *how would I make coffee in the morning?*

Stopped at the porno store the other day because they have some fabulous rubber vests in stock. A packin' butch dyke makes them by hand from used Goodyear tire inner tubes. As I was about to leave in walked dear Paulo (he of zoophile fame) ogling a *new* creation... "The Lion King." A dildo shaped like, yes you guessed it, a lion's genitals. I said, "All right Paulo... how in *hell* did the manufacturer get a mold of a lion's prick?!? Isn't that *dangerous?*" He said, "Well yeeees... but the manufacturer contacted me because a friend of mine works in the San Francisco Zoo. Late one night, he doped up..." "OK, Paulo", I interrupted, "*I get it.*" He caressed the dildo, his eyes got dreamy as he said, "The lions eat their young, you know." He fondled the tip of it and said, "Looks sorta like the tip of a dog's dick... they're pointy like this." He looked at me and said, "I love it when they're just about to mount you... their hot breath on your back... all excited. *Drooling* for you. You know what's unique about sex with a dog?" he asked. "... no," I said in a very small voice. "Their dicks expand inside you so much that if they pull out... they'll rip you apart. Even after they cum... their dicks stay huge and it takes a while for the swelling to go down. You have to hold on and calm them

down before you let them pull out. Otherwise... you'll be needin' a lot of stitches." He cackled madly. I, for once, was completely speechless.

Love, Sal

19 March 1997

Dear Tim:

Spent the day with Pete Sunday... that was it. We met in the morning, went to brunch, then to a movie. He took me home in the afternoon. I was quite ready for him to go... I wanted to be alone... and take a nap. I've still been tired a lot. He sat down on the sofa and looked at me. Quiet. Waiting. Finally he asked, "So... where is this going?" I told him, "I think it's going... nowhere." It's just not there for me anymore.

He left.

A year ago I was battling the same sort of decision. I was trying to choose between rough, crazy, S/M sex with Pete and the type of relationship dear supportive Blake could offer. S/M slavedom won. Today, I've faced the same choice... to go back to Pete and all that the relationship entails... S/M, et al... or the easygoing, loving, calm type of relationship Jon could offer. This time... I'm heading towards the type Jon can offer.

And it does feel over. Oh, yes. Now, *now* I'm missing him again and my head is flooded with images of the wonderful times we had together. Laughter, passion, and deep love for each other. Flashes of sitting next to him in Vegas casinos, exploring the woods in Alaska, walking down Market Street with my arm threaded through his. A *couple*. For the first time in my life, I felt as if I were part of a couple and wasn't terrified of it. I didn't feel stifled by it and looked forward to the time we would live together. I do love him... *still*. I miss my Papa and all the things we did and were going to do together.

Hey!! Max's 2nd birthday was this past weekend and I helped Sher throw a grand party. She rented a playroom at a park district playground and invited forty kids and their parents. It went *magnificently*. I made a huge veggie and hummus platter, which all the dyke moms loved. You know you did a great job when a San Francisco dyke loves your hummus. The playroom was enormous and had every toy imaginable... a jungle gym, toy cars large enough for the little ones to get into, trikes, huge stuffys, and a mini merry-go-round. It was a *blast* and Max was the absolute star.

It's completely amazing to watch the kids relate to each other. Max goes to an alternative, "earthy-crunchy" day-care that encourages the individuality

of the children and boasts vegetarian meals. Max loves tofu with tamari…
yick… can you imagine eating *that* as a kid? Most of the kids went to the same
day-care and a handful went to other ones or had a parent home to take care of
them. The kids from the day-care Max goes to were by far the most advanced
and socialized of the group. They really stuck together and were supportive of
each other… *even at 2 years old!* When it came time for cake and candles
(Sher and I practiced with Max the week before so she'd know what to do)
Sher held Max in her lap as everyone gathered around to sing. It was beautiful.
I looked around at the group of "alternative" families, many dyke and gay-boy
parents, my fellow San Franciscans, singing to the sweetest baby I know… and
my heart swelled. Our voices rose and filled the room. Max's eyes shone. At
the end… when we cheered, Max, who was getting very excited, jumped up
and down in Sher's lap, laughing… then burst into tears, clung to Sher (who
later told me that she almost cried right before Max started to) and sobbed.
Overwhelmed? Overexcited? Before any of the adults could do anything…
five of Max's friends from school, not one of them over three years old, rushed
over to comfort her, saying, "it's OK Max, it's OK." They helped her blow out
the candles. It was just about the sweetest thing I ever saw.

Max has become even more attached to me… whenever I call she
demands to talk to me. Sher tells me when Max is playing she often "includes"
me in her play… talks to me on her play phone, colors pictures for me and
loves the Sesame Street tape I bought her (she calls it "Saltape"). Sometimes, I
feel as if I'm surrounded by angels.

Jon has been delightful to be with but he threw me for a loop last night.
After all his talk about not futurizing he told me he's "falling for me." I didn't
know what to say. I'm not at all ready to jump right into something serious and
I told him so. He calmed me down and said not to worry… he doesn't want to
get *married* or anything… he just wanted to be honest. So, I let go of the
building panic and was able to have a wonderful evening and night with him.
We slept together for the first time. It was comforting. I like how I feel when
I'm with him. It's passionate (sex that night was astounding… I left my body)
but it's a much different passion than Pete and I had between us. If you know
what I mean.

Kirk's being more conscientious about not leaving the gas on and the
door unlocked (thank Christ) but the other day I came home to find the kitchen
flooded and soapsuds pouring out of the dishwasher. Apparently we were out

of dishwashing powder and he used *laundry detergent* instead. I felt as if I'd stepped into an episode of "I Love Lucy."

Love, Sal

22 March 1997

Dear Tim:

I just returned from my doctor's office. I've recently changed drug cocktails because of a rise in my viral load… it went from 100,000 to 300,000 in January. After a month of taking new medications it went back down to 100,000. I was *never* one of the lucky ones who reached undetectable levels… the lowest it's ever been was 28,000 last February. Certainly nothing to sneeze at. The results of the test show my viral load has grown to over *a million* (my t-cells are holding steady at 300). I'm not panicking. I know panicking won't help at all. I'm getting another viral load test to see if, in fact, that *is* where my numbers are. If so, I'll have to change drugs again. I'm certainly willing to do so… I'm just shocked it grew so quickly in only a month and a half. My doctor urged me to take more time off work and I'm probably taking another week. (Yeah, *twist my arm.*) It's odd though… I don't *feel* sick. I'm still a bit fatigued but getting lots of rest and have begun working out again. And getting lots of hugs and snuggles with JonBear. It sure helps.

One thing though. Jon's HIV-negative. In the past I've made it a strict rule *not to date HIV-negative men*. He and I have safe sex, but I'm worried about infecting him. And there *is* the issue of him getting what I call "diseased meat." I've talked to him about my fears and hesitations, to which he listened graciously. And kindly told me, "Get over it… I don't care you're positive!"

But I *do* care. And am trying to get past it.

What also comes into play is the fact that in a partnership if one person is positive and the other is negative, the pair is already at an inequality at the onset. Now, Jon and I are nowhere near this point, but what if he and I were to become lovers… and I were to become sick? It would be understood my lover would be my primary caretaker. If my lover were positive as well, at least there's a 50/50 chance one of us would get sick… leaving the other responsible. Jon's a healthy HIV-negative adult. The chances are much greater I'd be sick before he would. I don't want that inequality pressure on anyone.

A very scary thing happened yesterday morning. I spent Thursday night with Jon and in the morning as I was saying goodbye… I said, "I love you." As

it was tumbling out of my mouth, I thought, "What the *hell* are you saying?!" My jaw dropped open and I looked at him in shock. He smiled and said, "What did you say?" I tried to take it back and said, "uh, nuthin'." He said, "No… what did you say?" I told him again. "I love you." And he said, "I love you too." We talked about how we do love each other and the different kinds of love and both said we weren't "in love" (not yet, anyway) but it's OK to have feelings for each other. He and I are very loving people… I love all my friends (something Pete never understood and was jealous of) so I'm trying not to freak at this new development. Yet… I do think it's a bit soon to be spouting "I love you's."

Love, Sal

29 March 1997

Dear Tim:

Ya know, sometimes it hits me I'm such a *fag*. And *thrilled* about it. No, not the sex thing. It's other moments in one's life when you realize you're a raving homosexual. The other night at Jon's house, in the middle of hot sex, we noticed an A&E TV Special was about to begin… "A Portrait of Judy Garland." We were completely transfixed for two hours. We sat watching it naked on his bed, holding each other and were crying at the end as she sang "Over the Rainbow." I looked at him, laughed and said, "Ohmigod! We are such *huge* fags! How many heterosexual men are holding each other right this minute, weeping over the life story of Judy Garland?" He said, "None of them. The poor souls." Ain't he a peach?

I do struggle with fear about getting close to someone… about getting hurt… fear I'll get too afraid and will bail.

Oh, yes… I got the latest results of my viral load test… it's gone down again to 300,000. Certainly not the greatest but a *helluva* lot better than a million. I'm very much relieved. And I know, *I'm sure* it'll continue to decline.

Last night Jon spent the night… lots of cuddling up to his furry little body. Up, to Easter brunch with friends of mine. Afterward, we went to Collingwood Park where the Sisters of Perpetual Indulgence (drag queens in white face and garish make-up wearing outrageous nun drag) performed an "Easter Service" and recreated the twelve Stations of the Cross. Jon and I were recruited to carry the huge wooden cross down Castro Street to where "Jesus" (in flowing, bloodstained robes, and bright red wig) was waiting. Many passersby stopped to yell at us, "Drag it! *Drag it!!* Don't carry it!!" The final

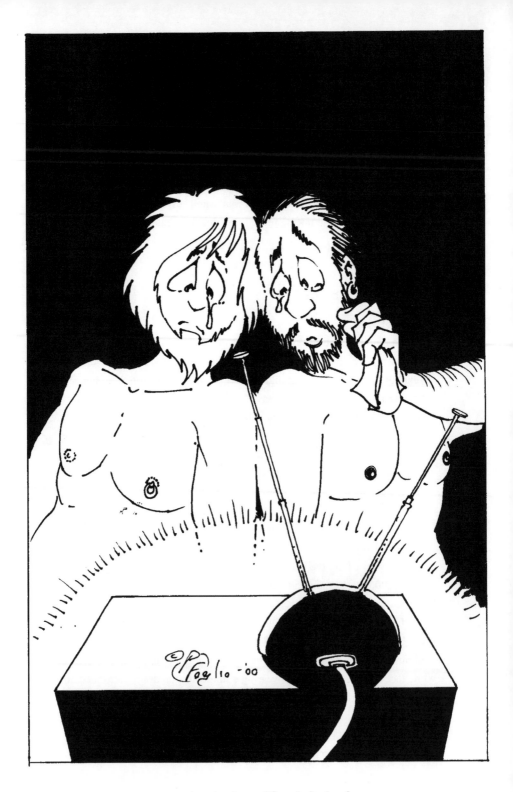

...crying at the end as she sang "Over the Rainbow."

service was held in the middle of 18th Street. Jesus was nailed (actually... he was tied) to the cross. As the congregation pelted him with condoms they screamed, "Our Father! Oh Daddy! Love ya, mean it, *let's do brunch!!*" Then home with gentle Jon to nosh on chocolates from the Easter basket he gave me that morning and to suck his dick while he smoked a cigar. He settled in to read the paper and I napped curled next to him.

I've seen very little of Kirk lately but haven't been too concerned because I knew he was taking a two week massage training intensive at The Body Electric. He had told me classes are from 9:00am - 7:00pm in Berkeley so I figured he hooked up with some other muscledude from class and was staying across the bay because coming home to San Francisco would be too far to travel. I saw Kirk this evening and asked how classes were. Kirk replied that he quit after two days because he "didn't want to become a massage therapist after all" and he's been staying over at this guy's house all week (he had a "torrid affair" with but is now over). I asked if his money would be refunded and he responded, "Oh I don't know... and I really don't care... a friend in San Jose paid for it." How *rude.* Even if he didn't want to become a massage therapist... wouldn't *anyone* in their right mind finish the goddamned training anyway? It was *only* two weeks and they teach a very respected program. Hell, if I knew he was going to dump it, I'd have asked to go in his place. Honestly, I would have *loved* to have the training. I *really* had to bite my tongue when he said, "I'm working hard with my therapist to *not* beat myself up about it. So, I quit... what's the big deal?"

This is none of my fuckin' business. But no one is offering to pay *my* way through massage training. And I'm jealous he has such a clear conscience while being a complete flake. *And* that his therapist seems to be supporting such behavior. The whole "irresponsible California attitude" *unnerves* me.

Well... my glorious three weeks of relaxation, leisure and afternoon naps with Jon are up. Back to work tomorrow morning. What an incredible three weeks they've been. I've ended things with Pete, had a successful surgical procedure, dealt with a health panic, had it resolved. And I've... fallen in love (not that I've told Jon yet) (though I'm sure he knows). And not a crazy, tortured sadistic one this time. But rather a sweet, calm, wonderful one.

Love, Sal

4 April 1997

Dear Tim:

I'm falling in love again. How on earth did this happen? I am *completely* shocked this has happened again. Well, maybe not *so* shocked, I guess.

The other night, our one-month anniversary, Jon and I told each other how much we loved each other. My, oh my, how my heart was beating. It was something I had wanted to say all weekend but kept stopping myself. I did say so a couple weeks ago but that was a quick awkward "slip." And when I said it to him *then* I clumsily stumbled around and made light of it (yet I *did* love him). But now, I'm *in* love with him. And he is with me. Oh, I was scared and cried as he held me and told me how much he loves me... and that he was waiting patiently for me to tell him because he knew I was afraid to say it.

But, so *soon* after Pete?

I reassure myself Jon is a completely different being. Perhaps going through what I did with Pete helped me open up and appreciate what a gift Jon is. Perhaps Jon is here to help me heal the wounds from Pete. Jon is a wonderful, magical man. He is supportive, kind, gentle, treats me with respect and love. I'm very grateful to have him.

A movie is coming out I'm *dying* to see. It's the latest in the series of disaster flicks we seem to be inundated with... "Volcano." The subtitle is "The Coast is Toast." *I can't wait.* Interesting... I'm quite content to have disasters and drama-nightmare portrayed on the screen... rather than in my own life.

And I have to say, once again, San Francisco is not a city. It is a ridiculously, infinitely tiny *village* where everyone has their nose up everyone else's butt. Jon, who's in recovery and goes to AA meetings, knows Kirk. A good friend and old flame of Kirk's is a guy named Carl who happens to own the bookstore next to Pete's office. So Kirk knows Pete and sees him often when he visits Carl. From the beginning, I've had to caution Kirk not talk to Pete about anything I'm doing (which I'm sure Kirk has respected). Jon also knows Carl and sees him at AA meetings. While walking through the Castro with Jon on Easter, he said hello to at least fifteen people who he knows... who *I know* are friends or acquaintances of Pete's. A boy named Larry was hot for Pete and was constantly chasing him, fueling my volatile temper. Jon knows Larry and told me Larry has been chasing him for years. Jon has also had sex with one of Carl's employees. Round and round and round we go...

Forget about six degrees of separation. In San Francisco... it's more like *two*.

Love, Sal

11 April 1997

Dear Tim:

Passion. What is passion? What is the difference between the passion I feel for Jon compared to the passion I felt for Pete?

The high. With Pete the *high* was so great. The intensity. And in its own right, it *was* passionate. The high of S/M sex. The high of sex. The giving, the reaching for a "bonding"... for trust. For the spirituality of S/M sex. I loved Pete and loved sex with him. And loved (mostly) the S/M dynamic of our relationship. It came part and parcel with him and at the time I wanted it. For some reason needed it.

Till it became too much. Until... I couldn't take it, didn't want it anymore. Until I realized he didn't respect me. And now. Oh, and now with Jon. The passion is so, so great at times it feels as if my heart could burst with love, excitement. Passion. Bliss... oh bliss. It's passionate in a completely different way. Worlds away. A touch. An embrace. A look. Means so much. Touches me deeper than any of the things Pete did. Jon touches my *heart* deeper. With a kiss, with a tender caress. Jon brings me to heights (spiritually, emotionally and yes, physically) Pete could never bring me.

I was reaching for a high through S/M sex. And achieved that high. But the highs I feel with Jon are brighter and less "loaded" than those I experienced with Pete. Everything with Pete was "loaded"... with lies, double entendres, deceit. With Jon, honesty and love reigns.

Could I have gotten to the point where I could accept what Jon has to offer if I didn't go through the fire with Pete? By surviving the fire. I was able to come out of it... and be ready open and loving for Jon.

I can't tell you how grateful I am for that.

That's *not* to say S/M sex is invalid. It sure is a *helluva* lot of fun. There must have been *something* in it for me to keep going back to it. I didn't do it just for Pete. Nothing, but *nothing,* is done simply for someone else. I needed Pete to catapult me to a new point. A higher acceptance of my worth. It brought me to the point where I could accept the kind of love Jon offers.

And poor Kirk. He told me the other day, "Hey, I'm gonna have surgery this weekend." Concerned, I asked, "Oh, really... are you OK?" "Oh, yes," he said, "I'm getting liposuction to have some fat removed." I looked at him in shock, swallowing what I *wanted* to say, which was, "You're gonna have fat removed? Where from... between your *ears*?!" He said he's having his "love-

handles" removed. I looked and he does have "love-handles" but fa'crissakes... *he doesn't work*. Why doesn't he do some goddamned sit-ups? He has nothing *else* to fuckin' do. Ah... the life of a bored ex-underwear model on disability.

Love, Sal

30 April 1997

Dear Tim:

Things are progressing along beautifully, amazingly, with Jon. Now I understand what all this fuss about love, what all the poems, songs, movies, novels and plays are about. I understand about love on a much deeper level. Much deeper than I've ever known before.

Being with Jon has shaken up what I know about sex and what I want. I would never, never trade one moment of the loving, passionate caresses from Jon to once again feel the sting of Pete's belt. Never. When Jon and I are together, I feel so wonderful about myself, about him, about us. A kiss from Jon is like floating in loving warm, clear, positive energy. I've never felt so happy with someone.

Husbands. Jon and I decided to call each other husbands. We thought "boyfriends" sounds high school. "Partners" is too businesslike. "Significant Others" is impersonal. So "Husband" seemed to fit. I'm so unafraid... it's odd for me. I'm usually so full of fear about the "commitment" thing.

The differences between Pete and Jon:

Jon and I kiss and cuddle for hours on end.

Pete and I rarely kissed outside of sex.

Jon and I constantly tell each other how much we love each other and how beautiful we think each other is.

Pete and I occasionally said "I love you" and never really mentioned or reinforced how attracted we were to each other.

Jon loves to put hickeys on my neck.

Pete loved to put bitemarks and bruises on my neck, back and ass.

Jon mixes well with my friends and they all adore him.

Everyone despised Pete and hated when I'd (rarely) bring him along.

I'm able to write in my journal with Jon at my side and leave it lying around... not concerned he'd read it.

I never wrote in front of Pete and hid my journal when I brought it along when we traveled.

Jon lightly, gently touches my nipples and I go completely nuts with passion and feel clean about it afterward.

Pete used to bite my nipples hard, hard, hard, leaving them sore and scabby for days. I would go completely nuts with passion, yet feel hurt and resentful afterward.

Jon and I take turns spending the night at each other's apartments.

Pete flatly refused to spend the night at my place.

I had a very strict boundary with Pete... to spend Sunday evening alone. I needed to regroup and pull myself together after being with him all weekend.

My favorite night to spend with Jon is Sunday night to put a lovely cap on the time we spent together over the weekend.

Pete used to piss on me all the time, in various states of dress and undress... from the Alaskan mountains, the Boardwalk in Santa Cruz to the Nevada desert.

I had Jon piss on me in the shower once and we both broke out into laughter.

I loved Pete... yet didn't trust the fuck as far as I could throw him.

I love Jon and I do (as much as I can) trust him.

Pete, unforgettably, unforgivably, didn't know the color of my eyes a full five months after being together.

Jon adores my eyes and tells me they sparkle like emeralds.

Pete used to have me dress in military fatigues and fuck me in them.

Jon bought me a hot *mini-dress* in a military fatigue pattern and loves to fuck me while I wear it.

...and Jon and I are already discussing the "living together" issue. Not right away but it's certainly looking definite in the future.

Love, Sal

19 May 1997

Dear Tim:

It's so damned hot here at the moment. In the 90s the past few days. It's completely awful because, unlike in the Midwest, when it gets hot, one can escape the heat by going to the movies, shopping, whatnot. Most places in San Francisco are *not* air conditioned, including the hospital where I work *and* my gym. And if a place *is* air conditioned... it's really not that effective. So it's completely miserable. I never thought I'd say this but... *where the hell is the coastal fog?* I want a gloomy, foggy, cool afternoon.

I do know I want to be with Jon and my old behaviors simply don't work for me right now. Jeez... all I need to do is look at Kirk who is a living, breathing, incredible lesson for me right now. Kirk goes through a "boyfriend" a week (I don't even bother to memorize their names anymore... I simply call them all "Greg"), he tricks out all the time and spends an inordinate amount of time in AOL chat rooms hunting up new meat. Kirk's neither happy nor satisfied in his quest for "love." Perhaps I just need to look at Kirk to see what I've let go of and realize it's by far the best lifestyle choice for me.

Jon and I have been talking about living together possibilities. One option would be to give Kirk notice (at least a month and a half) and have Jon move in with me. Ultimately we want a home together and for me this apartment could never quite constitute a "home." There's no outside space and it's *way* too sterile, so we're keeping our ears open for available apartments. I want a garden space and Jon wants something with a fabulous kitchen... he loves to cook (which is perfect 'cause I hate to cook but love to clean). I'm really looking forward to having a home... none of the places I've lived in San Francisco have had that feeling yet. I may get my garden after all.

Love, Sal

31 May 1997

Dear Tim:

Between seeing Jon and keeping up with the various interesting characters in my life it's been difficult to sit down and put thoughts to keys, as it were. That and the fact I work full time, am about to begin an acting workshop, attend Qi Gong classes twice a week, see a therapist, and take care of the numerous errands one needs to accomplish. I'm just trying to fit everything in. How I wish I didn't need to frikkin' work... who has the time?

On Memorial Day, Sher, Max, Jon and I went to Golden Gate Park to take Max on the carousel and romp in the playground. It's actually turning out to be a comfortable situation. Sher and Jon get along well (it's like watching two "straight guys" being buddy-buddy). It was a complete blast running through the playground sand, pushing Max on the swings and climbing around on the jungle gym with her. Jon loves her as well and afterward... looked at me with big "puppy-dog" eyes and told me he has a dream of being a father. I said, "Uh. OK. I'm sorry but I *don't*. No *way*. I'm way too selfish." He knew that, of course, which is why he never brought it up before. He's thinking of going back to school to get a teaching certificate and teach grade school.

Perfect. I absolutely support that. He can take care of his parental urges *there*. I adore kids… adore Max… but I know there is *no* way I'm gonna co-parent.

Other than those minor things everything's going along quite nicely. Oh yeah… except for this ridiculous, outrageous, mind-boggling drama…

Jon and I decided for him to move into my apartment August 1. We're very excited about it… we're ready and anxious to share a space. We spend every night together, so it'll be a helluva lot easier for us to live together. Besides, I'm tired of living out of a carry-on bag. I'm too old and settled to play "sleep over" every night. The only difficulty I could foresee would be Kirk… whom I told on Tuesday. I stressed to him it was nothing at all personal but I loved Jon very much and wanted to live with him. Jon's tiny studio is out of the question and I have a lease here till February. Kirk looked crushed and said, "I have to think about this for awhile." (What's to think about? Get *out*.) I felt badly but I gave him plenty of notice and did it in as nice a way as I knew how. Well, I guess no matter *how* I say it… I'm still telling him to get the hell out. Anyway, Kirk did not take me approaching him to move out well. At all. I had told him on Tuesday night I wanted Jon to move in on August 1, giving Kirk two months to find a new apartment. He refused to speak to me about it. I thought, "Well, of course he's upset… I'd be too… but he'll get over it." When I left him a note on Wednesday, asking for June's rent and May's bills… he sent me the following email (a fucking *email*) on Thursday…

> *Subj:* *rent*
> *Date:* *97-05-29 15:07:32 EDT*
> *From:* *SFhungmodel*
> *To:* *Sal*
> *Sal*
>
> *i am angry about you making me move out after only 4 mos. you gave me two months notice and i appreciate it, and I'll find a place that suits me. use the security deposit I paid you for june. that way if suddennly something becomes available i can put a deposit down right away. i am sorry if this is an invonvinence. but i am more inconvinenced than you, the way the situation is with apartments right now. i will pay for july if i can't find a place.*
> *Kirk*

What? After talking it over with some people (Ben, Jon, my boss Irl… who happens to be an ex-lawyer), I decided to tell him (in person… not e-mail), again… he is welcome to stay till August 1… but if he chooses to do so… he must pay for June's rent, and I'd apply his last month's rent to July. The way *he* has it, I could quite possibly be stuck for two months' rent (June and July). Jon could move in on July 1 or August 1, but needs to give his building manager notice, so I told Kirk he has to decide when he leaves. I told him if he refuses to pay June's rent I'd consider it his one-month notice and expect him to leave by July 1. Otherwise I would be stuck with July's rent as well if he left at the end of June not giving Jon enough time to give notice at his apartment. I thought if I approached him calmly and reasonably, he'd be OK with everything. Kirk flatly refused. Wouldn't hear me when I said that in giving him two months' notice, I was being more than fair. He was furiously angry and said he simply *won't* leave. *Won't leave.* And if I give him one month's notice for not paying June's rent, I'll have to evict him. *Evicted.* He said he'd have no problem making this as ugly as possible and dragging this out for as long as he could.

Roommates… bloody*fuck.*

I went to an agency on Friday called The Tenant's Board… a nonprofit organization dedicated to offering legal advice to people in San Francisco who have questions and issues regarding renting, landlord harassment, evictions and unfair rent increases. Hallelujah… an organization in this city that makes sense. (The place is a trip and deserves a whole letter in itself.) Basically, they told me I could evict him for nonpayment of rent. It would be a pain in the ass and would take between six to eight weeks… but I would certainly win the case.

That day, Sher happened to bring Max to work. When I saw Max I had conflicting emotions. First off, I was thrilled (as always) to see her and she was overjoyed to see me. Then was torn because I needed (wanted) to spend all my energy dealing and obsessing over this fucked issue. It turned out to be perfect because Max insisted on sitting with me on my lap and cuddling against me. It was exactly what I needed to pull me from the racing, frantic thoughts in my head. Max (*a two-year-old*) turned out to be the calming force, the turning point in my whole outlook on the situation. I held her for about an hour and carried her around the hospital doing errands. We calmly ate lunch together and then she took a nap.

I went through the available options. Should I proceed with eviction? Should I let it go and allow Kirk his way? Should I break my lease, put my stuff in storage and move in with Jon to his tiny studio apartment? On one hand I thought… fine… let Kirk have his way. It would cause less stress in my life, he would get out, and the only thing I'd lose is money. I thought it would be the most "spiritually evolved" thing to do. Then my thoughts would flip-flop. I would get *livid* at the thought of Kirk stubbornly, childishly, unfairly trying to screw me and I would decide to go after him with a Sicilian vengeance. How *dare* that overblown, puffed-up, manipulative, pathetic, ex-underwear-model bastard try to do this? *Fuck* being "spiritually evolved"… *I'm not leaving this apartment.*

I finally decided, not out of anger and revenge, but out of sticking to what I think is right (and to stand up for myself), I would, as adultly and as calmly as possible, evict him. I decided in a very calm, strong place I was completely in the right and I could not live with the thought of allowing myself to be screwed like that.

I came home with a "3 day notice" letter to begin the eviction proceedings (under the advisement of the counselor I saw) and found *Kirk had left me a check for June's rent and May's utilities…* completely diffusing the entire episode. I was overcome with relief and sat on the floor laughing hysterically. I immediately ran to his bank and cashed the check.

Oy.

Well then. With that done… back to my calm life. (Please and *thank you*.) Jon's participating in the California AIDS ride and will be gone for a week. I'm gonna miss him like a sonovabitch.

All is well on the lovely West Coast.

Love, Sal

9 June 1997

Dear Tim:

I missed my dear Jonny a lot while he was gone. It was difficult drifting off to sleep. A few days before he left he confessed he was having a difficult time not "acting out" and having sex with others. It hadn't happened but he was afraid it might because he had been so tempted. I told him if it happened I'd understand but I'd really rather he didn't. Especially since he was about to go on the AIDS ride for a week, spending the night sleeping in a tent… along

with *3000* other gay men. Well, he promised he loves me with all his heart and he wouldn't. Yet... by Monday (he left early Sunday morning), I was convinced not only was he fucking every hot man in sight but he had fallen in love with someone and didn't love me any longer. He hadn't called by that night (it shouldn't have been a surprise... there are only two or three phones available for over 3000 people) and my mind was just going wild. (Oh, Christ... my crazy head... makeitstop) By Tuesday night, I was convinced when I met him in LA on Saturday, he would tell me it was over. Jon called me that night to say he was having a miserable time (oh, hoo-rah!) (I mean... oh, too bad!). He said he's been worked to death twelve hours a day, he was completely exhausted and missed me with all his heart. *Alleluia.* I shamefully confessed what I was thinking and he reassured me as best he could. I was relieved and afterward felt so foolish. I went completely over the top and was convinced of all kinds of untruths... things that were all in my head. Well... I guess this *is* a pretty new relationship but the boundless insecurity that came up was overwhelming.

Went to LA on Saturday to meet Jon at the end of the AIDS ride. The song really rings true, *"LA is a great big freeway... "* I wasn't there long enough to get a good feel of it but on first impression... I wasn't that dammed impressed. Some of LA was pretty... there's lots more trees and flowers but it seems a bit harsher (in a weird Californian way) than San Francisco. Everyone was pretty (or trying a bit too hard to be) and was carrying a cell phone. Blick. I missed Jon immensely and was so looking forward to seeing him. Jon had asked me to meet him at four o'clock at the end of the ride. Masses and crowds of people, fuckin' Enya blaring from loudspeakers... it took two hours to spot him. Two hours in a loud, California crowd with my heart in my throat waiting for a glimpse of my beloved. Ran to him and jumped to his arms.

The insanity saga with Kirk continues. And hopefully will be over soon. Jesus H. Christ in a slinky red dress. Did I really think it was resolved? Kirk left a message on my voice mail while I was in LA. He had found an apartment, needed to put down a deposit and asked me for the rent check back. Hello... *what planet are you from?*

I didn't return his call and when I got home, I told him I checked into it legally and didn't owe him the money. He completely lost it. Crying hysterically, swearing, slamming doors, promising to make my life "a living hell," refusing to talk about it and slammed himself into his room. I calmly thought... wellnow and gollygee. Is this worth it? Can $500 possibly be worth him being a huge negative energy in my home? Besides which he could smash

my computer, trash the place… on and on. Nope. Not worth it. I wrote him a check.

Love, Sal

21 June 1997

A few hours after the blowout on Monday night and after Kirk got his money back, he left a pile of my mail on the kitchen table. Apparently, he was holding it hostage. Isn't *that* nice? Spent part of Tuesday going to the post office to have my mail temporarily forwarded to where I work for the duration of the time Kirk and I will be under the same roof. Why take chances? Then went to a hardware store to purchase a lock for my bedroom door (and economically, when he finally, finally departs, I can transfer it to my front door.) It made me feel better to take actual physical steps toward protecting myself but I still feel very upset and angry to be put in this position. I dealt with huge anger that day. I also went to the corner store, the "Psychic Eye," to purchase some candles and smudge. Jeez… I'd rather there was a goddammed 7-11 in the neighborhood. The place is kinda high-priced Californian… how can you put a price tag on spiritual protection?

Been in a funky mood most of last weekend. Part of it is because of this fucked situation at home and part is because the last two times I spent the night at Jon's apartment… something bit the hell out of me and I got an allergic reaction. The area around the bites swelled up comically. One on my hand caused it to swell up like a balloon. It's been excruciatingly uncomfortable… irritated and itchy. Called my doctor who prescribed Benadryl, an antibiotic and ice packs to reduce the swelling. Jon, who tends to be overly concerned about these things, insisted I go to the emergency room. "No, thanks… it's a minor allergic reaction, babe… relax, OK? Here, take an antidepressant." What I find frustrating is I don't feel completely safe here (yet, Jon and I insist on keeping to our schedule of every other night in my apartment to show Kirk we're not intimidated). I love being at Jon's apartment because it feels as if it's a safe haven. But, now… even that's taken away. Well, bull*shit*. This is something I can definitely do something about. *Immediately.* I bought bug-bombs and we're about to go there and set them off. Sorry Mother Nature… I need my safe haven back.

Ya know, I can be pretty dammed insensitive. Jon, who is HIV-negative, gets very emotional over the subject of AIDS. When I met him at the end of the AIDS ride (which happened to be near a snappy shopping mall) (which LA

seems mostly comprised of), he asked me, "Did you *see* the closing ceremonies? They were so beautiful and inspiring!" I said, "AIDS, *schmAIDS. No*, I didn't see them. I was shopping for shoes at Macy's." Gratefully, Jon understands. He laughed and said, "Bitter! Party of one!" That evening in LA, we went to dinner with a group of others who did the AIDS ride with Jon. The city was crawling with them and many stopped by our table to say hello. When I was introduced as Jon's partner, they invariably asked me accusatorily, "You *flew* down here? Why didn't *you* participate?" My deadpanned response was, "I *did* my part. I *have* AIDS."

The other day he was getting all shaken up over a TV special on AIDS. During the commercial break he looked over at me with tears in his eyes. I looked at him and *á la* Cher in *Moonstruck* said, "Oh, snap out of it! I ain't going anywhere, so stop worrying." Well, I do kinda like it. If *he* gets all emotional and upset over AIDS (mine and the world's) that leaves me free to not care so much. Ooo-*honey*... am I a burned-out old hag, or *what*?

The other night, Jon and I went to dinner with Sher and Max. Jon adores her and started making "puppy-dog" eyes again. He does so want to be a father. I reeeeeeeally wish I were on the same page as he on this issue but I'm *not*. Well, I'll just make sure we see Max more often. And support him in going back to school to become a teacher. I do think Jon hasn't given nearly enough thought about going into parenthood... I don't think he's thought about any of the details, not to mention the big stuff (like *money*. The man doesn't even have a steady job). I suspect he has a romantic idea of it. And how was he thinking of doing it? He's friends with a lesbian couple who want to co-parent with two gay men. I think that makes things outrageously complicated. Just think how fucked up we turn out absorbing two parents' idiosyncrasies... not to mention *four*. Maybe I should arrange to take Max for a week or so... a week of sleep deprivation should shake the parenting bug right the hell out of him. I doubt Sher would go for it, but maybe for an overnight...

Love, Sal

3 August 1997

Dear Tim:

Ah... how things have changed. Kirk's gone, gone, gone. It was bearable the remaining time he was here. He pretty much shut himself in his room and made himself scarce. In his usual fashion, he waited till the last minute to pack

and did most of it the night before he was leaving. At 5:00am I heard a tremendous crash and flew out of bed. I found him lying prone at the bottom of the stairs covered in dirt. Apparently, he was carrying a heavy plant down and tripped. *Poor dear.*

I spent the weekend of his departure cleaning, smudging and painting... getting things ready for Jon and me. It's been *bliss* here with Kirk gone... what a tremendous relief to have him out of my life. Jon moved in last weekend. It had been great fun having Jon slowly bringing over stuff, but I've gotten a chance to see how completely anal retentive I can be. Everything has to be "in place" immediately. All my "neat freak/control freak" issues have raged to the surface. I've always been kind of obsessive that way. It stems from my childhood where I tried to control my environment so much because life seemed so topsy-turvy. Well, Jon understands and lets me do what I "need" to but he does urge me to slow down and relax at times... which I do. Also... I have a difficult time with all the "stuff" he has. Over the past few years, I've tried to weed out a lot of the physical (and emotional) crap I've been carrying around. I've enjoyed a rather "sparse" look in my apartment. Well, sparse for *me* anyway. Jon on the other hand has boxes and boxes of kitsch, and tchotchkes, and *crap*. He collects *obituaries* for cris'sakes. Boxes of clippings of *obituaries*. It's making me a bit tense. Until I realize... it really doesn't matter. And I'll hide 'em somewhere. Well... he's in and I'm surprisingly nonplussed. This is the first time I've lived with a partner/lover/husband in eighteen years (half my life) and it's great... I don't feel threatened, scared, freaked out.

I *am* concerned because shortly before Jon moved in, he quit his new job as a nurse practitioner at a health clinic. He hated it so much, I guess it was the healthy thing for him to do. He told me he'd sign up with temp agencies till he decides what he wants to do. I'm worried about money and hope he gets a real job soon because I can't afford to support us both.

Oh yeah... Pete ran for the SF Leather Bear title this year and won. He is San Francisco Leather Bear XX. Whoopee. So... he's finally a Sash-Queen. I noticed from the picture in the paper he did *not* have an adoring boy-slave at his feet as he won the title. To think... it could have been me. He sent me an email the other day and proudly signed it, "Pete Dickenson, SFLBXX." I asked him if he now signs his checks that way. The *putz*.

Something interesting is happening... Sher applied for nursing school in Connecticut (Yale) but is being *very* secretive about it. The only reason I know

is because Irl (our boss) swore me to secrecy… then told me. I do hope she gets accepted… it would be great for her… *and* I'd really like her job, which is *much* more interesting and better paying. *But*… but but but. The Maxter, of course, would go. Which would be so, so sad. The latest news is she was accepted but applied too late so she's slated to go next year. She's on the waiting list for this year… so there's a chance she might, at the last minute, get in. If she does… she's gonna go.

Having a bit of a struggle with my health again. Again, again, *again*. My viral load has been creeping up… it's gone up to 200,000… although my cd4s went up as well… from 290 to 410. What*ever*. My viral load shows that the virus is once again busily replicating so I've had to switch medications to slam it down. Unfortunately, I've burned through most of the available options and have had to go back on AZT. It hasn't been *too* bad, but I've been feeling quite fatigued. Well… it's only been a week and I'm banking on the fact my body will adjust and new, less toxic medications will soon be available.

Love, Sal

1 October 1997

Dear Tim:

Yeah. It's been a while since I've written… hold on to your hat. *Newsflash.* Yale called Sher with an opening in the program *this* year and she accepted. She left in two weeks… with Max. My little angel. I miss my little one so much. So, so much. She's been wonderful to have in my life and I fear the huge void that will be left now that she's gone. Perhaps it's unfair to put such burden on a baby, but she really brought out many magical feelings, emotions in me. She's taught me a tremendous amount and to think of her not being here is terribly, terribly sad. The evening I said goodbye weighs heavily on me. I went to Sher's apartment to watch and entertain Max while she packed. Max entertained *me* was more like it… Max loves to sit in my lap with a storybook and "read" to me. It's sort of half gibberish and "plots" she fabricates from the pictures… but… much of the time, she makes sense. Sher and I tried to explain to her they were moving away, and she wouldn't be able to see me often. I think Max understood because when I left, she refused to hug me and say goodbye… it was almost as if she were thinking if she *didn't* say goodbye to me… it wouldn't happen. Sher told me the next day Max cried

and cried after I left. I did as well… and felt emptier then I did when I broke up with Pete.

And now… Sher's job is open and I want it. Will I get it? Probably. I'm already doing *most* of it… in addition to my old duties. It's a better, more interesting job at better pay (which is a relief… things are tight) (*thanks*, Jon). But… it's at a time when I really don't want a job taking away from my downtime… from my personal life. Yet… I felt I did want (and need) to take this position. That is, *if* it were offered.

Jon's looking for a job… and is trying to get a position at the daycare/ school Max went to. He's doing temp work right now. It's also why we're feeling a pinch. I've been shouldering all the bills (except rent). It would be great if it works out. Jon loves kids (that "Father/ Parent" thing) and he and Max really hit it off. Before Max and Sher left, Jon and I went to visit. The four of us went to the library, where Max sat Jon and I down to "read" to us. Max wouldn't let Sher near us… telling Sher… "Go away Mommy, these are *my* friends."

Things were good with Jon… for awhile. Then I started to have a lack of interest in sex. I attributed it to being so wiped out. As I wrote before, I've switched medications and am now on AZT. Since I started it, I've had a marked decrease in energy. I'm *so* apathetic at times. And it's difficult to get through the day without a nap. It finally got better and I was taking great pains to *not* push myself too hard. But still, my lack of interest in sex was worrisome. Jon understood and was supportive but I feared I'd never be "into it" again. Oh, yeah… my mind certainly works in absolutes, eh? Well, it was a temporary thing and I thought my body was already adjusting. It's the loss of… control I hate. Not being able to do *everything* I want to. Not being able to be myself.

Then things started getting uncomfortable with Jon. What am I frightened of with him? I'm not sure. Unlike other relationships I've been in (certainly with Pete) I don't feel as if I would lose it or Jon would leave me. I know he does love me and would stick by me… if I wanted him to. I don't think it's a question of "quitting before I get fired." And I do trust Jon more than I had trusted Pete. No problem there. Frightened of "intimacy"? I was fine with the intimacy for a while… then it started to feel "squirmy" for me. This relationship with Jon has lasted past the point it had with others. But, as I mentioned in letters past, I do have a pretty poor track record. Six months

going on seven is about twice as long as my relationships last. So, what is it about?

Jon's lack of drive. I'm resentful at having to cover him financially because he can't. And I'm resentful Jon seems "fine" with it. And sex. I've lost my attraction and I don't want to be sexual with him. He raised (very sweetly) the fact he'd be willing to "expand our sexual boundaries." Meaning, we should try to get into "kink" more. But I'm not interested in that with him, it would feel false. He also suggested we open the relationship and have sex with others. Well, I *do* want to have sex with others… but I know it would in no way serve as a catalyst to get closer to Jon. He said we could be "monogamous in our hearts" but that's not it for me. I'd rather just be sexual with him… but I don't feel it. At all.

What I do struggle with is Jon's lack of "oomph." He's been in a job transition since I've known him. Yes… as he pointed out to me… I knew about it from the start. It's difficult for me to be with someone who has no direction. Someone who doesn't have my drive. I know it's unfair to expect *him* to meet *my* standards… but the fact he's so unmotivated makes me think, "Didn't I realize that before?" If I did, I know it would have been a signal bell.

I felt awful about this. I do love Jon. He's a lovely, warmhearted, gentle, sweet and loving man. The fact I'm causing this turns my stomach.

I know Jon has struggled with this and I've been very uncommunicative. One evening he sat me down with a list of his "needs and desires" as I was sitting on the sofa, sorta dozing. It was 10:00pm, we had both gone our separate ways that evening, it was the first opportunity to talk and I was very tired. I was in no space to deal with him and he came at me in a barrage… which completely overwhelmed me. I tried to be as kind as possible… but I know he saw me as being cold, aloof, uncaring.

He called the next day at work (with his "Drama-Queen" energy) (yikes… *two* Drama-Queens in this tiny apartment) and told me he couldn't take it anymore and was leaving that night, to stay with friends. Then called right back to apologize. His seesaw, flip-flopping emotions are too much. I, at least, am solid in my indifference. (I am *such* a cunt). I feel as if I need space right now and the pressure of him insisting I deal with things was pushing me over the edge. If I'm a yellowchickenshitbastard who doesn't want to evolve and have a real relationship… then so be it.

We're going to try to talk things out tonight.

Love, Sal

15 October 1997

Dear Tim:

Here we go. Ah, life. Our talk didn't go well.

Jon packed up to spend some time with friends. Two days? Two weeks? He couldn't say. He did seem to be in a better space.

Ironically, from our talk that evening, what hurt him most was when I told him his anger frightened and threatened me. Throughout his dealing with what's been going on between us, he gotten very angry at times (has slammed doors, stomped off). I'm fairly sure he wouldn't strike out at me, but the outpouring of anger made me feel very uneasy because he seems to be "out of control" with his emotions. And also… I have a history of abuse as a child, not to *mention* the whole Pete episode. Anyway, he was offended by my fear that he'd hurt me. I tried to explain it was more about me than him.

He did admit to "battering" me emotionally and mentally… and that's just what it felt like. As much as I didn't want to… I would "cave" and avoid emotional contact with him… which would propel him to more frantic, insistent measures to "get at" me. I was very relieved he's decided to go for awhile. I'm exhausted. From everything.

I called Jon the next day… mostly because I felt I "had to." Jon was thinking of ways for us to get back together, and I was worrying about whether or not I could find a decent apartment. We talked briefly and he was resigned as he asked, "So, is it over between us?" I told him, "Yes, I think so." He wasn't hurt, angry, upset, he simply said he misses me… as a friend. He told me he's never had a friend like me before… which kinda shocked me… he with his high 12-step tradition had never opened up to anyone as much as he has to me. He asked about our living situation and said he simply cannot afford to get his own apartment and move right now. And that's quite true. So he came back from his stay at his friend's house and we're sitting down to talk… about us being roommates. Well. *That's* gonna be interesting. Truthfully, I do feel a tad (and did you ever wonder just how much a *"tad"* is?) resentful. I want to live alone… yet here I am, again, asked to be in a situation where I'm helping him financially.

I've gone out there again to clubs 'n' other sex venues. Hot sex. With many. Well, a *handful* anyway… hey, it hasn't been that long. I have to admit to relishing in "no strings attached" sex. It's quick, easy and gratifying. For now. Actually, the ease in which I've delved into that particular arena again is rather frightening to me. But not frightening enough to keep me from doing it.

Ben and I went to a "Sexual Carnival" held at a local sex-club. A sexual plethora of sex act demonstrations… from vanilla to kink. Ben, who's ending his stint as a leather bar manager to work in the glamorous, exciting world of AIDS care with me, recruited me as a volunteer. I watched as a masseur gave an "erotic teasing" massage demonstration. He tickled his client with feathers, stimulated him with low voltage electricity, dribbled hot wax over his back and buttocks, then cooled him with ice chips.

Went into the "Glamorama Palace" where a hot dominatrix and her "boy" (who had everything but his eyeball pierced and had long, greasy black Jesus-like hair) fitted me into a black and cream-colored rubber corset. As they laced up the back, the boy slipped off my underwear (a bright circus-colored pink, green and orange pair) (it was a *carnival*, after all) and rubbed his rock hard dick against my butt-crack, moaning in unrestrained lust at my constrained, ridiculously small waist… they brought me down to 22 inches. I almost fainted from the pressure, lack of oxygen and the BO stench of the "boy." After showing off throughout the club… I went back to the Dom for freedom. The "boy" insisted on undoing me. I turned my back to him and to my shock, he merely tightened it… causing me to swoon into his big, manly (reeking) arms. I croaked, "enough." The Dom saw what was happening, admonished the "boy" and turned me loose. She made sure I was all right, then turned to give her "boy" a swift kick in the ass.

Went to watch a "temporary piercing" demonstration. I recognized many leathermen and some stared at me questioningly… trying to place me? Remembering who I was? But few spoke to me. Daddy Mike (a hot daddymaster I drooled over during my Pete days) had his boy stretched out on a mat and was pushing large needles into the skin of his chest. Mike would then flick at the needles… to his boy's delight (and *pain*, of course).

Then to the "Psychic Palace" where people were offering tarot card reading, palm readings and… penis readings. Yes, that's right, *penis* readings. How could I pass *that* up? I sat down, hauled out my equipment, and nestled my dick and balls in the "psychic's" hand as he gave me a reading. He was quite good. *I guess*. He told me I'm extremely strong willed, am going through a transition right now and have extensive trust issues. He also said I'm going through very intense job/creativity issues and I should definitely concentrate as much as I can on creative opportunities. He went on to tell me to drink lots of juice because I was about to get a cold. The cold pounced on me that night… stuffy head, sore throat, et al.

Then listened to an erotic reading by Scott O'Hara, a very big (in more ways than one, my dear) porn star (who has been battling AIDS and lymphoma the past four years). Scott has turned his energies toward writing, publishing and activism. Ben knows him and introduced us. He's very likable, down to earth and wise. And he's from the Midwest. No surprise there.

All in all, a well-rounded San Francisco Sunday afternoon.

Love, Sal

25 October 1997

Dear Tim:

It's official... I was offered Sher's old job. I'm thrilled because I have a lot more contact with our patients... and have the opportunity to learn more about upcoming treatments... which may come in handy for myself.

This "roommate" thing with Jon is getting to be a pain in the *ass*. Last evening, we got into a tiff. We were watching TV side by side on the sofa while he was eating dinner. He swallowed wrong and began to choke, gasp for breath and pound his chest. I calmly took a deep drag on my cigarette and exhaled smoke at him. "You OK, babe?" I asked nonchalantly. (*That'll* teach him to get on my nerves.) The choking fit passed. *Damn.*

The next morning, he was crying in his bedroom with the door wide open. I was rushing off to work... and didn't stop to comfort him. It simply felt too awkward. He called me that morning at work to say he couldn't stay in the apartment with me and he was going to move out. I was very busy and in exasperation said, "*Fine.* You *know* I'm busy... *don't* call me with bombs like that." We decided to talk that night. He went through big changes through the day, and realized he was doing everything he could to "hold on" to me. He realized finally, it's over and he was OK with it. And asked if it would be all right for him to stay. So he *is* staying after all. I called him on being a drama-queen and he just can't do that anymore. He agreed and again, we're doing the "roommate" thing. *But...* when the lease is up, I plan to find a nice studio. In this ridiculously overcrowded, insanely expensive city that has a .5% apartment vacancy rate.

The furious, relentless, brutal cold of winter is something I definitely do *not* miss about Chicago. What I do miss about the Midwest is the brilliant colors and fragrant smells of fall. The eternal, weird, rarely varying "seasons"

of the Bay Area lack the dramatic change of summer to autumn. Go for a walk, stroll through some leaves and think of me.

Love, Sal

2 November 1997

Dear Tim:

I've been rather, shall we say, *busy…* penis-wise. Though I must admit, something's missing now. Vertical sex in dark places with a hot (and sometimes *not* so hot) stranger simply isn't as… exciting, satisfying, as much *fun* as it used to be. In fact, it's rather boring. I think I've been hunting up sexual adventure because I feel it's the "thing to do." I recently broke up with a partner so, in my head, the old tapes are saying, "Now you need to go out, have a lot of anonymous sexual encounters to make up for the lost time you spent in a cloying monogamous relationship." This type of behavior used to keep me occupied for months… if not *years*. Not now. It's gotten stale fairly quickly. But, *dammit.* What *else* is there to do when nothing's on TV?

There *is* something I find I'm starting to miss though. The curling up safely in bed with someone. Not even the sex part. I miss the sharing of warmth… closeness… *tenderness*. Vertical, fast-food sex can be outrageous, wild and intense. But what I'm yearning for is good ol' snuggling up to someone's back.

Jon began bringing boxes home this week. He decided to move back to LA and is leaving on December 1st. Ahhhhh… so now what? I've got a $1,000 a month, two-bedroom apartment on my hands to dump or find a roommate for. *Soon.* Guess I better get crackin'.

He thoroughly pissed me off the other evening… and confessed to me he's been tempted to read my journal. *My journal.* He said he *hadn't* but was tempted and would I please hide it. I'm *infuriated*. I know he told me about it to "safeguard" against him actually doing it and to "be honest." But it makes me feel so… *trapped*. And furious to have to hide my journal in my own fuckin' apartment.

It's a completely gorgeous day… 75 degrees, bright blue cloudless skies. I'm heading to my favorite spot in Golden Gate Park.

Love, Sal

10 November 1997

Dear Tim:

Where was I? Oh, *yes*…. Golden Gate Park. Spent hours walking, looking at trees, visiting my favorite spots, and practicing Qi Gong exercises in the bright sun. Avoiding the scores of tourists basking in the glory of Northern California enjoying a 75-degree day in November. No problem… the tourists usually congregate in the museum and "pissy" flower garden areas. I like to frequent more secluded haunts in the park. It was lovely and peaceful. I visited Stowe Lake… a place Sher and I took the Maxter occasionally for boat rides. Cried a bit, remembering and missing the little one. Remembering how she loved to toss pieces of bread we'd bring to the gulls and ducks in the pond. Remembering how she thought it was hilarious I was so freaked out by the huge scavenging gulls (which I called flying rats). Visited the place where the three of us planted a little evergreen tree (leftover from last Christmas) and remembered how adorably curious and concerned she was when we planted it. I actually walked the length of the park that afternoon, which is about four miles or so. Ended up at the ocean beating the bushes by "Queen Wilhelmina's Tulip Patch" where, as per usual, scores of queers were shaking their wienies hoping to attract prospective sex partners. Had quick, furtive, hot sex with two different GrampaDads. Furtive because we were hoping the families hanging out in the adjacent football field wouldn't, at that exact moment, decide to cut through the bushes to get to the parking lot on the other side. *Yawn.* Well… it's cheaper than going to sex-clubs and forking over $10 for the dubious privilege of wandering around for hours in a filthy, dank, firetrap looking for penile gratification. Besides, I was out in the fresh ocean air, amongst the trees and bushes. What could be more "natural"? And more importantly, I could *smoke*. Which one *can't* do in a sex-club. *Sure*… have all the anonymous encounters you want… but just don't smoke. Who *makes* these rules? *Stupid* California.

Anyway, it was away from Jonny's (I've nicknamed him "Mopey") frantic packing and hangdog face. How, how, *how* can I go from utter love, devotion and lust to utter disdain so quickly? Oh, honey… *watch your back.* Which reminds me. I went to the Halloween celebration in the Castro. As always, it was the predictable zoo. Multitudes of drag queens, outrageous costumes and hysteria. I dressed as a "street disaster." I fashioned a fake orange "traffic-cone" out of poster-board and wore it as a hat. Added black

clothing, black grease paint on my face, festooned myself with yellow and black "Caution" construction tape, and wore a "No Parking" sign on my back. Given the disastrous relationships I've had this past year I thought it was an appropriate costume.

Um, well… I'm doing something a bit risky. What? Me? Little ol' "always play safe with your life" me? As I've written, I've had to go back on AZT in August. My viral load was rising and I needed to switch drugs again… I've gone through the others already and the only option available was to go back on AZT. The good thing is it lowered my viral load considerably. But… it saps my strength and it's taken a long while to feel at least halfway normal again. I told my doctor I consented to going back on AZT for a short time until the next new drug ("1592") becomes available. It's so new it hasn't even been named yet… it's still a number. The results have been remarkable… and there are few of the toxic, exhausting side effects one experiences with AZT. It's not available on the market and in pharmacies yet… only through "expanded access" programs through one's private doctor for people who have run out of drug options. My doctor told me if I went on AZT for a few months, she could get me 1592. So be it. Well, 1592 is now available. Hoorah. The fuckin' thing is… my blood counts are so good… it disqualifies me from getting the motherfuckin' drug. That's not my doctor's rule (I think she'd get me *heroin* if she thought I needed it… bless her heart) it's the drug company's rule. I spent two weeks struggling with frustration and anger after my doctor gave me the news I can't have 1592 thinking, "Sal, just be grateful you're doing so well." But to what cost? AZT still caused me fatigue. It was difficult to get through the day without a nap and I felt so lethargic all the time. I do get enough sleep at night… sometimes up to ten hours so it isn't a "not sleeping" issue. I decided enough is enough. I stopped taking AZT. Without telling my doctor. I figured, "If my counts stay the way they are, great, I'll be fine. *But*, if my counts *do* go back up… she'll think I'm failing on AZT and I qualify for 1592." I do, by the way, continue to take my other meds… I'm being a tad risky… but I ain't a fool. It's been two weeks since I've stopped taking AZT and the difference in my energy level is remarkable… I feel so much better. The grinding fatigue that's plagued me over the past three months has dissipated. I feel stronger, more awake, my workouts are easier and more enjoyable. My day, *my life* is more enjoyable. It's marvelous to feel so alive again.

Love, Sal

18 November 1997

Dearest Tim:

Yeah, well... I've decided to stay in this apartment and find a roommate... after waxing poetic about living alone. With the apartment situation the way it is... it's absurd to let go of the sweet deal I have to struggle to find an apartment and end up paying through the nose. I went to see two studios available in the neighborhood. When I called one of them for information, the voice mail message said, "The studio apartment is available for $800 a month and will be shown on Sunday evening from 6:00pm to 6:15pm. There are *no* appointments for viewing. Please show up with your apartment resume in hand." *Apartment resume?* What the *fuck* are they *talking* about? After asking around I found out that it's an actual resume listing the apartments you lived in the past three years (at least), your credit history, employment history, personal and business references. Christ *Almighty*. I actually showed up (yes, with resume in hand) to see the apartment. When I arrived (at 5:45... I thought it would be best to be early), at least 50 people were waiting to see it. And the apartment *sucked*. Yikes. And the other place was worse. So. *Fuck it*. I'm staying put and am roommate hunting.

My boss Irl suggested a friend of his who needs a place. We met and I liked him a lot... his name's Lenny, my age, works in the AIDS field. He doesn't drink too much or get stoned to excess and has a boyfriend (of two years). When I asked him why he's not moving in with his boyfriend he responded... "Hell *no* we're not living together... *why do you think we're still together?*" Smart man. I shoulda met up with him four months ago. Anyway, Lenny seems to be together... but... how can one really tell? We met again Saturday to spend more time together. So far so good. The thing is... I'm kinda attracted to Lenny. Not a biggie... I'm not worried it'll be a messy "sex with roommate" sorta thing. It's more important to me to find a sane, calm housemate than it is to have sexual intrigue. Hell, I'm attracted to just about any man with a pulse *anyway* so the fact I'm attracted to him isn't out of the ordinary. Besides... it's not as if there's a *shortage* of sexual intrigue in this Sodom-by-the-Bay.

Anyway, after questioning I found out he's a "pushy bottom" as well and is in a vanilla sex relationship looking for S/M trysts on the side with hot daddies. Cool. We'd have a rotten time together sexually. What would we do... bump purses?

I met Lenny for the third and final time. We got along well and were chatting like old friends. We're gonna do it. He's moving in on the first of the year. Hoo-rah. Well, *that* was easy for once. I do feel kinda foolish because Lenny's the only one I interviewed, but hell, why do I need to go through an interview process with Christ knows how many lunatics if the universe sent me someone right off the bat who's gonna be great? Here we go... roommate number *four*.

I had a "date" Saturday night. Someone I met at the gym. A sweet guy (older, bearded, shaved headed, tattooed daddy. My usual MO). We had hot sex for a while... till I felt such a weird *yearning* from him it really put me off. I felt he was... *liking* me too much? Too quickly? Anyway, it put my hackles up. It was OK for a while... but then my mind took over. I almost laughed in the middle of sex when I realized he looks like the strong man in an old fashioned circus (handlebar mustache, et al). Then, on top of it... he *reeks* of BO. Well, not at first... but after he works up a sweat... *nasty*. Granted, I'm not knocking good ol' musky man smell... but *this* guy... *blick*. I felt suffocated as his stench wafted up through my nostrils, forcing me to breathe through my mouth. It was either that or gag. I started thinking of wild animals in the zoo... the lion house specifically. *Enough with the circus analogies in my head, OK?* I turned over on my stomach and had him fuck me. Then I started to hear a maniacal circus tune weaving in and out of my head... do do do dododo do do do. I crouched there, pulling on my flaccid dick while his sweat rained down on me and thought I'd rather be eating ice cream.

I feel as if I'm tired of *everything*. Well, it *was* a busy day Sunday. I met Blake for brunch, then off to the gym (step aerobics classes seem to be my only unspoiled source of pleasure) (that and ice cream) (which is *why* I have to be sure to make *all* three step classes a week), then off to a late-afternoon party at a friends, then, finally, off to Harvey's bar in the Castro to catch Ben's piano performance. All this (mostly) orchestrated to keep me out of my apartment away from Jon.

I'm feeling a bit foolish and impulsive about the "falling in love" with Jon thing. It wouldn't be so bad if I didn't have him move in with me so quickly. Do I have a clear sense of what's true, honest, *real*? Am I full of pipe dreams, fantasies and illusions? C'mon, honey, move in with me, I *looooooove* you. I cleared out a sock drawer for ya'!

We've entered the dreaded rainy season. Not much yet... but it *has* come down hard a few times and more is promised with the threat of "El Nino."

Jeez… it sounds like an ex-lover of mine. It's been pretty gloomy and is much cooler… 60s in the daytime and low 50s at night. The inclement weather *does* put a damper on cruising the parks hunting up sex. It ain't no fun holding an umbrella kneeling in a mud-puddle.

Love, Sal

24 November 1997

Dear Tim:

Excerpt from the Bay Area Reporter… one of San Francisco's queer newspapers… *"San Francisco gay man dies after liposuction. Saint Joseph's Hospital is conducting a review of the death of a 25 year old gay man who died four days after a routine liposuction procedure performed at the facility."* Apparently, this 25 year old muscle-bound weight trainer with 1% body-fat wasn't *quite* satisfied with his near perfect body and wanted to surgically improve it a bit (No… it *wasn't* Kirk). The silly, vain fuck died from a surgical infection complication. The newspaper called it *"A terrible tragedy." I'll* say. It's a tragedy the gay culture in this city (and in this country) is obsessed with beauty and idealized physical perfection, wanting the perfect body, perfect dick and perfect hair. I'm having a difficult time finding pity for people sucked into this ridiculous phenomenon. Dish on the street says this guy was HIV-positive as well. *What* was he thinking? How much further is our culture going to go? Well… at least there are bears and bear lovers who glorify the "natural" body, love and accept each other for being *out* of shape. But *that* gets obsessive as well. Ben told me a friend of his purposely isn't exercising and is deliberately overeating to get a big beer-gut… to be more desirable at the Lone Star (the bear hangout). I, of course, am susceptible to this phenomenon as well. Why *else* do I obsessively work out six times a week? It's a *bitch* living in Sodom and Gomorrah.

For a few months now I've been off testosterone. I weaned myself off because I had started taking a steroid to guard against HIV wasting (Oxandralone, something or other). Testosterone made me too edgy… the ups and downs of it were getting on my nerves (and everyone else's) so I was relieved to dump it. Besides… I'm *on* a steroid… I didn't think I'd need *testosterone* as well. Anyway, the last time I had blood work done, my doctor tested my testosterone level and found it had dropped. I told her what I had done and before I knew it, my pants were around my ankles and I had a needle in my butt-cheek. *Here we go again.*

What a weird fuckin' weekend. Sometimes the dichotomies in my life are too damn freaky to deal with. And I bounce from one to another without a hitch. That is, until it's all over, and thankfully, can see the hilarity in it all.

Friday night. Got a testosterone shot from sexy (but straight) Dr. Lambert at work that afternoon. His strong be-gloved, heterosexual touch on my butt is too, too tempting sometimes. Awww... a testosterone injection is the closest I'll ever get to having him... which is fine by me. By that evening... the injection induced hormones were raging through my body. It wasn't raining, so I visited one of my favorite haunts... Lafayette Park at the top of Cathedral Hill. I arrived huffing and puffing after climbing the sheer cliff of the street leading up to the park. Met a guy in the shrubbery who removed his teeth, stuck them in his shirt pocket and treated me to a most delightful gumming. Home before 10:00pm and more importantly, *before Jon*... to watch *Pulp Fiction* on cable TV in time to catch the hot scene where Bruce Willis is bound and gagged awaiting getting brutalized.

Saturday night. Ben, some friends and I went up north to hear a famous composer of various musical theater/Disney extravaganzas perform. Yeah, I know... *big*fag music. Only a bigfag would adore that kinda thing. If you doubt me... send me a list of all the straight men who can sing the score from *Pocahontas*. Ben adores his work and was thrilled. The composer appeared at the San Rafael Jewish Community Center where the audience was filled with queer-sissy boys (who *adore* musical theater and Disney musicals) and older Jewish women (who adore him for being *such* a "mensch"). I got *very* frustrated and angry during the show because the guy is an obvious fruit-cake, twinkle-toes, toupee-wearing, *raving* homosexual... *yet* he sang love song selections from his new CD that either *avoided* pronouns completely or used "She." "She," *my ass*. "I am a big faggot cocksucker" exudes from his every pore. How *dare* he not be open about his sexuality? How dare he continue to live a lie? How can he promote a CD full of music he composed about his life and not speak the truth? I squirmed throughout the entire performance, praying for the end, praying I didn't succumb to my rampant urge to scream, *"When the fuck are you gonna come out and tell the world, 'I'm queer'!?"*

Sunday. To turn the tables, a woman who works in the hospital with me invited me to speak to the children in Sunday school at her church about AIDS. Marie is just as sweet as pie (she's about 70 and is such a kind "Gramma-type") so I agreed. Again, I got into something without asking enough questions... the church is in Bayview, the nastiest part of San Francisco where

whitey don't show his face. When I asked Marie which bus to take, she was horrified and said, "Oh, *no*... I don't want you to walk around in *that* neighborhood. We'll come get you and take you home, honey." Apparently, Bayview is worse than, say, Cabrini Green in its heyday. *Who knew?* I don't go there... there are no cruising spots. Anyway, 9:00am Sunday morning, (*Christ*) Marie arrived (dressed to the nines) and whisked me off to Bayview. We arrived at the church. Oh, oh. It's a Baptist church. *Shit.* Marie introduced me to Kimberly, a beautiful young woman around 30, who co-facilitates the children's program with Marie. I asked Kimberly, "How far can I go with these kids? Should I talk about drug use? Sex?" Kimberly answered, "Oh, yes, we don't hide anything from them. Tell them anything they should know about AIDS... how you can get it... and what happens when you get it. Marie told me you have AIDS and that's why we wanted you to talk to the children. We wanted them to see AIDS is nothing to be afraid of and that we should love everyone." Cool, I thought, perhaps they're hipper than typical bible-thumping Baptists. *Nope.* She *then* went on to say, "The only thing I *don't* want you to talk about is gayness or lesbianism... we teach the kids that it's wrong and it's a sin." *Whatwhatwhat?!* "Kimberly, why the hell (She didn't appreciate me saying "hell." *Too bad*) did Marie ask me to come? She knows I'm gay... and I can't *not* talk about it. Being gay is not *wrong*... it's not a sin." "Well, we teach them what the Bible says. And the Bible says homosexuality is a sin. As is fornication and lying. Besides, we didn't ask you to talk about *gayness*. We asked you to talk about *AIDS*." Oh, for *fuck's sake*... *how* do I get into these goddamned situations? At 9:30 on a frikkin' Sunday morning when I should be home in bed sipping java and smoking cigarettes. I said "Listen... I wish I knew about this before... I would *not* have come. I absolutely disagree with what you're teaching these kids... you're teaching them hatred and prejudice. But I'm here now and I will speak. I do need to tell you that if they ask me... I'm *not* going to lie. I'll tell them I'm gay and there is *nothing* wrong with it." She said, "We don't teach them hatred... it's not that we don't love and accept gay people... we do. It's just that we feel it's a sin and you're not saved."

What*ever.* I asked myself... did I come here to push the queer issue? No. I came to talk about AIDS. Fine. I did promise myself to confront the queer issue if asked but decided not to push it. Thankfully (or perhaps, too bad) the kids didn't ask me anything about how I got HIV. It was actually a lively morning... the kids were great (there were about 10 of them all around 12 years old). They were very bright, curious and had a lot of questions.

Afterward, I felt proud that I had done a good thing. Yet. I dunno… especially after the fury I had the night before about the closeted composer skirting around the queer issue… how could I, in turn, do the same thing? Does that make *me* a hypocrite as well? I wasn't pretending to be something I'm not. But then, isn't the fact I *omitted* being queer the same thing?

Was whisked home by Marie and Kimberly (who told me how wonderful my talk was) then tooled around the city, backpack on my shoulder, staying away from home (and Jonny) all day. I went to Golden Gate Park to my favorite place under the fragrant eucalyptus trees.

Dashed off to the gym where I jumped up and down on a long, flat piece of plastic several thousand times to loud, frantic dance music (step aerobics class) to work off the sexual frustration building all day…

… *which didn't work.* Got home, made a feeble excuse to Jon about needing air (that was dumb… I had been *gone* all day) and was going for a walk… then beat a hasty retreat to the Suck Hole. I thought I might be pushing it arriving so early… it was only 8:00pm… but was pleasantly surprised with a bustling, randy crowd. *Whee…* is every man in this city getting testosterone shots? At one point I was on the catwalk getting "done" and looked over at the guy next to me getting the same treatment and realized it was my roommate-to-be, Lenny. He looked over, smiled and said hello. I had sent him an e-mail that morning with a "rental agreement" between the two of us (a girl can't be *too* careful). He told me he'd read it and it was just fine. We clinched the deal with a handshake, then continued with business at hand. I was relieved to discover I wasn't interested in having sex with him. I *did* notice he didn't make a lot of noise when he came. Good. God knows I *despise* a noisy roommate.

Love, Sal

12 December 1997

Dear Tim:

Spent the past week and a half nursing a horrid flu that's making the rounds in San Francisco and from what I hear, throughout the country. Christ. Ya'd think with the vast amount of knowledge at our fingertips in today's world, we'd be able to prevent the fa'crissakes flu. Well, now that I think on it… perhaps it's no surprise we can't. Anyway, I *despise* getting the flu… it makes me feel as if I'm dying of AIDS… night sweats, fevers, blahblahblah. It's makes me all too morbidly aware of my mortality. *And* it happened right in

the middle of Jon moving out. Thank you *very* much. Muthafucka. I had planned to be out of the apartment avoiding the whole scene during the blessed event but *no* such luck. I was wracked with fever, chills and ended up shutting myself up in my bedroom watching stupid TV and napping till it was over. Christ-on-a-rubber-raft. In the rapids. With a hole in it.

At least Jon's gone. It was very strange... he left the keys on the kitchen counter and left without saying goodbye. All that remained were piles of newspapers and his frikkin' mattress. *Great*... the two things about him I despised the most... his frikkin' newspapers all over the place... and his dust-mite/whatever infested mattress. Left for me to drag down four flights of stairs. Which I did, cursing him to *hell* all the way. *Thanks*, chum.

He called the other day (after being gone over a week) and said he wants to meet over coffee and talk about what the hell happened between us. I'd rather stick needles in my eyes but I suppose meeting him *would* be the adult thing to do. Goddammit.

Jeez-o-man, I'm going through the men in this town like Kleenex. And I'm quite tired of it happening over and over. Hell, every other queen in this city is going the liposuction/plastic surgery route... I might as well join in. So, I've decided. I'm having my heart liposuctioned and having it replaced with dry ash.

Speaking of cosmetic surgery. Victor (the bio-medical nurse who I've occasionally "done" in my office and in various tucked-away corners in the hospital) told me about his lover/whatever who's in the process of his own plastic surgery. Victor's lover, who is drop-dead gorgeous, works out all the time and has a perfect body, is undergoing *penis* surgery. Apparently, he felt his penis wasn't large enough so he's put himself through a series of five operations where the surgeon removes fat tissue from his *ass* and wraps it around his dick. Victor says his lover's cock is now "fat as a beer can." Unfortunately, it looks oddly disproportionate because the head of his cock *is still the same size.* Typically he wouldn't have to go through five surgeries... but the plastic surgeon fucked up on the fat removal from his ass and three of the surgeries have been to try to correct it. Victor says his lovers' ass looks like a sack of potatoes. Hey... now *that* sounds sexy. To top it off, Victor's lover is a total, screaming bottom and doesn't like to fuck or have his dick sucked. What's the fuckin' point? All that trouble, pain and expense so it looks as if there is a salmon flopping around in his lycra workout pants?

I found out something a tad upsetting the other day. My apartment building manager (a sweet woman from Ireland who has a delightful accent) told me the building was sold and the new owners are raising rents (*a lot*) as leases expire. *Bullshit*. I hauled my ass down to the Tenant's Union. I was told there *is* rent control in San Francisco and landlords are *only* allowed to raise rents 1.8% per year for existing tenants. Hooray. *With the exception of buildings erected after 1979*. Shitfire. The building I live in was built in 1994. This is the most fucked, ridiculous city on the face of this planet. I truly wouldn't see it as a great loss if a huge earthquake rattled the entire state of California off the continental US and sent it the way of fabled Atlantis. Hey... that would mean Las Vegas would have an ocean view. *Cool*. Anyway... I spoke to my landlords who informed me they *could* raise my rent $600... but will give me a "break" and only raise it $300. Gee, *thanks*... but I usually get lubed up before getting rammed up the ass. *Bastards*. Insanely enough, $1,300 for a two-bedroom apartment is *still* not bad and I may stay. Lenny's still moving in... he really has no choice at this late date... but because of the increase, he can't make it long-term and will be looking for another place. And I need to decide if I want to stay myself. Damn. I thought this was taken care of. Ah well. Life in paradise. Yeah, *right*.

 Love, Sal

19 December 1997

Dear Tim:

The rent increase really threw me for a loop. *Damn*... it seems as if just when I start to feel stable about one thing... the rug gets pulled out from beneath me about something else. I don't know what the *hell* people are supposed to do. I wonder what will eventually happen in San Francisco... it *must* be headed for financial collapse or uprising or *something*. What's feeding this whole rent (and buying) increase-frenzy is the multitudes of people moving to the increasingly ever-popular San Francisco Bay Area. Silicon Valley is growing by leaps and bounds... bringing in tons of "techies" making astronomical salaries who *all* want to live in San Francisco, who *can* afford the outrageous rents in this city and who blink nary an eye at paying upwards of $1,200 to $1,500 for a one-bedroom apartment. What's happening to people like me? Sharing apartments with two, three, four roommates. Begging, borrowing, stealing to get a place to live. Now, I think I'm painting a rather

bleak picture (gee, how unlike me). The truth of the matter is, yes, that is happening… but also, there *are* bargains to be had. Certainly not the bargains to be had in Chicago… but options nonetheless. One option is… get an apartment in a building built *before* 1979 and *never leave it*. Another option is to find someone who already has such an apartment who is looking for a roommate. Another option is to look and look and look and eventually, something affordable *must* turn up. A neighbor of mine who left this building because of the rent increases found a one bedroom in the Mission (not a great neighborhood but I'd be able to deal with it) and it's only $650. Sure sounds like dreamland, eh?

What will happen to San Francisco, the funky European paradise by the bay that is being completely gentrified by rich, white yup's? Where will people who don't make upwards of $70,000 to $100,000 a year live? I, of course, can move back to Chicago. I've thought about it… but because of the emotionally vulnerable, lonely space I'm in, I feel as if I can't trust it.

Since things were on the slide with Jon… I've been on a spiritual avoidance trip. Well… that's my usual MO at the end of a relationship. Perhaps I go through a period of heavy anonymous sexual behavior and spiritual denial after the end of a relationship because I'm shrugging off and avoiding my feelings of failure, inadequacy, of being "unlovable"… proving it to myself by putting myself repeatedly in such emotionally numbing situations. For me, the end of a relationship is such a weird combination of relief from being *out* of it and pain that it's ended… I go into numbed-out mode (or try to) and engage in a lot of sexual encounters to escape (or *try* to). I find the pursuit of sex for sex's sake rather like a mini-vacation. I go on autopilot and concentrate on the "task at hand." No thoughts, no emotions, no ties (*again*, I try to). After a point, it doesn't work as well, isn't as interesting or fulfilling (as if it ever were) and I taper down to a less frantic pace. And I'm getting there. But… there *is* still something that draws me to it. It *is* great fun on some level, dammit… even if it *is* in a base, purely physical way. Hell, otherwise I wouldn't do it at all.

Does my body *want* sex all the times I go out to get it? Certainly not. I do go out for sex when what I really want is comfort, love, nurturing. I must, on some level, feel deficient in being able to provide it for myself… so I go out to "rely on the kindness of strangers." Ah, poor, dear, sweet, Blanche DuBois, whose downfall was the fact she desperately wanted to experience magic to escape the pain of harsh reality and to propel her to flights of fancy.

And if she found sweet escape from pain in the arms of a passionate stranger, who could find fault with it?

Interesting stuff is coming up in therapy with my new therapist (Joseph, who is sharp as a tack). We're talking about relationships and how I go into them with preconceived notions, full of expectations, dreams, desires and also the "foreknowledge" they're doomed to failure. We've talked about how I feel unworthy of love. Messages I got from my parents, from kids I grew up with (as a chubby, unpopular, geeky, loner sort). And that I have a difficult time accepting the love a partner has to give. The thought of a man, passionately touching *me*, holding *me*, getting pleasure from being with *me* scares the bejesus out of me. I feel much safer with some anonymous daddy/trick/ whatever touching me because really… he *isn't* touching the *true*, naked me. He's just touching my body. Much different, eh? Especially after I have effectively separated mind, body and spirit as I do when in an anonymous situation. Is this an issue of self-love? How, how, how do I get past years of patterns? How do I get past being surrounded by society's (the mass gay societies) thinking that we (I) am undeserving of love and passion with the same man?

The funny thing is I have none of this bullshit going on with friends (do I? *do* I?). When I enter into a friendship with someone, I certainly don't put nearly the amount of fantasizing, futurizing and preconceived idealism on it I do when I'm getting to know someone I have a sexual interest in. My friendships tend to be fulfilling, loving, honest and rather long-term. I don't put the pressure on them that I do with a sexual partner/relationship prospect. And with a friendship, I don't foresee them ending painfully, uncomfortably as I do with a sex partner. Now… if only I can put the type of energy into a sex relationship/ romantic interest that I do with a friend… I think I'll be on the way.

I just got back from my "goodbye" dinner with Jon. I feel much better with how we ended things tonight than how things were left when he moved out. We were both nervous, on edge. He exhibiting it more than I… he was very chatty and did most of the talking. He wanted to know if I was "OK"… hoping, perhaps, to hear that in some way I wasn't? I told him breaking up was difficult and sad for me and I've been lonely but I also feel ending it was right. We didn't discuss "what went wrong" because we realized it was much too soon. He did tell me many times how much he loved (loves) me, how special our relationship was and he was grateful to have had it. I uncomfortably

echoed his sentiment. He then chatted on about how much he's learned spiritually and emotionally about himself since our breakup and talked excitedly about his LA plans. I tried to interject a few times with what was going on in my life but it didn't seem to hold his interest or at least merit much of a comment. He already looks very different from the Jonny I knew. His hair is longer and "poofier," he's shaved his beard, and is intensely working out (he pointed out how huge his arms and chest are getting three times) (as if it weren't obvious *enough* with the too tight T-shirt he was wearing). Ya know, I think he'll be just *fine* in LA.

Something Jon said *did* resonate with me. He's glad to be moving back to LA because even after seven years, San Francisco never felt like home. I know what he means.

Jon and I went to a Chinese restaurant around the corner from my apartment and to my astonishment, right after we sat down, *Kirk* came in to pick up a to-go order. I pointed him out to Jon and asked if he thought I should say something. Jon said, "No... Kirk *hates* you and it wouldn't be a good idea." Kirk saw us and came over anyway to say hello. Quick pleasantries all around (it was obvious Kirk stopped by because of Jon rather than me). Poor Kirk looked like hell... a front tooth was missing and he had lost a lot of weight, looking really dragged out. Jon told me Kirk's been in and out of the program having many relapses with alcohol. Jon also said Kirk thinks I'm a jerk for "kicking him out" and was furious to find out Jon and I split (again, instigated by me), confirming Kirk's belief I'm a horrid, cold monster.

I guess *I'll* never win a popularity contest in this town.
Love, Sal

3 January 1998

Dear Tim:

I've been looking at the people with whom I've surrounded myself... and I think of my friend Ben. Someone with whom I've been a good friend with since I moved here. As you know, he and I now work together as well so I spend a lot of time with him. Now, this is something I've always known about Ben, but it's becoming glaringly clear. Ben is such an unhappy being and goes through life being angry, bitter and resentful. At times, admittedly, I enjoy his anger, bitterness and resentfulness... and have a good ol' time "sharing" that

state of mind with him. *At times.* But lately, I find it draining and have to be careful not to be sucked into that mindset. It was very clear to me on New Year's Eve. Ben, a friend of his visiting from out of town, another friend (Fred) and I went to dinner, then to a small party afterward. I was feeling fairly harmonious and happy (unlike Christ-mess, I *do* enjoy New Year's… not because of the out of control partying… but because of the "new beginnings" symbolism). Ben voiced a number of disparaging comments throughout the evening (as he is wont to do) and I was feeling rather uncomfortable with it. Ben wants (or claims to want) a partner, a lover and he's never found one here… something that frustrates him to the core. He's inclined to rail on about how this city is filled with freaks and he's "too normal for the teeming masses of flaky queers in San Francisco." That, coupled with the fact I'm in a new relationship every five minutes, seems to bring a thinly disguised jealousy and resentment from him. It's ironic (or perhaps it isn't) that I never look for a relationship and fairly consistently have had a love interest, while Ben, who desperately wants one… never has one and constantly meets up with disappointment. For example, Ben also has AIDS. While I have rarely experienced weirdness, fear and rejection from my HIV-negative partners (I can only think of two instances where it's ever happened to me), Ben *constantly* finds that HIV-negative men he's interested in can't deal with the fact he's positive and sneakily, weirdly reject him.

I've felt rather… calm lately. After digging myself out of the dumps of Jon leaving and the subsequent emotions that arose I've been feeling rather good. I've been looking at my sexual escapades of late and do realize a lot of my behavior is "old" patterns. Yet still… there is a pull to it (and did I think it would disappear overnight? No, indeed.) My mind keeps playing images of dark, smoke-filled back-rooms with hunky, horny, hirsute Dads to have sex with. Visions of nasty sex-clubs, leather bars, and the tasty, mouthwatering hot Dads who may be there are dancing in my head. The thought of loving someone again, caring about someone again so soon, shakes me up and I wanna run. Run to the nasty, the familiar, the escape from my true feelings… which (right now) is that I'd rather be curled up in bed with a man.

Oh, yes, Lenny's moved in. He's easygoing and we're getting along well. It feels better than when Kirk moved in… I feel more "friend vibes" coming from Lenny and am more at ease with him than I ever was with Kirk. We do need to have a conversation about whether or not he's moving out in

two months. I think I'm going to stay myself. The apartment situation is damn fierce and I'm not willing to go hunting right now.

And my new landlords responded to a letter I wrote them. I had written pointing out I've been an ideal tenant for two years and asking for a further break on the rent. They replied with a letter saying they'd lower the proposed $1,300 to $1,250. I hate to look a gift horse in the mouth… but jeez… *why'd they waste a stamp?*

Love, Sal

23 January 1998

Dear Tim:

Raining. It's raining here. Raining raining raining rainingraining raining*raining*. And raining some more. For seventeen straight days. Flooding to the north and south of San Francisco. A few streets have caved in. Still, rainingrainingraining.

I'm on my third umbrella… the first two broke in rainy windstorms. Wet towels don't dry. It's cold and damp. *Moss* is growing on sidewalks. The gym is packed with people desperately trying to stick to various New Years "physical fitness" resolutions. And as of the 1st of this year… *all* bars in California are smoke free. Yes… smoking is actually *completely* banned in bars. I've *never* heard of anything more ridiculous in my life. At least I can still smoke in my goddamned *apartment*. What could be more unpleasant than Northern California in January? *Christina… bring me the ax!*

Last Sunday morning Blake and I went wandering downtown. I took him to the Hyatt where the hotel scene in Mel Brooks's *High Anxiety* was filmed. I *adore* the lobby because it is *so* mid-'70s tacky. I sang "High Anxiety" to him as we held hands and skipped through the lobby (*only* in San Francisco). We then rode up and down the glass elevators, gawking at the view. We walked through the Embarcadero Center (another mid-'70s extravaganza of disastrously bad architecture) and raced each other up a spiraling walkway, laughing all the way, while passing a number of children running down… who stopped to stare at the grown-ups engaging in the same behavior they were. We ended up in Chinatown at Blake's favorite place for dim sum… a place hilariously named… Hung Ah. (Get it? Hung. *Ahhhhhhh…*)

I've started volunteering at an organization called Project Inform. It's an incredible place that provides HIV/AIDS treatment information and education. One of the many things they offer is a free national HIV hotline, allowing

people throughout the country to call and ask about treatment issues. I was worried because Kirk volunteers there and was leery of bumping into him. Not to worry... the volunteer coordinator told me Kirk hasn't been there in months. Too busy drinking, I suspect.

Last weekend I did the hotline training and will start manning the phones this week. The training was fairly grueling... they threw tons of information at us in two eight-hour sessions. But, I'm not too worried... when on the phone, all the information is at our fingertips. I felt quite gratified during the training because through the last two years at my job (and especially lately) I already knew a lot about the treatments they were talking about. And because of working at The AIDS Alternative Health Project in Chicago I had the market cornered on Complementary Therapy information as well. Cool. And honey... if you ever wanna meet men... *do volunteer work.* During breaks, as I stood outside smoking (with all the *other* HIV-positive gay men) (while the HIV-negatives stayed inside drinking bottled water and decaf coffee) the sexual tension was thick enough to cut with a knife. I left with three phone numbers (after groping one of them in the bathroom). He leaned back from the urinal to show me that he was *huge*... I had to oblige him with a squeeze and a yank or two, didn't I? What was I to do?

Obviously, I've gotten over the whole "I'm done with anonymous sex" thing. I've been delving into sex because I want to take the "seriousness" off the rest of my life. I know it's fucked, but there it is. Also, frankly, I think it's also related to the issue of AIDS (OK, Sal, explain *that* one). The whole issue of AIDS overwhelms me at times... death fears, sadness, so many intense emotions around it and sometimes, I just want a break. A mini-vacation. To zone out. And what easier way to escape than to have quickie, fast-food sex? The deep sadness and despair within me about AIDS is too much to bear and I choose to "click it off" at times. And, no... it wouldn't work that way with anyone I'm seeing. This "zoning out" requires the lack of emotion, the lack of feeling, so what I'm trying to achieve wouldn't work with someone I care about. Is it any surprise I ended up groping someone on break at the hotline training after 16 hours of non-stop AIDS information? Is it any wonder I seek out Victor at work occasionally to give him a snappy suck-job in the afternoons? Oh, and hell, I *do* own up to the fact AIDS isn't the *only* reason. I also do it 'cause it's a helluva twisted, fun time.

Something I realized during the training (while hanging around outside with the other HIV-positive guys smoking) was that I feel a... *kinship* with

other men and women who are positive. It was something I felt uncomfortable about in my relationship (whatever) with Jon.

Funny… it's difficult to recall what it was like with Jon. I can *still* vividly recall so many memories from my Pete days. What being with him felt like, things we did, how it was to sleep with him, what sex was like. I can still recall his *scent* for cris'sakes. And still… yes, occasionally I miss him. Certainly not in the way I used to. And I don't feel strongly enough to do anything about it. Although, from time to time, Pete makes attempts to get together, mostly through email invites, which I promptly (and gleefully) decline (I *still* get to be a *bitch*, don't I?). But, I feel hard pressed to recall what it was like with Jon… things we did together… conversations. And I don't miss Jon at all nor do I have *any* desire to see him. Odd? Poor ol' Jon. I wrote pages and *pages* about Pete, made scores of music tapes, obsessed about him incessantly… yet Jon doesn't even merit a break-up music tape.

Later tonight, Blake, Ben, his friend Jeff and I are going to Pleasuredome for the "Second Sunday of the month Disco Inferno" dance night. (It's only from 9:00pm-11:00pm so us old grannies can get to bed at a decent hour). Yippie! An audio flashback to those late '70s/early '80s when all I worried about was whether or not the DJ was going to play "Funkytown."

Love, Sal

15 February 1998

Dear Tim:

Constant, unending rain. Well, *one* day last weekend, we did have a much-needed reprieve… last Saturday was stunning. It was the first day in over a month where it didn't rain at all. Bright blue skies and everything is *so* green and smells so fresh. Alas… the rain's back. Rain and more rain for the "left coast." Flooding in valleys, mudslides, houses worth $500,000 are sliding down hills smashing into each other, cliffs are crumbling into the ocean, small towns along swollen rivers have been evacuated, power outages, Santa Cruz and Santa Clara counties have been declared state of emergency disaster areas with the frequent, almost constant rain. And more storms on the way. I'm starting to struggle with cabin fever and claustrophobic anxiety attacks (as I write, the light outside my window is getting dark, threatening and rain is beginning to tick off the skylight). I've always thought San Franciscans tend to be rather slow and self absorbed (*Hey*… waittaminute… aren't I a San

Franciscan now?) but with this constant wet onslaught, with this *unending deluge*, people seem to be even slower and duller. Normally cheerful souls tend to be short-tempered… people are becoming veeeeery edgy. Animals are starting to congregate two by two.

My last "attempt" at uncaring, unattached sex recently was with Vince. Vince was (oy… another complicated San Francisco story) Jon's ex's (Donny) ex. Get *that* one? I met Vince at a birthday party when I was still with Jon and thought he was hothothot. Jon can't bear the sight of him and turned green when I mentioned I thought Vince was a stud. Jon told me Vince has really bad teeth… something I didn't notice because I was distracted and obsessed with Vince's bountiful, hirsute chest and bulging arms. I neglected to tell Jon… but Vince slipped me his number and told me to call him. Sneaky me, *always* the sexual packrat, kept it. Vince, in complicated, ridiculous San Francisco tradition, currently lives with Donny and Donny's new partner Jim (who replaced Jon) (whom Jon *also* despises). I think all three of them are tasty lookin' and I have been entertaining delightful thoughts of a four-way. Partly because it would be a kick and partly because Jon would be furious. Hey… did I say I was emotionally and spiritually evolved? Well, we *all* backslide at times. Anyway, I met Vince for coffee and saw I *had* been too obsessed with his manly chest and neglected to look at his teeth… which *are* really bad… he's missing half of them and the other half are crooked and an unappealing yellowish color. Blick. I'd rather stick my dick in a meat grinder. I immediately lost all thoughts of four-ways and begged off saying I had a sore throat and picked up my favorite bed companion… a pint of Haagen Dazs's newest creation… Dulce de Leche.

Poor Ben has been a depressed mess. He put together a piano recital performance this weekend past at the MCC Church (a queer church in the Castro). I went to Friday night's performance (which was grand… he plays really well) and called him Sunday to find out how Saturday night went. With the torrential rainstorms of this past weekend, there was a rather poor showing. Many people who assured Ben they'd attend didn't make it. Ben was horribly disappointed and absolutely furious. He was all doom, gloom and completely inconsolable. Never mind the fact half of California is sliding into the ocean. Ah… I suppose I'd react the same way. I tried for *an hour* to point out the good parts of the weekend and the gifts and blessings in his life… no deal. The boy is stuck and nothing short of a dynamite blast will shake him.

I've been studying lines for a scene in a docudrama I was cast in. It's a scene between a street hustler (Tony) and an older gentleman (Mr. Findley… a married-with-children closet case). Throughout the scene, the audience is given the impression Mr. Findley hired the street hustler and it goes haywire. The hustler becomes more and more verbally and physically abusive and ends with Mr. Findley groveling at Tony's feet, crying… and has an orgasm. Then *snap*. The roles change and the audience realizes it was a carefully orchestrated scene Tony and Mr. Findley play… and have played many times before. It becomes obvious Mr. Findley hires Tony on a monthly basis to create abusive scenes based on humiliating him. After Mr. Findley's orgasm (which is depicted by Mr. Findley frantically rubbing himself on Tony's masculine boots) (fully clothed, by the way), the roles change. Mr. Findley drops the "sniveling, cowering pansy" routine, Tony drops the street tough façade and becomes a gentle, respectful young man. That, I think, more than anything, drew me to the part. I completely relate to the whole game-playing aspect of the scene. The character is like an old shoe. I've played this hardass/sexy-street tough type before and it's quite easy to jump into the feel of it. It's something I've done, oh, all too often in my life. Perhaps this will help make clearer for me the whole ridiculousness of it. And my scene partner is Trauma Flintstone… a fabulously talented drag queen. He's not in drag for the scene, of course. Rehearsals are going well… we throw ourselves completely into the wretched twisted sickness of the scene and have a great time playing off each other. It's also very physical and involves a bit of pushing, slapping, punching and spitting (as he grovels at my boots) yet he's being a real trooper about it, encouraging me to go further and trust he has a "thick skin." It's actually kinda funny because he's a good foot taller than I and probably outweighs me by 30 pounds. It's a fun, good acting experience to overcome that physical challenge and dominate him on stage, which is what my character needs to do. Well, it's an interesting way to spend my Saturday afternoons anyway.

Love, Sal

19 March 1998

Dear Tim:

Ben continues to be… self-pitying and just a case. I've had to distance myself from him a bit. Funny… he's accused me of spending less time with him lately… and I've made a concerted effort to try to but I just can't right now. Poor guy… he created a self-fulfilling prophecy.

My viral load keeps going up. It was down around 10,000 and has risen to 50,000 in the past few months. I think it's contributing to my fatigue and apathy. It's been difficult for me to concentrate... let alone sit down and put thoughts to paper (or, in this case, to keyboard). I've been taking it easy and resting a lot. But still... I've been dealing with incredible lethargy. So my radical activist kick-ass doctor changed my HIV drug regimen. She had me drop AZT (not that I was taking it *anyway*) which left me with three drugs... two Protease Inhibitors (Ritonavir and Saquinavir) and 3tC. She *then* added ddC (to pair up with 3tC), a new non-nucleoside analogue, Sustiva... and an old anti-cancer drug that has gotten a *lot* of attention lately in drug trials... Hydroxyrea. So... I'm the first kid on the block to enjoy a *six*-drug HIV regimen. *Egad.* I've been on this combination for a week. I don't know if it's an improvement in the weather... but I'm starting to feel better. I've had more energy and I feel as if I'm thinking a bit clearer. I do worry about the long-term effects of all these meds. Latest scoop is people are having a lot of side effects from long-term use of Protease Inhibitors. Articles about fat redistribution in the body are beginning to appear in medical journals and the press. I guess it's not too surprising... these drugs were whipped through the approval process and there was never any long-term studying done on them. There was no time... we needed them. Because of these meds, I have my life, my health and my strength. If I didn't take them... I don't think I'd be nearly as healthy as I am now and frankly... I think I may have died.

But then... I awoke last Saturday covered in a furious red rash (a common side effect of one of the medications I'm now on). I find it ironic that a lot of my dealings with HIV/AIDS symptoms and medications are physical manifestations on my skin... ugly rashes, skin molluscum that need to be burned or frozen off leaving healing scabs, blotchy skin, back acne (from my bi-monthly testosterone shots)... not to mention the recurring "bug-bites" I used to get while with what's-his-name... oh yeah... Jon. It really pushes my vanity buttons. Yes, I'm quite a vain thing and when I get an "ugly" weird skin thing I just wanna go into hiding. No matter *how* much whomever holds me and tells me they love me. Sure, and *I'm* the one to condemn Kirk and others like him for choosing to undergo liposuction surgery. Am I any better? Who am I to point fingers?

My friend Mark from Chicago was in town for a while to take the national acupuncture certification exam. It was so pleasant to have him here... the time flew. He was here a few years ago and left not liking plastic/fantastic

San Francisco much. This time though, I think he got a different flavor. I rented a car for the weekend (feeling very cosmopolitan and adult) and took great pride in showing him around the city and down the coast. I brought him to the most stunning views San Francisco had to offer and to some of my favorite eateries and neighborhoods. I did feel challenged to show him the seedy side of the city. No… not the seedy *sexual* side. I offered, of course, as the consummate host, but he showed no interest. We kept comparing San Francisco to Chicago (unavoidable, I suppose, as we two Chicago boys tramped around). He kept commenting on how much cleaner and safer it felt. Everywhere… even in the "bad," "unsafe" neighborhoods. As you well know, there are neighborhoods we (as white crackers) would never set foot in Chicago. I was hard pressed to present that side of San Francisco to him. And the harder I tried, the more laughable it became. The weather was gorgeous… trees and flowers were in bloom, the perfume of nature was everywhere. And lucky him, the weather was perfect. It was great fun playing host and in return, he treated me to two kick-ass acupuncture sessions. He's a fascinating, wonderful man as so many are in Chicago. Hey… I thought *San Francisco* was supposed to be filled with fascinating people. Well, I guess it is. They're just fascinating in a different way… if you know what I mean.

I shot the scene with Trauma last week… it was quite a task. (And I complain about my life being boring.) Trauma and I developed a wonderful rapport and had a blast chewing up the scenery. *Christ*… I *love* being in front of the cameras. And to be paired with a seasoned drag queen like Trauma… *look out.* The guys putting the documentary together (who live in a *fabulous* loft in the Mission I completely coveted) are a bit green at it so I think it may be a while before it's ready for viewing… but, I do hope to get a copy of the scene soon. "Soon" in San Francisco terms anyway… which probably means months.

I've been spending a lot of time taking care of my extremities… lots of dental work has been done, to the delight of my new dentist… and to the kind people at VISA (hoo-boy). And I've made a determined attempt to stop biting my nails. To aid me in my effort, I treated myself to a manicure at a beauty salon. I felt like the consummate homosexual sitting in a cloyingly fragrant salon with two Japanese women fussing over my disastrous cuticles. They spent an *hour* on my nails… trimming, sanding, buffing them and they look stunning. (Even if they *are* a tad stubby.) I can see why one would have a standing weekly appointment. *Such* pampering. I did have a moment of panic

though. At one point… one of the women nicked my skin and made me bleed. She apologized and dabbed me with an astringent-soaked cotton ball to stop the bleeding and was nonplussed about the whole thing. I, on the other hand, had a complete panic about it… snatched the blood-dabbed cotton off the table, stuffed it in my pocket and told her to go wash her hands. Perhaps I made too much of it, but hell… what *should* I have done?

Ya know… HIV is just a tiny microscopic germ; yet, it can control my body and my life so intensely sometimes. It's especially true right now when I'm in the middle of adjusting to a new medication regimen. The rash I wrote about has dissipated… gratefully. Yet… I still break out painfully, angrily on my back. I've also been dealing with an ongoing lethargy. I'm not sure I can completely attribute it to the meds I'm on, though. Oh, I'm sure on some level, the meds are affecting me physically, but I also feel such an uncharacteristic lack of… passion. I go through my days, doing what I have/need to. I go to work, pay bills, work out, swallow pills and vitamins. Taking care of myself. It's just that, right now, I'm not feeling… all that damn excited about my life. Although, things *are* fairly calm and I'm not used to it. I think I confuse "high emotional drama" with "a full life." And when things are on an even keel I begin thinking/feeling my life is boring. Perhaps it's really *not* boring but merely… calm. What I miss… is an excitement about things.

Well I'd better stop now… I'd *hate* to ruin the buff-job on my fabulous nails (I'm kidding, *I'm kidding*).

Be well.

Love, Sal

April Fool's Day, 1998

Dear Tim:

Walked to work, as is my fashion. Bright, blue skies even though it's been a bit chilly… jacket and sweater weather. Arrived at 9:15am. Checked voice and e-mail. Nothing pressing, so I dashed across the street to the pharmacy to drop off prescription refills. A small order today… only four scripts needed refilling.

Stopped in the cafeteria for a large cuppa Joe. Saw my friend Peter who is the "chef" (a kinda glorified title for someone who plans the menus in a hospital) (it's OK though… the title doesn't go to his head). We stepped out on the balcony to catch up (and smoke). He just returned from visiting his father

in Boston, who's very ill with cancer. He may have to take a leave of absence for a few months to be with him. I'll miss him… he always has the hospital 411. Chatted with Greg (the charge nurse on the 10th floor) who was also on the balcony having a smoke. He's considering going on disability because he's terribly stressed out and his HIV medications are no longer effective. His face is drawn and his dark brown eyes swim in his shrinking face. As we lit our second cigarettes, we talked about the possibility of selling our life insurance policies. As we smoked our third cigarettes I commented on how sexy his butt looked in his tight jeans and said we should "get together sometime." He smiled and agreed.

10:00am. Back up to my office. Checked voice mail. A friend excitedly called to tell me a San Francisco radio station (LIVE 105) had changed their format for the day (and perhaps for good). They changed their call letters to… KGAY - an all gay radio station. All gay… *all day.* I tuned in just in time to hear the announcer crow, "We're here, we're queer and we're in your ear!" I don't know if it's just an April Fool's Day joke or what… but the station was kick-ass. *Fabulous* non-stop "queer" music. Within a half-hour, they delighted me with "Sex" (by Berlin), "Dancin' Queen," "Downtown," "I Feel Loved," "You Spin me Round," "Into the Groove," "Fame" and "The Time Warp" from The Rocky Horror Picture Show. Throughout the day, they plied happy homo listeners with Queen, The Go-Gos, Culture Club, The B-52s, The Pet Shop Boys, The Village People, Bronski Beat, Erasure, on and on. And they inter-spliced the music with sound bites from queer movies. The announcer explained they did a survey and got tons of requests for an "alternative" radio station… and since this *is* San Francisco… they came up with… KGAY. I thought I would pee when the DJ shouted out, "We're the all-new KGAY radio! We're gonna *lick* the competition." They also had interviews with "high-profile" queer San Francisco personalities. Pussy Tourette was on, fresh from a New York tour where she warned of a huge East Coast vs. West Coast drag-queen war. Believe me… *that* frightens me more than the threat of nuclear war. Granted, most of the tunes they played were '70s disco and '80s techno-pop (how many times a day can one listen to "It's Raining Men"?), but Judy Garland, Bette (the *Goddess*) Midler, Barbara Streisand and kd lang were thrown in to boot. It was like Prozac comin' out my radio speakers.

10:30am. Strolled down the street with my boss Irl (whom I adore) to get another jolt of Java from our favorite café, Mo's Morning Sun. Flirted with Mo the sexy Iranian owner. On the return trip, Irl remarked that I am the

calmest, most levelheaded member of our staff. I asked him if he neglected to take his Ritalin that morning.

11:00am. Went to the outpatient lab to give blood for a multitude of tests… cd4 count, viral load, liver function and testosterone levels. My doctor thinks my back is breaking out because my testosterone level is too high and wanted to check the level in my blood just before my next shot. Joe the phlebotomist chatted me up as he drew vial upon vial of blood, telling me he and his boyfriend have been incorporating electro-shock into their sex-play.

11:05am. Ran into Victor waiting for the elevator… who is growing a beard. Victor asked me to stop by his office later so he could tickle my butt-hole with it. I declined demurely. *For today.*

11:10am. Dropped my pants for sexy Dr. Lambert who artfully placed his strong, be-gloved hands on my bum to inject me with my bimonthly testosterone fix. Hoo-baby.

11:15am. Called my mother and listened to her bitch about my brother and sister for about 15 minutes (all I could take) then begged off the phone.

11:30am. Dashed off to the gym for my "lunch-hour" workout. Ran into Jeff (in nursing administration) who was checking his car. The hospital is surrounded by "two-hour" parking zones. If the roving gangs of Meter maids mark your tire… you get a $50 ticket. Every two hours, *all* the hospital employees who drive check their cars and move them to a different parking space if the tires are tagged. Jeff, who's a tasty looking, hairy, cubby-bear, patted me on the ass, winked and wished me a good workout.

12:30pm. In the shower room at the gym, I noticed the staff hung up signs stating, "Any member engaging in lewd and lascivious behavior will have their membership revoked." The killjoy bastards.

1:00pm. Back at my desk to eat lunch, open mail, check voice and e-mail. Nothing interesting. Turned on KGAY and called everyone I knew in the San Francisco area to tune in.

1:50pm. Stared out the window at the rain (god*damn* it) and thought of the many people I miss in Chicago (and in other areas of the globe).

2:00pm. Listened to Ben bitch about how unhappy he is and noshed on the chocolate he keeps in a jar on his desk.

2:30pm. Called The Kabuki Eight movie theater and purchased two tickets to the Friday night premiere of *Lost in Space* (I can't *wait*) for Ben and myself. Called Body Manipulations and made an appointment to get my navel pierced on Saturday. It was either that or bleach my hair.

2:45pm. Talked to a patient on the phone and prompted him on the "correct" things to say to the nurse in charge of the study he was interested in to ensure he was enrolled. He doesn't really qualify because of the medications he's been on, but hell... it pays $500 and he needs it.

3:00pm. Called the hospital Human Resources department to ask the representative to check into *why* my medical insurance isn't paying for my viral load tests any longer. I keep getting bills from a lab in LA demanding thousands of dollars.

3:15pm. Left work early for a dental appointment.

What can I say? It's been slow at work.

Happiness. I've been struggling so much with this issue lately. What is it... that oh, so elusive emotion? Who is happy? Are we ever *truly* happy? Can we ever expect more than a fleeting moment of it?

Happiness, as you well know, is one of many emotions we humans are lucky enough to experience in our day-to-day lives. Happiness, sadness, anger, angst, fear, delight, embarrassment, excitement, terror, disgust, pride, love. It's a mixed bag. How can we possibly expect to always be happy? I've become satisfied with the happiness I *do* feel. I simply don't think it's healthy to always be happy when there is such a range of magnificent emotions available. If we were always happy... I suspect we would get rather bored and take it for granted. At least *I* would. Without deep sadness, how else would happiness seem so sweet? Without red anger, how else would forgiveness and release feel so transcendent?

What makes me happy? Many things do. *Most* of the time they do, anyway. My first sip of coffee in the morning. My first morning smoke. A stroll through Golden Gate Park looking at the magnificent blooming philodendron ablaze in reds, pinks, yellows and greens. Talking to a long distance friend on the phone. Having a tourist stop me on the street and ask for directions because I obviously look as if I live here. Seeing a movie I've waited for months to see. A new pair of shoes. Blue skies, warm balmy days, the sharp ocean air. A new episode of the X-Files. Jon finally moving out. Lenny cleaning the bathroom. When a flu ends. Watching *Who's Afraid of Virginia Wolff* for the umpteenth time. Helping people. Pushing my nieces, Gina and Paige, on their swing-set. Writing letters.

Sometimes these same things don't make me as happy as other times. It depends on what else is going on... and if I allow myself to open up and experience all life has to offer. Perspective. Perspective. Sometimes one can be

happy (albeit, momentarily) for the simple fact of being alive. Sometimes it ain't that easy. It ain't that easy at all.

Part of what I'm feeling is that I feel tainted. Yeah I know, kind of a strong word... but it's how I feel. When things are going along OK with me physically, HIV-wise, I seem to have no problem. But when I battle with fatigue and weird skin stuff (zits, rashes, et al) I struggle with the need to withdraw. I feel overwhelmed, frightened... weak. And I despise feeling weak. It's the most difficult issue for a control freak like myself to deal with... feeling out of command of my health. Some of it is the human failing of self-pity. But some of it is simply being flipped out, feeling things really are out of my hands. Yes, I do my damnedest to take care of myself... vitamins, herbs, working out, resting, switching medications when needed. But there are times when I *do* feel as if it all will simply do no good. And also, unfortunately, switching medications sometimes brings along a whole other slew of side effects. Am I moody because of the fatigue or are the medications making me moodier and on-edge? All of this affects me physically and consequently emotionally. It makes me feel uncomfortable being touched, kissed. Being intimate.

About, oh, a year ago or so, I remember one of Sher's sisters was in town visiting. One chilly Sunday afternoon, we all went to Golden Gate Park to view the vegetation. Sher's sister and I were making chatty small talk. She asked me where I was from and how long I've lived in San Francisco. She then asked me if I was happier here than I was in Chicago. I thought for a moment, confused and conflicted as always when confronted with that volatile of all emotions... happiness. And said, "Happy? Well, I'm less *miserable* here, anyway." She understood. We walked through the Oriental Garden, looking at trees, flowers and plants. Max, after spending an hour or so chasing birds, chattering and delighting me to great heights as usual, was tuckered out and climbed into my arms to cuddle as we walked back toward the car. She lay her sweet head on my shoulder, threw her arm around my neck and sucked her pacifier. I could smell her innocent, almost out of babyhood scent. I said to Sher's sister... "*This* is happiness. This *moment*. What more is there?"

Love, Sal

26 April 1998

Dear Tim:

I went to an "HIV on the Frontlines" Conference in LA last week. It was fun to play "AIDS Professional," attend workshops and schmooze. The most

interesting presentation was on Alternative/Complementary therapies. The presenter was an MD at Irvine University who had done clinical studies on various "miracle" AIDS cures and substances that boast "immune system enhancing" qualities. Garlic, Echinacea, Korean Ginseng, and a concoction of Olive Oil lemon juice and lecithin were all clinically proven to have immune system enhancing qualities. Kampuchea mushrooms, astragalus, and "Cats Claw" didn't fair quite so well, I'm afraid. He also mentioned that although massage and acupuncture did wonders for pain and symptomatic relief... they didn't do much for the immune system. Can't say I agree with him.

As far as Southern California?... *blick*. The conference was held in a hotel in Costa Mesa, a town forty miles south down the coast from LA. I rented a car and had the freedom of exploring the southern part of this state. I arrived at John Wayne Airport (yes... that's what it's named, I'm *not* kidding), stopped in a restroom to relieve myself where an older guy positioned himself at the next urinal. Out of the corner of my eye, I noticed a lot of movement. I looked over and he was stroking his half-hard, uncut dick. We jerked off for a minute together, staring at each other's pricks. Even though it was very risky, I *couldn't* resist... I have a "soft spot" for uncut dicks. And the thought of jerking off in "John Wayne" airport really blew my skirt up. I soon tired of the game (too many people were about) and I left. I had arrived at 6:00pm, in time to pick up my snappy rental car and get caught in a maddening traffic jam on the freeway (they're called "freeways" rather than "expressways"... because there ain't nothing "*express*" about them). I thought *San Franciscans* got on my nerves. Los Angelenos are *way* more annoying. On the freeway, well-dressed people chatting away on cell phones in sleek sports cars surrounded me. It took an hour to get to my hotel... and it's *only* two miles from the airport. If I had known better, I could have taken side streets and have gotten there in a flash. Hell... I could have *walked* and gotten there quicker.

That evening, I pulled out a trusty map and made my way to LA, which took about forty minutes speeding along the freeways. Hunted around the queer neighborhoods for a while and was very unimpressed. One of the things I hunted up, of course, was sex. I ended up at a sex-club called "Outer Limits"... *such* a LA name. In San Francisco, we call things what they *are*... like "Suck Hole." The place was creepy and dark... as I like it. I hooked up with a hot older Latin daddy and we retired to a booth. After forty-five frantic, sweaty minutes, we were through and I left. I went into the bathroom to check if I looked OK, but there was *no* mirror. *Hey*... I thought this was LA?! Forty

minutes later, I arrived at my hotel and stopped across the street at the 7-11 to pick up a tasty ice cream treat. Everyone stared at me... I thought, "Jeez, haven't they ever seen a queer in a leather jacket before?" and went about my business. I got the same treatment and stares in the hotel lobby. When I got to my room and finally looked in a mirror, I saw what they were all staring at. My face, neck and white T-shirt were streaked with huge, black smears and smudges. At first I thought it was dirt, then realized it was *eyebrow pencil.* Apparently my hot Latin dad had touched up his beard with black eyebrow pencil to darken it. *Queen.*

After a month of being on my new mega-anti-HIV-drug regimen, I got the results of my viral load... it went from 50,000 to *400,000.* What the *hell?* Here I am dumping all these pills down my gullet, yet my viral load persisted on growing. *Damn.* Well, I've had another blood draw and am anxiously awaiting the latest results. Perhaps the rise in my viral load was a fluke and the latest results will show a lower reading. If not, I'm tempted to throw these goddammed pills into the frikkin' toilet.

I've decided to try to sell my insurance policy and am waiting to hear from the viatical settlement company. I'm worried because it's a group policy through work and it may not be worth much. Also, my doctor is being unforgivingly stubborn about it. She's required to fill out a "Physician's Report" that came with the application. My doctor refuses to sign it because the document contains the statement, "This patient has a terminal illness." She says that, yes, I have AIDS, but she refuses to acknowledge it's terminal. I blew up at her and said, *"What the hell do you call a viral load of 400,000?!* Would you *please* stop being so bloody Californian and sign the dammed thing?" She consented to scratching out the statement and acknowledging I do have AIDS. *Thank you.* Truthfully, I'm not giving up on my health yet and I'm looking at this increase in my viral load as a minor setback... but c'mon, let's not get caught up in semantics, OK?

Love, Sal

25 May 1998

Dear Tim:

My health is a bit of a concern... *again.* My viral load persists on going up... the last reading was over 500,000. *Goddammit.* I've got to switch drugs around again. *Again.* The problem is... I've burned through most of the HIV

medications currently available. I may be going for a clinical trial San Francisco General Hospital is offering. It's what's called a "salvage" trial, offered to those who've already "failed" most of the drugs on the market. *I beg your pardon...* I prefer to think the *drugs* failed *me*. Anyway. I've switched medication combinations at least four times since I've started taking them nearly three years ago. On one hand, I understand why my doctor urged me to keep switching... I've never hit on the "perfect" combination and after awhile, my viral load escalates. Yet... this constant switching has left me few options. Well, I ain't giving up yet. The trial I'm trying to get into offers a new anti-viral nucleoside (1592), a new non-nucleoside (Sustiva) (which I'm already on... but am gonna lie and say I've never taken it to get into the trial) a new Protease Inhibitor (141W94) and a drug from a new class... a non-nucleo*tide* (Adefovir). Hopefully, all these new, fabulous meds will do the trick.

The sick and twisted thing is... the people at the viatical settlement company, with whom I'm trying to sell my life insurance, are overjoyed. Because of my escalating viral load, it makes my case more desirable. The sicker they think I am... the quicker they think I'm gonna die, the more money they may offer me. Ah, life. They can think I'm gonna die soon all they want. I ain't going nowhere. *Fuck* 'em.

Tonight, ShowTime is airing the premiere of Armistad Maupin's "More Tales of the City." I plan to watch it with Ben and sneer at the highly romanticized portrayal of San Francisco in the late '70s.

Love and kisses, Sal

10 June 1998

Dear Tim:

An update on my health... according to the latest reading, my viral load went down again, from 500,000 to 40,000... a significant decrease. Without switching medications. A blip? Perhaps it's on a downswing again? No matter... I'm extremely grateful and relieved. And am going to stay on the medications I'm currently gobbling.

I saw a fascinating documentary on TV about the history of the Castro. I knew San Francisco was an incredible place that pushed gay rights issues to a head and set AIDS care standards for the rest of the country, yet who knew such history existed right under my nose? It was a heartfelt (semi-self congratulatory) piece about the birth of gay rights and the struggle the queer community had to bring civil acceptance and tolerance to the world.

What happened to the Castro? To San Francisco? That hotbed of activism, strength and community? The feeling of "family"? (Did I come here looking for family? For Oz?). Queers in the '50s, '60s and '70s flocked here to escape the crushing oppression in their communities and created a neighborhood unique the world over. An openly gay neighborhood where gay men and women could express their love for one another. It was a long, difficult fight... yet was accomplished. In spades. But today, the Castro has become a white strip mall. Wall to wall bars, overpriced clothing, tchotchke stores and tourist trash. Ya know, some queers *still* move here and think, "this is the end of the rainbow" and stay, basking in the glory of *The* Gay Disneyland. Perhaps I don't feel that way 'cause I never really felt oppressed in Chicago. To a significant degree, anyway. Is this what those powerful, angry, activist-minded men and women of the '70s envisioned for "our homosexual haven" as they fought negative stereotypes, oppression, harassment, gay bashings and homophobia? Did they envision a "gay wonderland" rooted in greed with outrageously priced housing where activism memorabilia is delegated to decorating the walls of an overpriced eatery on Castro and 18th insultingly named "Harvey's"? (Named after Harvey Milk, gay civil rights activist in the late '70s who was the first openly gay person elected to a supervisory position... then shot and murdered six months later.) Actually, I think it's something *all* the unique neighborhoods of San Francisco are experiencing. The gentrification and commercialization of America's favorite city. How very sad. Was it different in the '70s? If I had moved here in '78 as a green 18-year-old... would I still be here, twenty years later, reveling in the glory of San Francisco?

After almost two weeks of gloomy, misty fog covering the city, it's finally cleared up this weekend. It was warm, sunny and gorgeous today. I spent some time with Ben (who's lightened up a lot) brunching and tanning in a park.

I'm still waiting to settle things with the viatical company I'm working with. I've recently completed the necessary forms to convert my "group" policy to an individual one. When it's processed and I receive confirmation, I then turn it over to the viatical company for an evaluation. Shortly after that, they'll make me an offer.

Love, Sal

20 June 1998

Dear Tim:

I met a veeeeery interesting guy recently... a fantastically funny, irreverent daddysort named Mario. My roommate Lenny met him on AOL, tricked with him and came home to tell me I'd just *love* him. So... I put Mario on my AOL buddy-list and pounced when he showed up. We got together the other night and Lenny was quite right... Mario and I clicked beautifully. After kissing frantically, passionately for the first fifteen minutes after I got to his apartment (which is a filthy, confusing pigsty), we said to each other, "Where the fuck have *you* been the past three and a half years?" He's a 40ish Dago from New York and has lived in San Francisco for 16 years... a big nasty leatherguy with a filthy mind and a slight tough Dago New Yorker accent, which I find *incredibly* sexy. Yet... underneath... he seems really vulnerable. Sensitive. He, of course, comes with his own particular interesting "baggage"... don't we all, *don't we all?* Before taking off his shirt, Mario said sheepishly, "Uh... I have a few scars you should know about. I was... *involved* in a stabbing." I glanced around the "living" room jammed with overflowing ashtrays, dirty dishes and clothing, with chains and shackles hanging from the walls and ceiling. I asked, "Oh... ? As the stabb*er* or the stabb*ee*?" He chuckled throatily and told me four years ago his therapist attacked him, stabbed him repeatedly and tried to kill him. I would have been horrified by the story if not for Mario's matter-of-fact "isn't life a hoot" take on things. Off came his shirt and indeed, his back, chest and stomach were littered with twisted, healed-over stab wounds. I ran my hands over them, kissed them and told him, "What the fuck are you complaining about? People pay damned good money to get scars like that from "scarification artists" at Body Manipulations!" He laughed and held me closely. We spent hours together talking, laughing, taking a bath (he has a poster of the shower scene from the film *Psycho* on his bathroom wall) and having great sex. He fondly calls me "pokey butt-wipe" and I call him "special scar-daddy." A match made in heaven.

I did a search on the Internet (using the key words "psychiatrist," "stab" and "blood") and found this article...

Bay Area Psychiatrist Accused Of Attempted Murder
A University of California at San Francisco
psychiatrist was brought into custody yesterday, charged

... I screamed like a teenage girl in a horror movie and nearly fainted.

with attempted murder. Allegedly, he attacked a nude
patient with a knife and an ax.

Monday night, a number of Hayes Valley residents
heard screams from a neighboring apartment and phoned
police. Police arrived at the residence and found Mario
Mondelli drenched in blood. Mondelli, naked and bleeding
from multiple stab wounds and ax injuries, reported that his
therapist was giving him a massage when he was attacked
without cause.

Mondelli was rushed to San Francisco General
Hospital where he is in critical but stable condition. Dr.
Dan Steinberg, his alleged attacker, is a clinical instructor
in psychiatry at UCSF. Steinberg was also bleeding and
clad only in socks and undershorts when arrested at the
scene. Steinberg refused to give a statement, saying only,
"I'm tired. I want to sleep."

Mario told me he went to see the psychiatrist (Steinberg) because he was
very depressed and addicted to Crystal. It turned out Steinberg *himself* was a
Crystal freak. They began having a sexual relationship, Steinberg flipped out
about it, and decided to murder Mario in case Mario tried to turn him in.

I can sure pick 'em, huh?

All is well on the West Coast.

Love, Sal

24 June 1998

Dear Tim:

Lenny and I went to the Suck Hole the other night (hell, I just got a
testosterone shot the day before… I had to do *something)*. Within minutes, I
was in a sweaty lip locked frenzy with a fuzzy creature who looked like an
older Raymond Burr. We clicked well… until I called him "Granpadaddy." He
got pissy about it and asked me how old I was. "I'm 37, Granpa." He said,
"Well I'm only *three years older* than you, so fuck off." Jeez, so he had
prematurely graying hair… he didn't have to be so goddamned *sensitive* about
it. Hell, I thought calling him "Granpadaddy" was a compliment. I was glad he
brushed me off because I quickly came across a delectable studman. He was
tall, dark, with a shaved head, an incredible kisser and had a hard muscled

body with closely clipped body hair. *Such* a delicious piece. I knelt before him and headed "south." His prick was average sized… but he had *huge* low hanging balls (by the way, I am *not* a size queen… *any* size will do). I tried to play with them, but he kept pushing my hand away. Persistent cuss that I am, I kept fingering them… and realized the reason he moved my hand away was because he had *three* balls nested in his scrotum. Some guys have *all* the luck… the son-of-a-bitch shot like a *fountain*.

I spent another evening with Mario. Hey, I've neglected to mention how very funny he is (he writes for the "Dennis Miller Live" show on HBO… and sends jokes by fax… ah, the technological '90s). He's constantly cracking hilarious comments and keeps me in stitches. Ya know… I'm starting to get a soft spot for the guy… his life has been so tragic. His eyes, at times, reflect the soul of a fragile, frightened little boy. I think it's a "pity/interested" thing on my part. Mario's *way* too messed up and is too much of a piece of work for me to fall in love with him. But… that night as we watched TV, he brought out a tub of warm water, soap, a pumice stone and powder. He knelt before me and carefully, endearingly washed my feet. No one had ever done that before… I was so touched.

I've also neglected to go into much detail about how incredibly disastrous his apartment is. The first night I stopped by, he had a hammer, screwdriver, a huge dildo and several filthy washcloths in his bathroom sink (no… I *didn't* ask. There are some things I simply *don't* wanna know). When I was there four days later… they hadn't been moved. *Where* does he brush his teeth? Curious, I asked Lenny (who had been at his apartment the week before) about it. Lenny told me that, yes indeed… they were there then. And I could write volumes on his kitchen alone. Good Christ, I could write volumes on his kitchen *floor* alone. The other evening he asked me to get him a Diet Coke. When I opened his refrigerator… the putrid smell of rotting vegetables, meat and moldy, indiscernible food assaulted my senses like a sledgehammer. I screamed like a teenage girl in a horror movie and nearly fainted.

Love, Sal

1 July 1998

Dear Tim:

I realize why I like Mario and enjoy his company. The man is *majorly* fucked up. Yet… completely acknowledges it… makes no excuses for it at

all… and in no way tries to hide it. I can't tell you how goddammed *refreshing* that is.

We were at his apartment the other evening lounging around naked half-watching TV, when a commercial for *Scream 2* aired. One of the announcers was wielding a knife and the other had fake blood dripping down his face with an ax buried in his skull. Mario became silent, turned pale, became transfixed with the screen and said, "Oh. How very, *very* funny. That man has an *ax* buried in his head." He shuddered and curled into a ball in my lap (which is no easy feat… he's a full foot taller than I and outweighs me by 30 pounds), shoving his head between my legs, trying to crawl under me. I held him and rubbed my hands over him in comfort. Caressing the puckered, twisted scars on his back.

He has a motorcycle and that evening, I asked him to give me a ride. He smiled, said, "Sure thing, pokey," shoved a butt plug up my ass, told me to get dressed, gave me a black leather motorcycle jacket and a helmet to wear and took me out. It was twilight and the twinkling lights of the city began to glow as we tore through the streets. The wind whistled through my helmet, my legs clamped about his waist as I held on to him and burrowed up against his broad back. I cried. At the beauty of the city, the thrill of racing through the streets. And because the butt plug kept banging against my prostate.

Gay Pride Day. Rainbow flags had once again appeared on lampposts stretching the length of Market Street. A huge, bright, pink triangle appeared on the hilltop of Twin Peaks overlooking the entire city for all to see, declaring once again this city's tribal insistence of hysterically celebrating Gay Pride. Oh, *please* excuse me… I mean Lesbian, Gay, Bisexual, and Transgender Pride, *thank* you.

Sunday morning, Gay Pride Day, my roommate Lenny was joyfully preparing to spend the day on the streets with the multitude of revelers a scant three blocks from our apartment. On his way out he saw me sitting at my computer working and said, "It's *Gay Pride Day*… aren't you going out?! What kind of a queer are *you*?" I responded, "I'm a 'way over it' queer." I met with Blake a little later and we wandered through the riotous throngs, chatting. We made our way to the end of the parade route and to the party in The Civic Center. He was in an "anti-pride" mood as well, thank Christ. After an hour of craziness we left the hysteria-induced crowd and quietly chatted over brunch. I kissed Blake goodbye and headed home for a nap. En route I passed a pack of hot, young, studly, bear-daddies. One dark eyed dude locked eyes with me.

Rather, he *tried* to… I was wearing mirrored wrap around sunglasses. I stopped, leaned nonchalantly against a lamppost taking a deep drag off my cigarette (oh, how *very* cliché), and stared him down. He said something to his friends who kept walking and he turned back toward me. I told him, "I'm heading back to my apartment for a breather… come with me." Five minutes later, he was seated on my bed as I treated him to a frantic blowjob (hoping he didn't leave any skid marks on my cream colored down comforter). Three minutes later, we were done (and I checked. Good, no skid marks)… and I mentioned I was ready for a nap. He asked, "Alone… or with me?" "Alone," I said decidedly. He scrawled his number on the pad of sticky notes I keep by my phone and asked me to call if I wanted. Sure, *whatever*. You are *dismissed*, dad. I curled up with my teddy bear and tried to rest.

I miss you, Tim.
Love, Sal

15 July 1998

Dear Tim:

Mario continues to be entertaining and surprising. I went over to his apartment last week and to my surprise… he was washing his dishes. And had already cleaned out his refrigerator. I asked him why and he sheepishly told me he was tired of my shrieking every time I opened it. I drew a bath and washed him as he smoked a cigar. And pissed on him a couple of times. Later, after sex, I was holding and kissing him. I told him how lonely I've been feeling lately and asked if he ever felt lonely. "All the time. That's why I go for 'pinball' sex," he said. I know what he means. Oh, so well. Then he said, "I love you." I told him, "I love you too." Oh oh. Now what?

I do worry about Mario. It's so difficult to communicate with him. He's almost always "on." Theatrically "on," that is. It's tough to have a real, heartfelt talk with him. He constantly turns serious topics into something funny, or simply refuses to discuss anything. Probably guarding himself.

I still see him once a week or so… it's about all I can handle. And I actually got him out of his apartment again this past Saturday. After sex, we discussed what we wanted to do. I wanted to go to the top of Twin Peaks and enjoy the magnificent view as the sun set and he wanted McDonald's. We compromised… went to McDonald's on his motorcycle and took it to Twin Peaks to eat. Near the top, we got turned around… the streets are very twisty

and most of them aren't thoroughfares. At one point, I spotted the correct way to go, but he couldn't see my hand as I pointed... the peripheral vision in his left eye is shot as a result of getting clobbered on the head with an ax. Something he neglected to tell me *before* I got on the cycle... *thanks a lot.* Suddenly... he stopped in front of a house where a man and woman were in the driveway unloading groceries. Mario pulled over near them and stared. They looked at us with trepidation, obviously thinking, "Why are these two leather queers on a motorcycle glaring at us?" I was thinking the same thing. After a moment, Mario yelled over the puttering of the cycle, "Hey... the guy who used to live in that house tried to *kill* me. He hit me over the head with an ax and stabbed me twenty times." The man, trying very hard to be California-cool said, "Oh dude... that's uh... too bad. Uh... well... *we* live here now." Mario said, "I just thought you'd wanna know" and tore off down the street, to their obvious relief. Two blocks away, Mario pulled over, wracked with shudders. I calmed him as best I could. Gee... maybe getting him out of his apartment *isn't* such a good idea after all.

We finally got to the top of Twin Peaks, pulled over at the lookout point and spread out our feast (by now, rather cold and smashed). I felt oh so San Franciscoesque, wearing leather chaps and jacket, helmet at my side, eating bad junk food next to my freaky daddyfuckbuddy, overlooking the magnificent vista, ignoring the scores of tourists who were *freezing* in their summer shorts.

Unfortunately, I've just come down with a lovely San Francisco cold. (I caught it from Mario... dammit.) And the cool, damp, foggy air has done me in. Nights are in the 50s and daytimes rarely get above 60 degrees. The sun *occasionally* breaks through for an hour midday. San Francisco in midsummer. *Blick.*

Still... Blake and I had a lovely time on Sunday. We hopped a bus and went to the Palace of the Legion of Honor Museum to walk along the grounds by the ocean (not *too* close though... the land along the cliffs is a bit, shall we say, *unstable* from all the rain last winter). We took a stroll along the cliff overlooking the crashing surf, the Golden Gate Bridge and the sweep of the bay. *Breathtaking.* Blake turned to me with tears in his eyes and said, "People ask me why I stay because San Francisco is so expensive and is such a tough place to live... but I stay because of this. There are so many gorgeous places to be in... it's worth it." I echoed his sentiment and said, "Yes, it's incredible here but I do miss my friends and family a lot. I think of them every day. And

sometimes I wonder if it's right to stay when I still have such sadness over that… after three years."

I've been here over three years. At times… it still doesn't feel quite real. Even after all I've gone through. Or perhaps *because* of all I've gone through it doesn't seem real. It doesn't feel like home.

I've also been going through *terrible* homesickness. It's partly due to this cold (I always get melancholy, bitchy and self-pitying when I've been sick) (can ya tell?). Why do I stay here?… besides the obvious. Job, insurance, et al. Really… what the hell am I doing with my life here I can't do in Chicago? Ahhhhh… I'm in a very vulnerable state and feeling lonely. And everything just seems so difficult here. Yeah, well, things were difficult in Chicago as well. *Life* is difficult, eh? I'm so looking forward to seeing you in Chicago next week. Damn… I sure need a vacation.

Love, Sal

31 July 1998

Dear Tim:

So. And so. Back in San Francisco. Seeing you and everyone else I care about was delightful. And I've decided… to move back to Chicago. What good is living in "paradise" if your heart aches for the people you care about and feel closest to? I felt more connected and more excited about life during my trip to Chicago than I have this entire year here in San Francisco.

Time to go home.

Home. To friends and family.

I didn't want to come back to San Francisco and since my return, I've been miserable. Simply *miserable*. It's as if I'm in a foggy dream… one that I'm ready to wake up from. The weather has been perfectly stunning and San Francisco is incredibly beautiful as ever. Yet I don't feel as if I belong any longer (have I ever really "belonged" here?). How ironic… I live in one of the most beautiful cities in the United States, everyone's "favorite city," yet I yearn to return to Chicago, to live near the Dan Ryan Expressway in Pilsen. Go figure.

I can tolerate many things but loneliness is something I have tremendous difficulty with. I always have. The loneliness I've been struggling with here is about all I can take.

Mario is so vulnerable and childlike… sometimes I just want to cradle him in my arms… which would be rather impossible since he is such a big boy. I'm really gonna miss him. Nevertheless, I'm watching some remarkable changes in him. He's continuing to clean his apartment and is starting to acknowledge he could benefit from therapy. This time though, he's gonna find a nice dyke. *Good move.* And he's opening up more and talking about what happened and how it's affected him… he says there aren't many people in his life who are willing to listen. Actually, I find it fascinating to hear about. After the attempted murder, he was in a coma for two months. He remembers people talking to him and he dreamt a lot about Mary Tyler Moore. It turns out the nurse who would sponge bathe him and change his bed linen would turn on the TV and watch that show during her duties.

Oh, this city… this *town*. Doesn't it just figure? The moment I decide to leave San Francisco… I begin having a fuckin' *blast*. Perhaps it's 'cause I only have a little time left and I wanna "blow it out." I had heard The Stud in SoMa is great fun on Wednesday nights… they play retro dance music from the '70s and '80s I hadn't gone before because I'm hyper-responsible about getting to bed at a decent hour when I have to work the next morning. But now… who cares? Off I went this past Wednesday and had a marvelous time. The crowd was friendly and diverse with quite a few dykes… something I very much enjoy. Too many bars and clubs here are *so* segregated. Sometimes I feel as if this city were drowning in a sea of queer men. The music was fantastic and I danced for hours among the undulating crowd. Last night, the DJ played "San Francisco" and Go West" by The Village People (gee… do you think they were *gay?)* and it struck me how unreal my time has been here. How unreal San Francisco can be. I can't believe I've been here for 3 years…. Where the *hell* has the time gone?

I went to my favorite sleazy sexclub Saturday night. Things were hoppin' beyond belief because this past weekend was "Dore Alley" Fair… yet *another* over the top, wacko, S/M leather inspired street fair held in SoMa. It's on the order of Folsom Street Fair, but is much smaller, much more severe, with fewer tourists and mostly packed with queers hell bent on showing off outrageous behavior in public (many getting arrested) demanding their right to have public sex in the middle of a crowd, on the street, in broad daylight. A "Yeah, fuck me and whip me on the hood of a car Daddy with everyone watching" sort of thing. The club was filled with men in various leather ensembles performing a plethora of sex acts. I wandered around,

simultaneously entertained and bored. I hooked up with a hot Dad for a while, who after having sex for an hour, told me to come find him again because he's on Viagra and will be hard all night. He also, generously, offered me a dose. I declined, knowing it may interact adversely with one of the protease inhibitors I'm on. That and the fact I think it's ridiculous. Yep, Viagra has hit the sex-clubs bigtime, complete with signs plastered throughout the club warning patrons of the fact Viagra and "poppers" *don't* mix... they are a lethal combination and their combined use may result in a fatal heart attack. Ah, the '90s.

The next day, Mario and I went to the fair. It was actually quite a stretch for him because, first of all, *he went*... and also because he wore a leather vest, his scars bared for all to see. I was very proud of him. And yeah, the fair was the same old, same old thing. Men and women of all shapes and sizes in various stages of dress and undress. Cigar smoke and the sounds of pounding music filled the air. It was a hot afternoon, which prompted fairgoers into more revealing outfits. I was quite warm in my tight rubber vest and thick dog collar Mario asked me to wear... the price we pay for fashion. Scores of buffed chested hairy men and sexy bare-breasted dyke dominatrixes were everywhere. In a tucked away corner, a leathermaster had handcuffed his boy to a chain link fence and whipped him leaving lash marks on his otherwise smooth, bronzed, flawless back. Mario and I watched for a while munching on grilled Portobello mushroom and pesto sandwiches we picked up at the neighboring concession stand.

Later, Mario and I retreated to his apartment. He was riled up by the activities of the day and promptly put me over his knee to spank me. *Not* being in the mood (I was hot, tired, and my feet hurt from wearing heavy boots all day), I struggled with him and fell off his lap to my knees. He then "playfully" (so he says) cracked me across my face. That is one of my major "no" buttons and I saw red. Without thinking, I reached up and smartly cracked him back. His eyes bulged in shock... then he cracked me *again*. Furious, without missing a beat, I returned the volley. He grasped my arms and said menacingly, "Don't you ever, *ever* hit me. And *you* need to decide whether you want to be a bottom or a top, Mr. Control Issues." I told him my control issues have nothing to do with it... I despise getting hit in the face and I simply react when that happens. And I wouldn't apologize for hitting him. That pushed him completely over the top. He told me to get out, saying he refuses to have anyone in his life who won't apologize. I left as he slammed the door in my face. A piece of advice... *never* slap an attempted murder victim in the face.

I went home to try to nap. After an hour of fitful dozing, trying to block out the shrieks of joy, the insistent, thudding dance music, the yelps, howling and hooting traveling to my bedroom window from Dore Alley Fair, I gave it up. Took a long hot shower, got on a Muni train and went to Golden Gate Park. *Ah...* blissful peace and quiet. The thick fog put a delicious chill in the air... which was probably why there were very few people about as I walked through the Fuchsia Dell, marveling once more at nature's graceful riot of color. I finally felt at ease. Centered. I wandered and found "my bench." I reflected on the first time I retreated to Golden Gate Park three and a half years ago... shortly after I moved here. I brought myself back to April 1995... two weeks fresh in San Francisco. I remembered the tremulous thoughts that raced through my mind... "Will I get a job?... What will my life be like?... How will I survive?... Everything here is so foreign and strange to me." My, oh my, what a trip this place has been. I cried, remembering the tremendous fear and excitement I had at the beginning of this adventure. I cried, thinking of all the trials I've been through. I remembered the various scenarios of what could possibly happen to me that had flooded my mind that April. Nothing came close to what has happened. Truth, my dear, is much stranger than fiction. And best of all... I don't regret a moment of it.

Love, Sal

6 August 1998

Dear Tim:

Big news. The viatical company I'm working with *called me with a buyer.* They're offering a *fuck* of a lot more money than I dreamed they would. I wonder if one can make a career out of this? This completely takes away any financial worries I've had about moving back. Hell... I'm gonna get a car and look into buying property. God*damn*... I'll be coming back in style. Who says having AIDS is a drag?

I've struggled a lot with whether or not to call Mario. I've thought I *should* because hell, the guy *has* been though a lot and if I were more understanding... I'd call him and let bygones be bygones. Then, stubbornly, I think, no fuckin' way. The motherfucker slapped me... and kicked me out of his apartment. I've *never* been kicked out of anyone's home before. I decided I wouldn't put up with it. That crazy bullshit was something I put up with *way* too long with Pete... and I will *not* put up with it again. Dammit. So, I'm

determined not to call him. Nor has he called me. Jeez... are we two stubborn Dago-bastard-mules, or *what*?

Love, Sal

17 August 1998

Dear Tim:

My... I've just experienced a *very* "Tales of the Cityesque" conclusion to a mysterious unresolved issue. As you may remember... Max's father (donor) originally talked about the possibility of co-parenting with Sher... then tweaked in the middle of Sher's pregnancy and blew town. Sher never told me whom Max's father is... all she would say was "he was a gay guy who used to be her close friend, who flipped out at the last minute and moved back to the Midwest." *Well*. That was *partly* true. The guy did in fact flip out and refused any responsibility in the matter. What Sher *didn't* tell me was the donor worked in in our department... and was there throughout her pregnancy... and during the first four months of Max's life. He was there during the first three months I was working there. What I find incredible is *not only* was the guy right under my nose... but Sher had to work with the son of a bitch the whole time. Actually, it's probably a good thing I *didn't* know I was working with him... I'd have had a difficult time keeping my big fat mouth shut. This chump worked right down the hall from the mother of his child... her office filled with Max's photos... yet would have nothing to do with her or with Max, who, as far as I'm concerned, is the sweetest, most joyful child on the face of this planet. I marvel at the strength Sher has... and at this guy's hideous behavior. I found out quite by chance. I was training my replacement (who worked in this same position before Sher had it) (round and round and round we go). He saw the pictures I have of Max all over my office and casually mentioned who her father is. When he told me... I almost plotzed. And of course it's true... Max is the spit 'n' image of her father.

I called Sher to tell her I found out and to let her know I think she has bigger balls than any man I know. We had an interesting conversation about what it's like for her to be a big "out" dyke in stuffy Connecticut. She misses San Francisco a lot... if only for the reason it's so easy to be queer here. She asked if it would be difficult for me to be a big loudmouthed queer with AIDS in Chicago. I don't think so. It was never an issue before. Yes, it *is* easier, it *is* more accepting here. But is that a copout? Sure... it's easy to be a completely

out fag with AIDS in San Francisco… people *expect* it for cris'sakes. I think it's *too* easy… and it's much more important for people like Sher and myself to live our unapologetically queer lives in the midst of the conservative East and Midwest. It's the best, the bravest way to institute change. Granted… I wouldn't try it in *Utah.*

On my last day at work in a fit of inspired mischief (something I had been *dying* to do since the day I stepped into the place), I called the hospital operator… told her there was an emergency… and asked her to please overhead page Dr. Bombay to my extension *immediately*. As I hung up, I heard emanating from the hospital loudspeakers… "Dr. Bombay. Dr. Bombay… call 6215 *stat*." I nearly *pissed* myself with unrestrained glee.

I paid a farewell visit to my favorite sleazy sex club and had a delightful time… for the most part. Yes, yes, yes, multiple orgasmic couplings with various studly daddies… including the clothing check guy who kept leaving in the middle of things each time a new guest arrived. What turned me off was this… throughout the evening, I watched a tremendously muscular, bearded bear walk around completely naked. I came across him here and there in the club coupled with different guys. He seemed to get more and more intoxicated as the evening progressed (a bad combination of drugs?). He began stumbling, walking into walls, growling and grumbling incoherently to himself. He finally collapsed and passed out cold in a corner. Concerned, I went to the manager and told him what was going on. He gave me a look as if to say, "mind your own fuckin' business" and said he'd take care of it. I went back to check on the comatose studly-bear… only to find four motherfuckers surrounding him, jacking off over his prone, unconscious body. One noticed me watching them slack-jawed in disbelief… and motioned for me to join in. I said, "Get the fuck away from him… are you guys nuts or what?" I went to the bear and tried to rouse him. He snorted and came to. Good. He wasn't *dead*. He saw the four guys standing over him (still jacking off)… leaned forward and popped the closest prick in his mouth.

I was snapped awake at 7:10 on one of my last mornings by a sharp, violent jolt followed by my bedside lamp falling over on my head. Since I sleep alone (and intend to *keep* it that way), I quickly realized it was an earthquake. I pushed the lamp off me and jumped to the doorway. Good mornin'… *so much for sleeping in.* I turned on the radio to learn it was a "moderate" 5.5 earthquake. *Moderate?* It felt as if a giant foot kicked the side

of the building. I spent the rest of the day on edge waiting for aftershocks. Get me *outta* here.

I was lying on my roof one hot lazy afternoon taking a break from packing and I thought about Mario. I figured what the hell… I should at least *call* him and say goodbye. He was thrilled to hear from me and we both apologized for our behavior. How *very* adult of us. Apparently… hitting *him* in the face is a big boundary issue for him as well. Who knew? We got together for a farewell night and had a wonderful time holding each other. After hot sex (that did *not* involve any face slapping) he took a lot of raunchy nude photos of me to remember me by. Then later, sadly, we said goodbye. Funny. Of all the men I've been involved with here… I think I'll hold Mario closest to me. Hmm… perhaps because he's the only one I'm parting with as friends. Anyway, I'll surely miss my Mario. He really does have a good heart.

As the close of my 3-year San Francisco docudrama extravaganza is near at hand, I ask myself… does life imitate art? Has *my* life imitated art? Would life have been different… would it have been much calmer here if I hadn't lovingly, *painstakingly* recorded all my trials and tribulations? Would I have not repeatedly become involved in such a series of ridiculous situations if I hadn't known all along I was recording it for prosperity? Have I purposely, methodically sought out all the intriguing, complex, volatile people I could… simply because it would make for a more interesting story? Truth… or illusion? In any case… thank you for accompanying me on this journey, my dear one. I couldn't have done it without you. Sometimes, I think the only thing that kept me relatively sane was writing to you.

The time has come to say goodbye to San Francisco. Goodbye to your graceful hills, your mild weather, your damp fog, your incessant claustrophobia inducing winter raining. Goodbye earthquakes, rare burning hot days, nude rooftop tanning in February, stores and restaurants without air conditioning. Goodbye to clanging cable cars, the mourning foghorns from ships on the foggy bay, to hordes of tourists, to scores of restaurants of every caliber. Goodbye the Suck Hole, street pickups, late-night moonlit hilltop park cruising. Goodbye Castro Street, SoMa, queers holding hands on every street corner, inferior Mexican food. Goodbye astronomical rents, too-small apartments, packed neighborhoods, ridiculous roommates and swarms of street people begging for cigarettes and dollars at every turn. Goodbye Golden Gate Park, to your magnificent gardens, breathtaking fuchsia and rhododendron dells, flowers blooming in winter, Queen Wilhelmina's Tulip Patch, towering

eucalyptus and redwood trees and ocean cliffs. Goodbye drag queens, leathermen, boys, masters and slaves prowling the streets in broad daylight. Goodbye DaddyBob, PapaPete, Jonny, Mario… and scores of other *very* strange bedfellows too numerous to mention.

Goodbye San Francisco…

… *watch out Chicago.* I'm *back.* And I've learned a few tricks along the way.

Love, Sal

Goodbye San Francisco...